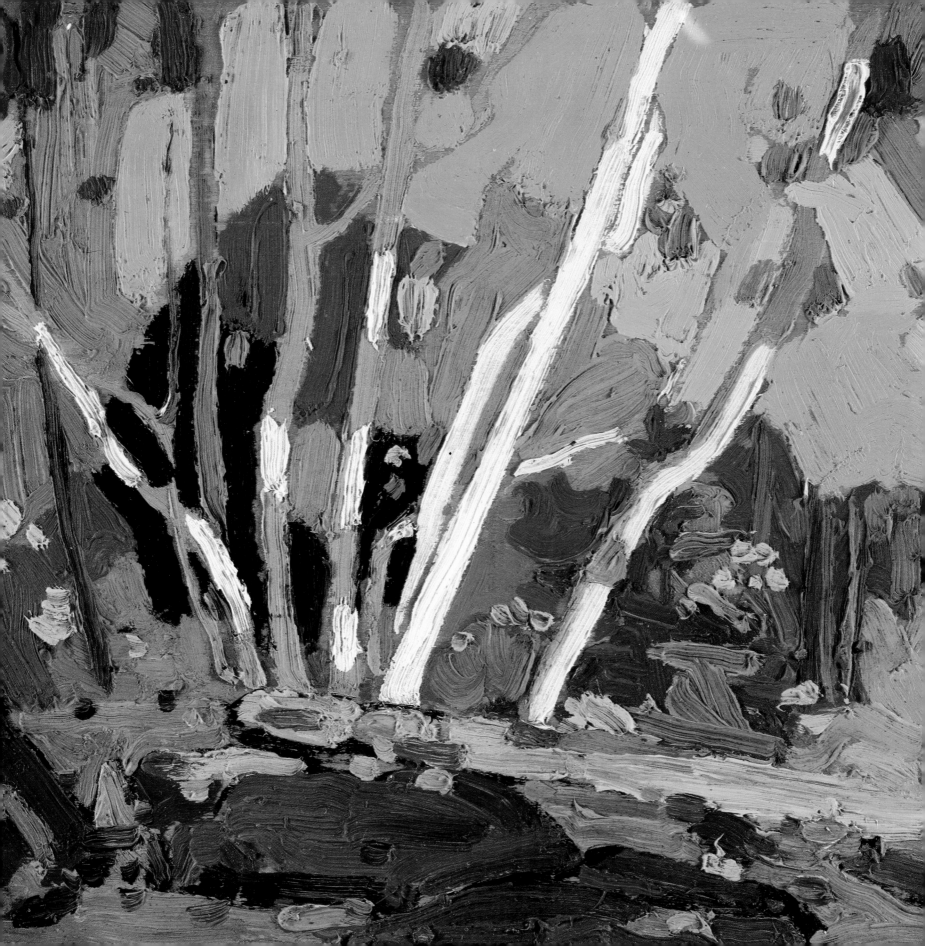

THE McMICHAEL
CANADIAN ART COLLECTION

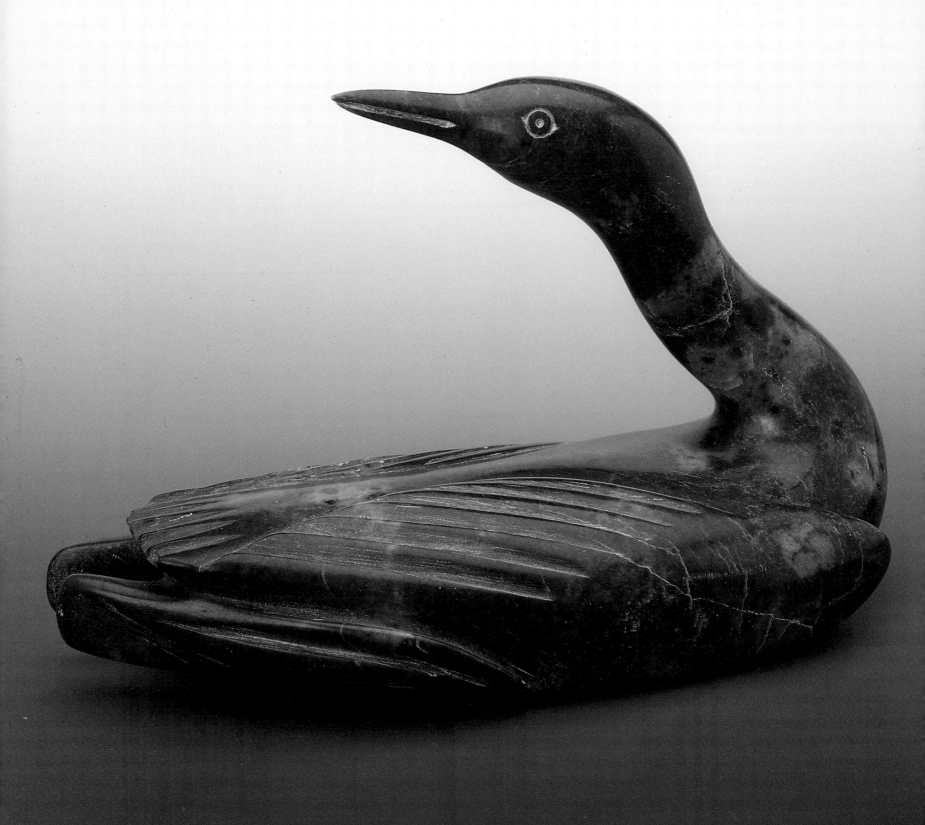

THE McMICHAEL
CANADIAN ART COLLECTION

BY JEAN BLODGETT, MEGAN BICE, DAVID WISTOW, AND LEE-ANN MARTIN

WITH A PREFACE BY DIRECTOR BARBARA TYLER

TWENTY-FIFTH ANNIVERSARY EDITION

1965–1990

McMICHAEL CANADIAN ART COLLECTION, KLEINBURG, ONTARIO

McGRAW-HILL RYERSON LTD., TORONTO, MONTREAL

89 90 91 92 93 5 4 3 2 1

The McMichael Canadian Art Collection
Islington Avenue
Kleinburg, Ontario
L0J 1C0
416-893-1121

McGraw-Hill Ryerson Ltd.
330 Progress Ave.
Scarborough, Ontario
M1P 2Z5

Canadian Cataloguing in Publication Data
McMichael Canadian Collection.
 The McMichael Canadian Art Collection

Issued also in French under title: La Collection
McMichael d'art canadien.
"Twenty-fifth anniversary edition, 1965–1990".
Includes index.
ISBN 0-7729-5745-2

1. Art, Canadian—Catalogs. 2. McMichael Canadian
Collection—Catalogs. 3. Group of Seven (Group of
artists)—Catalogs. 4. Indians of North America—
Canada—Art—Catalogs. 5. Thomson, Tom, 1877–1917.
I. Blodgett, Jean, 1945– . II. Title.

N910.K57M35 1989 759.11′074′011354 C89-099637-7

Canadian Cataloguing in Publication Data
Main entry under title:
 McMichael Collection

25th anniversary ed.
ISBN 0-07-549952-5

1. McMichael Canadian Collection.
2. Group of Seven (Group of artists)* 3. Indians
of North America—Canada—Art. 4. Art, Canadian.

N910.K57M3 1989 709′.71′0740113547 C89-095062-8

Photo Credits

Artworks were photographed by Larry Ostrom of Christie Lake
Studios, Richard Garner, James Chambers, Tom Moore, and Paul
Thomas.

Other photo credits are: *pages 8, 10, 151* John Reeves; *pp. 13, 49, 139*
National Archives of Canada; *pp. 17, 35, 63, 77, 111* McMichael
Canadian Art Collection; *p. 87* courtesy Peter Varley; *p. 95* courtesy
Art Gallery of Ontario; *p. 99* Fred Haines, McMichael Canadian Art
Collection; *p. 105* FEDNEWS; *pp. 119, 133* H.U. Knight, Victoria City
Archives; *p. 123* National Gallery of Canada; *p. 127* The Edward P.
Taylor Reference Library, Art Gallery of Ontario; *p. 161* Edward
Dossetter, Provincial Archives of British Columbia.

Design by Andrew Smith Graphics Inc.
Printed and bound in Canada

Front cover: Lawren Harris, *Mount Lefroy* (detail) 1930; oil on canvas,
133.5 × 153.5 cm; Purchase 1975, 1975.7

Back cover: 19th century Tsimshian mask; wood, paint, and abalone
shell, 22.5 × 20.8 × 11.3 cm; Purchase 1979, 1979.5

Page 2: Tom Thomson, *Autumn Birches* (detail) c. 1916; oil on panel, 21.6
× 26.7 cm; Gift of Mrs. H.P. de Pencier, 1966.2.3

Page 4: Sheokjuk Oqutaq, *Loon* 1977; green stone, 22.7 × 11.8 × 18.1
cm; Donated by the West Baffin Eskimo Co-operative Ltd., Cape
Dorset, 1989.9.4

The McMichael Canadian Art Collection is an agency of the
Government of Ontario assisted through the Ministry of Culture
and Communications.

CONTENTS

PREFACE

As the McMichael Canadian Art Collection reaches its twenty-fifth birthday, the collection is twenty-five times larger than it was in 1965 when the McMichaels turned over their home, property, and works of art to the Province of Ontario. Since the first book about the McMichael was published in 1967, the collection has expanded to include more than five thousand works. Some were purchased from proceeds realized through the sale of the book, since all profits from the sale of publications and reproductions go to the Art Acquisitions Fund; many more works were the gifts of generous donors, to whom we are most grateful.

At the same time, the gallery has grown behind the scenes. The staff complement is much larger, the programming has expanded greatly and—with the addition of a conservation department—many of the works have been cleaned, conserved, and rephotographed, all of which makes for better reproductions. So in celebration of our twenty-fifth anniversary we decided it was time for a brand new publication. The size of the collection precludes the reproduction of all the works, but what follows is a refreshing new sampling.

In this book we have endeavoured to respond to numerous requests for a volume that would provide basic information about the collection and its evolution, with biographical sketches of the artists and their times. Recognizing that different readers will be more interested in some artists than in others, we have structured the publication so that it is not necessary to read it from front to back; most sections can be read independently.

I am grateful to all the staff who in one way or another helped bring this book to fruition; but particular thanks go to the Chief Curator, Jean Blodgett, Curator Megan Bice, Registrar Sandy Cooke, and book packager Denise Bukowski, who so ably helped us put it all together. We appreciate also the special contributions of writers David Wistow and Lee-Ann Martin. I would be remiss, indeed, if I did not call attention to the provincial Ministry of Culture and Communications, whose on-going financial support enables this unique Canadian art treasure to thrive. Special thanks must also go to the Board of Trustees, whose efforts keep the staff energized, and to the thousands of sponsors, volunteers, and members whose financial and moral support not only helps sustain the operations but also challenges us to higher levels of performance. Finally, our greatest appreciation must go to Robert and Signe McMichael, who gave their property and their art treasures as well as their vision of a truly Canadian legacy.

Barbara Tyler
Director and Chief Executive Officer

The entrance and grounds of the
McMichael Canadian Art Collection.

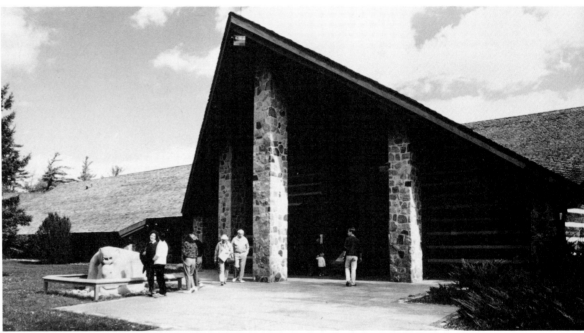

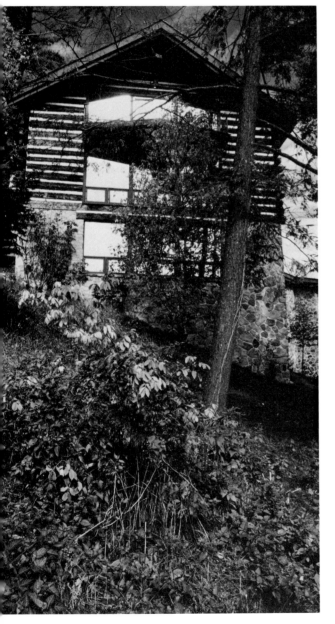

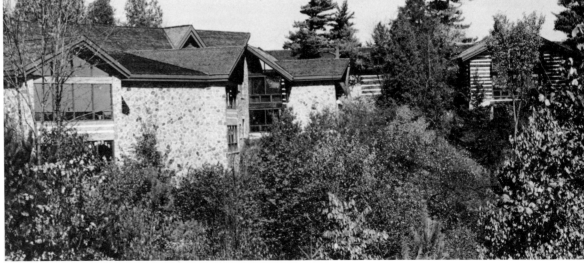

INTRODUCTION

WHEN ROBERT AND SIGNE MCMICHAEL GAVE THEIR ART collection to the Province of Ontario in 1965, their house and the land surrounding it were included in the gift as integral parts of the McMichael Canadian Art Collection. Today the artworks number in the thousands rather than the hundreds; the private home—much expanded—is a public building with gallery after gallery displaying Canadian art, and the surrounding acreage has increased by purchase and lease and is used regularly by locals and visitors alike. Nevertheless, a special atmosphere has been retained over the past twenty-five years. The log-and-stone buildings set in a hundred acres of trees and rolling hills continue to enhance the visitors' enjoyment of the works of art just as they did in the beginning.

The McMichaels began construction of their home in the country north of Toronto in 1954 on ten acres of wooded land just south of the small town of Kleinburg. The house, made of massive hand-hewn logs and local stone, was intentionally compatible with its setting; the hill-top location provided a panoramic view of surrounding hills and the Humber River valley below. The owners named their new home Tapawingo, an Indian word meaning place of joy.

There the McMichaels began to pursue another interest of growing importance to them: Canadian art. In his autobiography, *One Man's Obsession*, Robert McMichael explains that they were neither rich acquisitors nor conscientious members of families with a tradition of support for the arts; instead, they were typical Canadians with a love of their natural surroundings and their country and an appreciation of its art:

Whatever part our earlier experiences and education played in focusing our attention on Tom Thomson and his fellow painters, the sweeping views and intimate glimpses of nature surrounding Tapawingo greatly enhanced our appreciation of their art. We recognized that nature and the art derived from it are separate but related forms of beauty. We needed both.

The McMichaels placed a high priority on the acquisition of paintings by the Group of Seven, and Tom Thomson in particular. Robert McMichael, who had started his own photographic studio and then expanded into advertising, explains in his autobiography how important collecting was:

Paying for Tapawingo and financing my still marginal American business made it difficult, sometimes even impossible, for us to add to our collection during the 1950s, but we could never bring ourselves to pass up a Tom Thomson. Though further borrowing placed a strain on our precarious finances, we justified these expenditures by our certain knowledge that opportunities to acquire his rare works would never come again. Things that other people considered essential—appliances, cars, or even interior finishing work at Tapawingo could wait. These paintings could not!

They did not find a Tom Thomson for sale until 1956, shortly after they had purchased their first painting, *Montreal River, Algoma*, by the Group of Seven painter Lawren Harris (which they were buying in installments of $50 a month). When they found the Thomson sketch—a 1914 Georgian Bay scene—they were also offered a painting of Thomson's Algonquin Park camp done by Arthur Lismer. Seizing the opportunity, they purchased both.

The McMichaels were tenacious collectors. In order to find and purchase paintings, they did research, they talked to people, they visited dealers, they tracked down friends and relatives of Group of Seven members, and they befriended those Group artists who were still living. Through these people, they acquired new friends and first-hand knowledge about Tom Thomson and the Group of Seven and their art.

Over the years the McMichaels met Group members Arthur Lismer, A.J. Casson, F.H. Varley, Lawren Harris, A.Y. Jackson, and Edwin Holgate. They also grew to know such people as Thoreau MacDonald, the son of J.E.H. MacDonald, Ada Carmichael, wife of Franklin Carmichael, and Margaret Tweedale, Tom Thomson's sister. Many of these people were frequent guests at the McMichaels' home, and A.Y. Jackson lived there for the last six years of his life. Jackson and fellow Group members Lismer, Varley, Harris, and Johnston are

buried in a special cemetery on the McMichael grounds.

Visitors to Tapawingo enjoyed not only hospitality and a rural setting but also an ever-expanding art collection. While the McMichaels continued to specialize in Tom Thomson and the Group of Seven, they also began collecting works by Canadian artists associated with or subsequent to the Group, such as Emily Carr and David Milne. Even more significantly, their collection of Canadian art became truly national with the addition of works by Canada's indigenous peoples, the Indians and Inuit.

Before too long the 2,000-square-foot house was simply not big enough and so a wing was added in 1963. As their collection (and house) grew, interest in it increased so much that people came knocking at their door to ask for a viewing, and the McMichaels decided it was time to officially share their art with the public. In 1965, in a generous donation of unprecedented kind, Robert and Signe McMichael gave their collection, their home, and their land to the Province of Ontario.

Under the terms of the gift, the McMichaels acted as resident curators of the McMichael Conservation Collection of Art (as it was then called), assisted by a small advisory committee. In 1972 Premier William Davis introduced legislation changing the name to the McMichael Canadian Collection, appointing Robert McMichael as Director, and making a nine-member Board of Trustees responsible for the affairs of the gallery. Initially, the gallery reported to the Legislature of Ontario through the Ministry of Colleges and Universities, but responsibility was later transferred to the Ministry of Citizenship and Culture. In 1981 Robert McMichael resigned as Director and assumed the new office of Founder Director-Emeritus. Both the McMichaels continue as members of the Board of Trustees.

Visitors to the McMichael Canadian Art Collection may have some difficulty identifying the original home, now much changed by the addition of wings in 1963, 1965, 1967, 1969, and 1972 and further alterations and improvements in 1983. What was the McMichaels' home is now part office area, part public space: Gallery 2 and the Guides' Lounge on the lower level, Gallery 14 and the Director's office on the upper level. The public gallery now includes some 84,000 square feet, with fourteen exhibition spaces on two levels; office areas are below and above. The lower-level galleries display selections of paintings by Tom Thomson, the Group of Seven, and their predecessors, contemporaries, and successors. The upper level houses installations of Indian and Inuit art as well as temporary exhibitions.

The permanent art collection now comprises more than 5,000 works. Included are more than 90 of Tom Thomson's sketches and paintings, more than 1,700 works by the Group of Seven, and about 1,200 paintings, sculptures, and works on paper by Indian and Inuit artists. The selection of works by non-Group members, such as Emily Carr, David Milne, Clarence Gagnon, James Wilson Morrice, and Thoreau MacDonald, has also increased considerably.

Approximately half of the present collection was acquired by purchase, the rest by donation—an unusually high proportion of gifts. Not only did the McMichaels donate their original collection, they have continued to add to the gallery's holdings. Their dedication and purposefulness encouraged many others, and a number of very generous donors have substantially added to the collection.

Donors have also helped the McMichael realize new programs and initiatives in recent years. In addition to its collection and exhibitions, the gallery offers a range of public services and activities, including tours, lectures, concerts, school programs, art workshops, publications, and a variety of special events. Another facility, which was started by the McMichaels, is the library; now broadened to include artist files, archival photographs, correspondence, and manuscripts, it houses rare and illustrated books, exhibition catalogues, and periodicals. The programs, administration, and care of the collection are undertaken by more than 100 full- and part-time employees, augmented by docents and members of the Volunteer Committee.

The years since the McMichaels began collecting in the 1950s have seen tremendous change: their collection, the building, and grounds have greatly expanded; their private home has become a public gallery with more than 150,000 visitors a year; what was once the private passion of two individuals is now managed by more than thirty-five museum professionals. Yet despite such growth, the McMichael Canadian Art Collection has never lost that special combination of Canadian architecture, Canadian landscape, and Canadian art that makes it a unique national treasure.

JEAN BLODGETT
CHIEF CURATOR

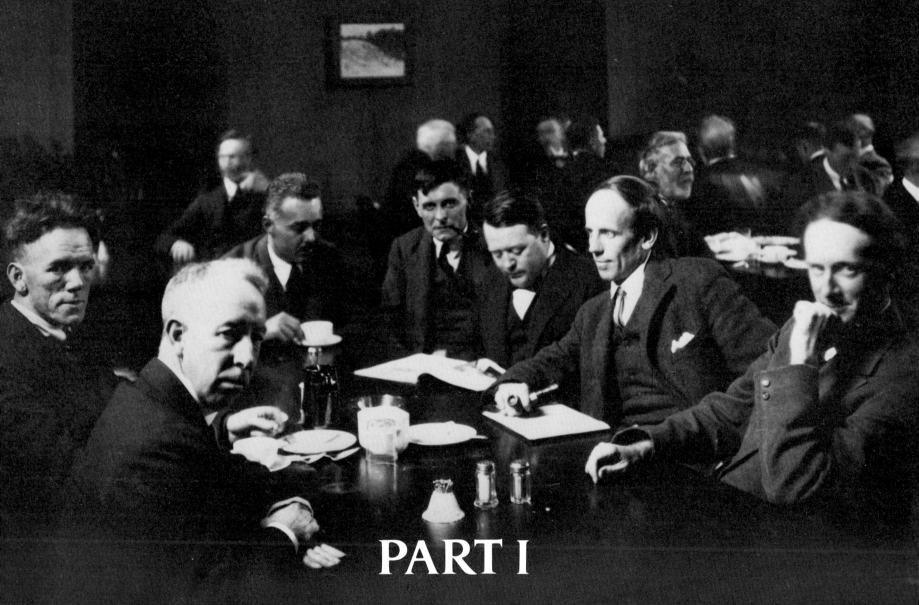

PART I
TOM THOMSON
AND THE GROUP OF SEVEN

Megan Bice

IN APRIL 1920 ARTIST A.Y. JACKSON RETURNED TO Toronto from a two-month sketching trip in the Georgian Bay area. As he later related in his autobiography, *A Painter's Country*, "The first thing I heard when I reached the city was that the Group of Seven had been formed, and that I was a member of it." A month later, the Group's first exhibition opened at the Art Gallery of Toronto (now the Art Gallery of Ontario), marking the debut of these artists as a formal association. The exhibitors were James Edward Hervey (J.E.H.) MacDonald, Lawren Stewart Harris, Alexander Young (A.Y.) Jackson, Arthur Lismer, Frederick Horsman (F.H.) Varley, Frank H. Johnston, and Franklin Carmichael. According to Jackson, if World War I had not intervened, the Group would have been formed several years sooner and another artist, Tom Thomson, would have been a member.

Two Toronto organizations served as gathering places for these artists, one professional and one social: the commercial art firm of Grip Ltd. and the private men's Arts and Letters Club. There these men first met, discovered common interests, and discussed ambitions and ideals. Working under the art directorship at Grip of senior artist J.E.H. MacDonald were Tom Thomson, Frank Johnston, and, later, Franklin Carmichael and Arthur Lismer. Unofficial activities of the firm included weekend sketching trips around Toronto. Varley too was employed at Grip in 1911, but only briefly, before moving to another commercial art firm, Rous and Mann, where Thomson and Carmichael had already signed on. It was at the Arts and Letters Club that J.E.H. MacDonald met Lawren Harris on the occasion of a showing of MacDonald's paintings from the Toronto vicinity. Also at the club were such older artists as J.W. Beatty and C.W. Jefferys, men who believed in and encouraged the dream of a distinctly Canadian art.

By 1913 these artists were already formulating their ideas about a Canadian art movement when several events took place that focussed them even more determinedly. In January MacDonald and Harris travelled to the Albright Art Gallery in Buffalo for an exhibition of contemporary Scandinavian painting. The show confirmed their own vision for Canadian art, and they conveyed their excited enthusiasm back to the others in Toronto. As MacDonald remarked in a 1931 lecture:

Not that we had ever been to Scandinavia, but we had feelings of height and breadth and depth and colour and sunshine and solemnity and new wonder about our own country, and we were pretty pleased to find a correspondence with these feelings of ours, not only in the general attitudes of the Scandinavian artists but also in the natural aspects of their countries. Except in minor points, the pictures might all have been Canadian, and we felt "this is what we want to do with Canada."

In the same year the Studio Building was constructed, with financing from Lawren Harris and his friend and art patron, Dr. James MacCallum. The building, which still stands on Severn Street at the edge of the Rosedale Ravine in Toronto, offered reasonably priced accommodation for its artist-tenants; when they moved in early in 1914, it became another centre for the lively discussions of the Group. Also in 1913 A.Y. Jackson moved to Toronto from Montreal at the urging of Harris. In November the artists arranged at the Toronto Reference Library the "First Exhibition of Little Pictures by Canadian Artists," which received mixed reviews. The Group's vigorous style of painting earned them the now-famous epithet, the "Hot Mush School."

The excitement of those days must have been almost palpable among this close association of like-minded artists. It was also a time, in the broader context of Canadian society, of pride in country and national growth. Although the Canadian Pacific Railway had laid track across the country by the 1880s, much of the land was still frontier. For artists schooled in the French Impressionist practice of painting outdoors directly from nature, Canada was a land to be explored and discovered. At first they painted mostly in Ontario's more rugged landscapes, venturing farther afield only after the war. With Tom Thomson's enthusiasm for the north, they were drawn into the wilderness of Algonquin Park. Outfitted with portable sketching boxes to carry paint and brushes and, in slotted fittings, several panels, the artists travelled alone or in small groups to painting sites—in the Toronto vicinity first, then the Georgian Bay area and Algonquin Park.

During World War I Jackson and Varley served overseas, and Harris with the army in Canada; Lismer moved to Halifax to teach. By the time all the artists had reassembled in Toronto after the conflict, one of the most important members of their group was gone: in 1917 Tom Thomson had drowned in an accident in Canoe Lake. His loss devastated his comrades. Jackson wrote to MacDonald: "Without Tom the north country seems a desolation of bush and rock, he was the guide, the interpreter, and we the guests partaking of his hospitality so generously given ... my debt to him is almost that of a new world, the north country, and a true artist's vision."

The artists resumed their former pursuits—sketching trips and exhibitions fired by the exchange of support and ideas. After visiting the Algoma region north of Sault Ste. Marie with Dr. MacCallum in the late spring of 1918, Harris was eager to return. He arranged the rental of a boxcar on the Algoma Central Railway and asked MacDonald and Johnston to join him and Dr. MacCallum. This was the first of the two famous "boxcar trips" to the Algoma region; on the second, in the fall

of 1919, Jackson replaced Dr. MacCallum. The railway car served as a rolling home and studio. Parked periodically on sidings, it provided the base from which to roam in search of subjects.

Although they had had group exhibitions at various times, the idea of a show officially labelling these artists the Group of Seven seems to have originated in February or March 1920. The first exhibition using that name opened at the Art Gallery of Toronto on May 7, 1920, and the accompanying catalogue clearly stated the artists' common stance: "The seven artists whose pictures are here exhibited have for several years held a like vision concerning Art in Canada. They are all imbued with the idea that an Art must grow and flower in the land before the country will be a real home for its people."

The Group was not a highly structured organization; "it had a name and a purpose but it had no officers, no bylaws and no fees," according to Jackson in *A Painter's Country*. Seven more exhibitions were held in the twelve years of the Group's history. For each show, other artists of similar vision were invited to contribute. Frank Johnston exhibited only once in a Group exhibition in 1920 before resigning as an official member. In 1926 A.J. Casson was invited to replace him. In an effort to widen the geographical base away from Toronto, Edwin Holgate of Montreal was asked to join in 1930, and in 1932 L.L. FitzGerald of Winnipeg was included.

Throughout the 1920s the Group diverged stylistically, with each member developing an individual approach. At the same time their search for new painting sites took them farther afield as did, in some cases, their search for paid employment. Mac-Donald and Harris separately visited the Rocky Mountains first in 1924, and both returned annually throughout the decade. Jackson often returned to his native Quebec but also visited British Columbia, the Great Slave Lake region, and, in 1927 and 1930, the Arctic on a supply boat. Restricted by his teaching duties, Lismer travelled less frequently but did go to Quebec and the Maritimes. Varley took a teaching position in Vancouver in 1926, remaining there for ten years. Johnston lived in Winnipeg from 1921 to 1924. Only Carmichael, tied by family and professional responsibilities, remained close to home; his painting trips took him to the territory north of Lake Huron and Lake Superior. These varying landscapes helped to shape the artists' styles—the stark, monumental terrain of Lake Superior's North Shore and the mountains of the west captivated Harris, for example, while the rolling hills and rustic villages of Quebec unfailingly attracted Jackson.

In spite of the popular belief that the Group of Seven was at first reviled by critics and the public alike, in fact there was both criticism and praise, and support came from many sources. In 1924 the National Gallery caused great controversy by asserting its right over the Royal Canadian Academy to choose the works for the prestigious British Empire Exhibition in Wembley, including those of the Group. The more traditional art community of the day complained that Canada should not be represented by a few "avant-garde" artists.

The Group of Seven's determination and their belief in Canadian culture was immensely influential in the years following the first group show in 1920, and that influence prevails to this day. They have become the most famous artists in Canadian history, symbolizing for many the concept of a distinctly Canadian identity. They recognized that their vision was shared by others, that there was a new attitude developing toward Canada for which their activities served as catalyst. They believed it was necessary to enlarge the Group, which ultimately was absorbed into a larger entity known as the Canadian Group of Painters (see Part II), whose first exhibition was held in 1933. This outspoken nationalism and belief in the continuing growth of art mark the Group of Seven as truly great contributors to the history of Canadian culture.

Page 13: Clockwise from far left: Varley, Jackson, Harris, Barker Fairley, Johnston, Lismer, and MacDonald at the Arts and Letters Club, c. 1920.

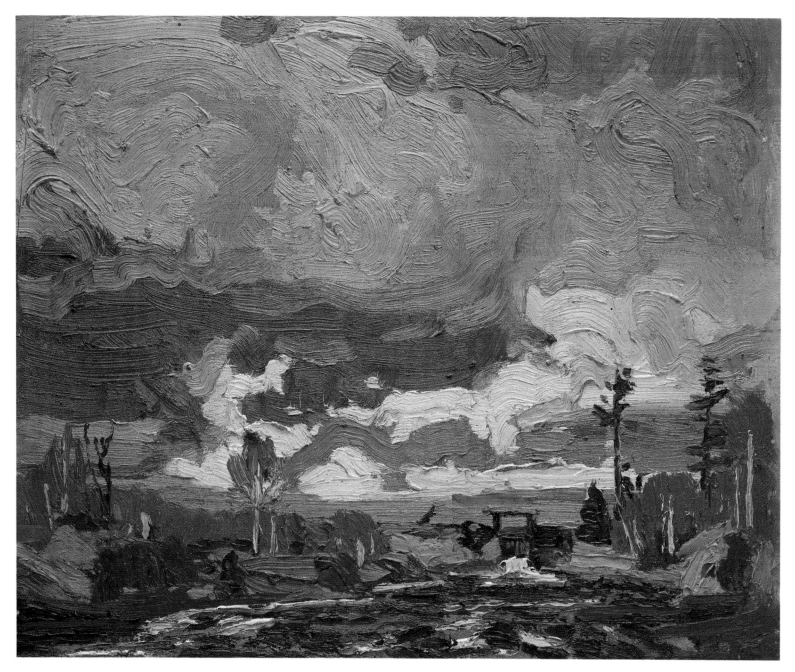

TEA LAKE DAM 1917
Oil on panel
21.3 × 26.2 cm
Purchased with funds donated by Mr. R.A. Laidlaw
1970.1.4

TOM THOMSON
1877–1917

Since his untimely and mysterious death in 1917, Tom Thomson has become the most famous artist in the history of this country and his life has become a Canadian legend. His early years gave little hint of the brilliant artistic contribution he would eventually make. He was raised on a farm near Owen Sound, Ontario, in an atmosphere more musical than artistic. As a young man he seemed unable to settle down and eventually found work in a photo-engraving firm in Seattle. By 1905 he was back in Ontario, and two or three years later he joined a Toronto commercial art firm, Grip Ltd. There he came into contact with men with serious artistic ambitions—J.E.H. MacDonald, Frank Johnston, and later Arthur Lismer and Franklin Carmichael. When he joined their weekend sketching trips outside the city, Thomson's art improved, and he was encouraged by his colleagues and by his expanding circle of friends: Lawren Harris, Frederick Varley, and A.Y. Jackson. It was the well travelled Jackson who, in 1914 while sharing work space with him at the Studio Building in Toronto, was perhaps most responsible for introducing the older Thomson to the art theories and techniques of the day.

Thomson in turn enthusiastically conveyed to the other artists his affinity for northern Ontario, particularly Algonquin Park, which he had first visited in May 1912; the area became his preferred place for the rest of his life. When in 1914 he gave up his work to paint full time, Thomson spent spring, summer, and fall in the park, returning to Toronto only in the coldest winter months. An accomplished outdoorsman, fisherman, and canoeist, Thomson earned a subsistence living as a guide at Algonquin, a lifestyle that freed him to work in the natural setting he loved and painted. In the winter he lived in a rented construction shack behind the Studio Building, where he produced large canvases worked up from the previous season's outdoor sketches. His *West Wind* and *The Jack Pine* have become two of the best-known works of Canadian art.

The final years of Thomson's life saw the full flowering of his talent. He found a way of life that suited him admirably and a confidence in his painting that established his mature style. Thomson did not simply depict the literal appearance of the Algonquin landscape; his interest was in showing its moods, weather, and seasonal changes. Mark Robinson, an Algonquin Park ranger and friend of the artist, recalled Thomson in the spring of 1917 claiming that he had done "something unique in art," that he had made "a record of the weather for sixty-two days; rain or shine, or snow, dark or bright, I have a record of the day in a sketch."

The work *Tea Lake Dam*, shown on the opposite page, was created during this period and demonstrates Thomson's artistic power at its height. It was painted on the spot on a small wooden panel of approximately eight by ten inches, revealing the artist's immediate impression of the day. Thomson's technique captures the movement of the clouds and the sensation of the change of light and shadow. The format is a recurrent theme in his work: the low horizon of the land is dwarfed by the more massive formations overhead, no matter what the time of day or weather conditions.

Thomson also favoured more intimate corners of the wilderness. Many paintings, such as the late works *Autumn Birches* or *Wood Interior, Winter*, reveal the patterns and the subtle colour tones of a scene closely viewed.

Tom Thomson died suddenly by drowning in Canoe Lake in his beloved Algonquin Park at the age of thirty-nine. Today the event is still the subject of debate over whether he died by accident or foul play. Whatever the truth, his loss was deeply felt by those artists around him who, three years later, would form the Group of Seven. His love of the north and his bold and experimental style had been inspirational to them. Since then many other Canadians have been captivated both by the story of his life and by his exciting paintings of Ontario's northland. Lismer called Tom Thomson "the voyager, the discoverer . . . He felt nature—he adored her—crept into her moods, . . . and his canvases lived in the Canadian mind."

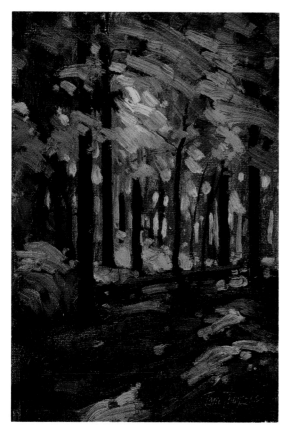

FOREST INTERIOR c.1912
Oil on canvas board
25.5 × 17.6 cm
Gift of Mr. and Mrs. R.G. Mastin
1982.1.2

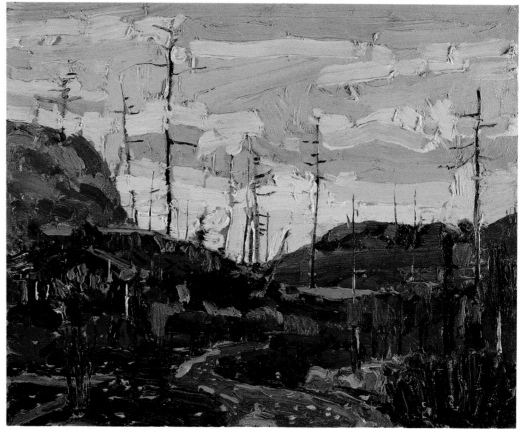

NEW LIFE AFTER FIRE c.1914
Oil on panel
21.5 × 26.7 cm
Gift of Mr. R.A. Laidlaw
1969.1

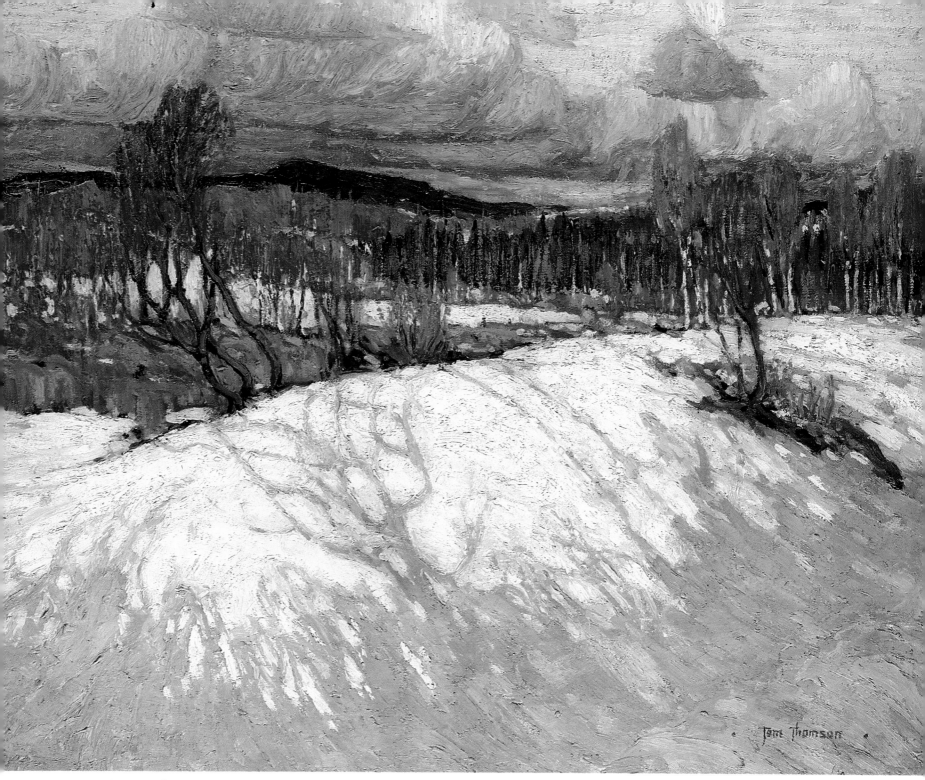

AFTERNOON, ALGONQUIN PARK 1914
Oil on canvas
63.2 × 81.1 cm
In memory of Norman and Evelyn McMichael
1966.16.76

TOM THOMSON

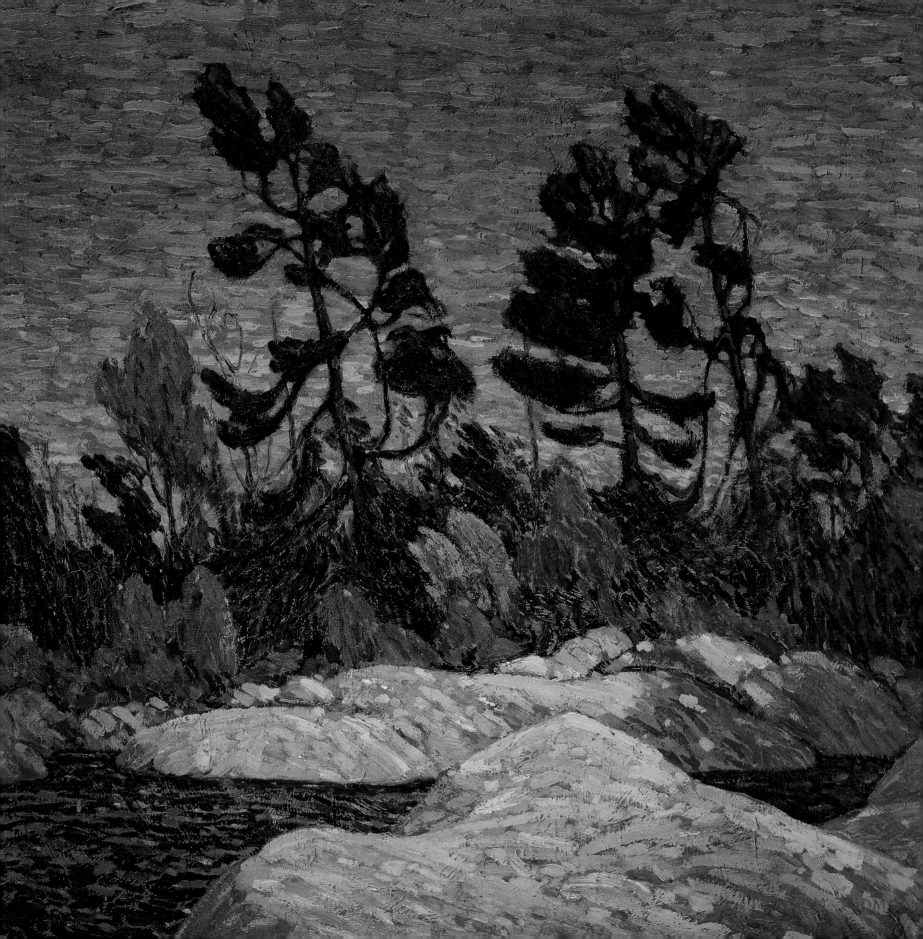

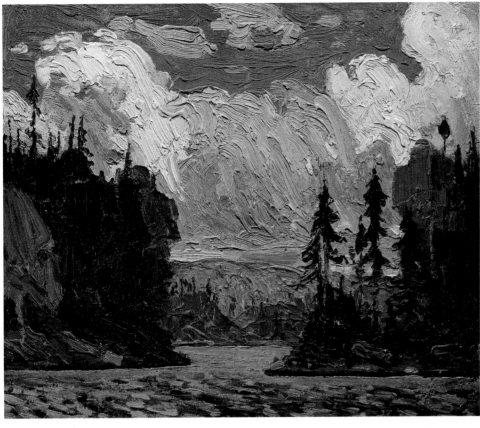

Sunrise c. 1915
Oil on panel
21.6 × 26.7 cm
Anonymous Donor
1966.16.72

Black Spruce in Autumn 1915
Oil on panel
21.7 × 26.8 cm
Gift of Mrs. W. Tweedale
1966.14

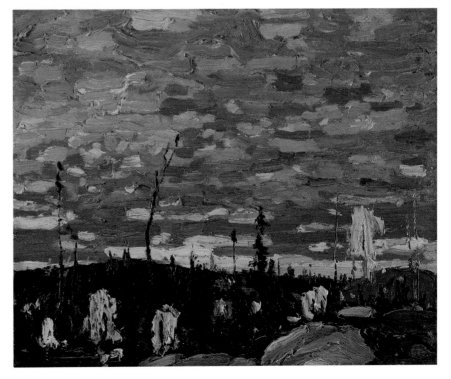

◀ **Byng Inlet, Georgian Bay** 1914–15
Oil on canvas
71.5 × 76.3 cm
Purchased with the assistance of donors and Wintario
1977.31

TOM THOMSON

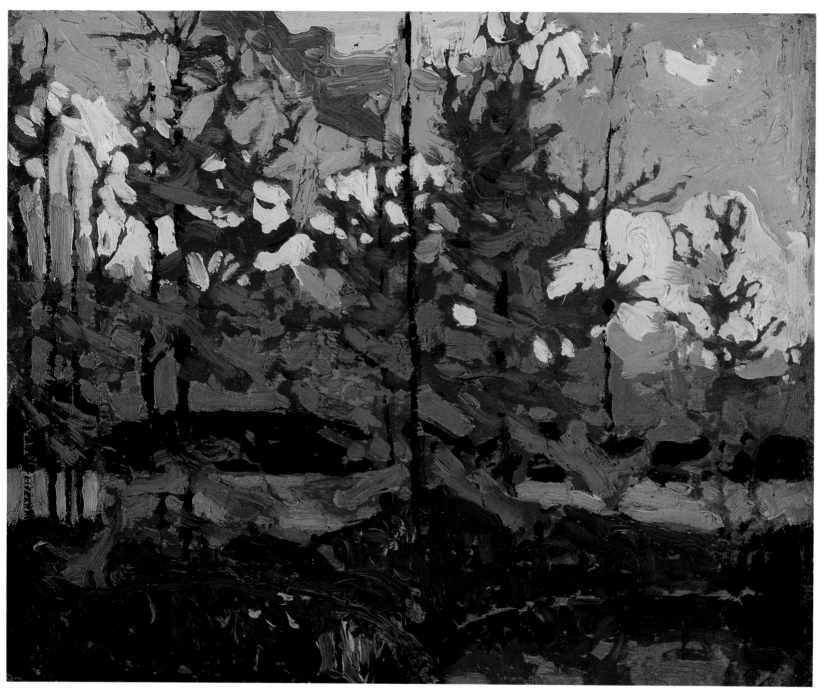

TAMARACKS 1915
Oil on panel
21.4 × 26.8 cm
Gift of Mr. R.A. Laidlaw
1968.12

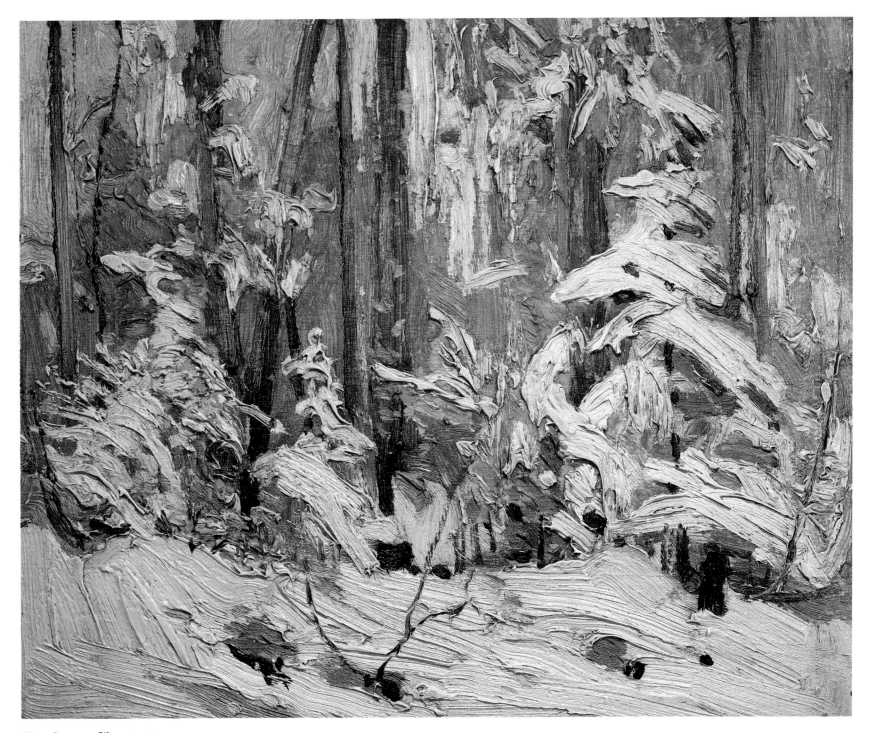

WOOD INTERIOR, WINTER c.1915
Oil on panel
21.9 × 26.7 cm
Gift of Mrs. Margaret Thomson Tweedale
1974.9.3

TOM THOMSON

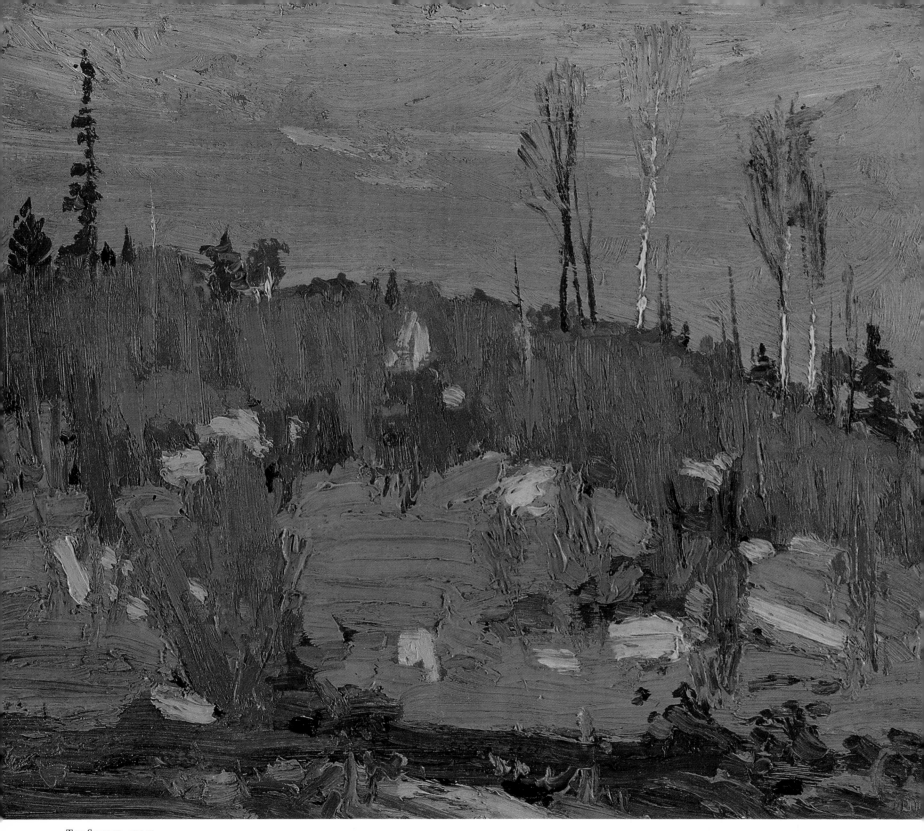

THE SUMACS c. 1915–16
Oil on panel
21.3 × 26.6 cm
Purchase 1980
1981.19

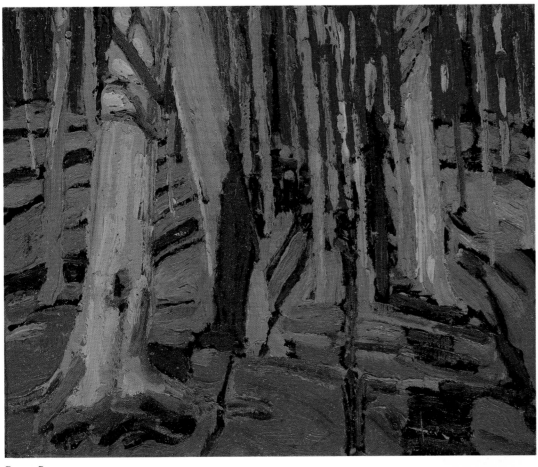

BEECH GROVE 1916
Oil on panel
21.6 × 26.5 cm
Anonymous Donor
1966.16.71

PURPLE HILL c. 1916
Oil on panel
21.6 × 26.7 cm
Gift of Mrs. H.P. de Pencier
1966.2.4

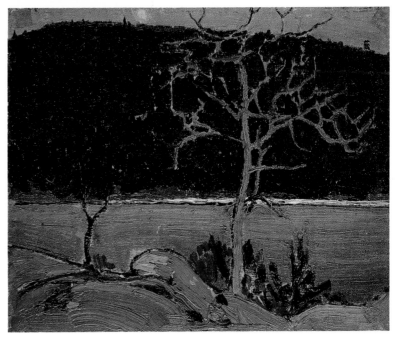

TOM THOMSON

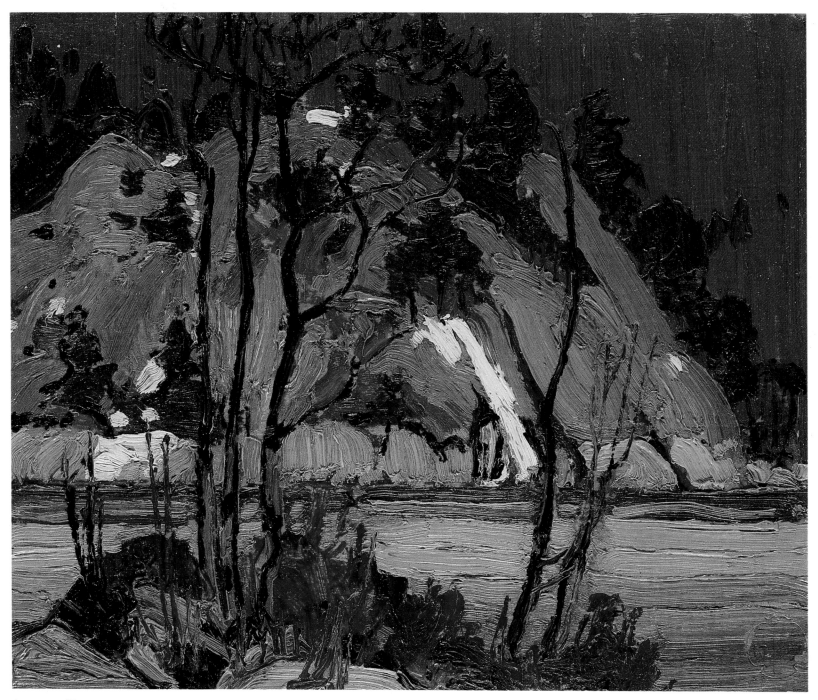

Algonquin Waterfall 1916
Oil on panel
21.2 × 26.7 cm
Anonymous Donor
1972.4

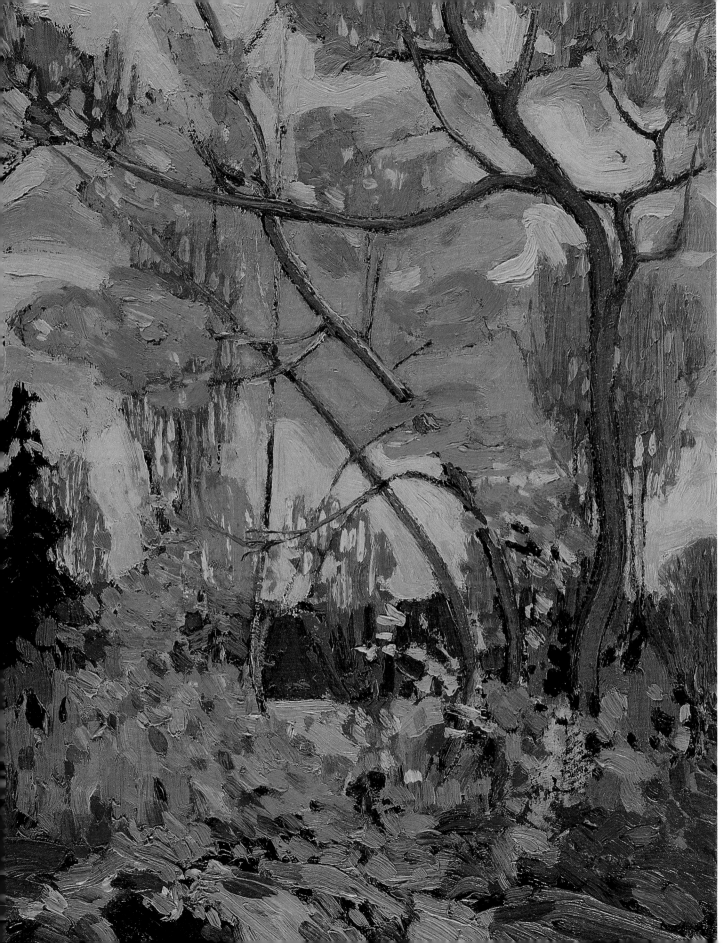

Autumn, Algonquin Park 1916–17
Oil on canvas
51.2 × 41.0 cm
Gift of Mr. C.F. Wood
1975.22

TOM THOMSON

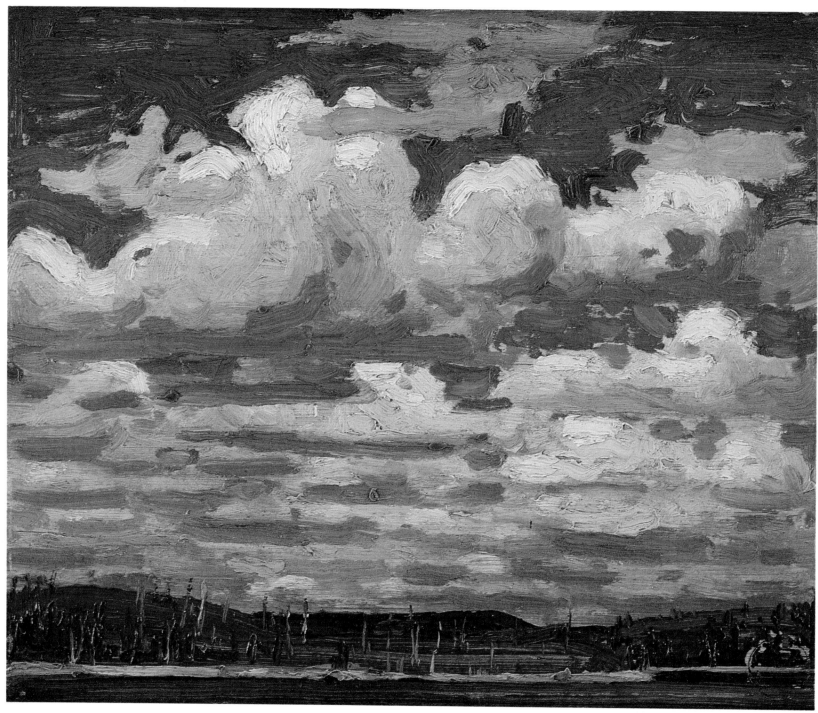

SUMMER DAY 1916
Oil on panel
21.6 × 26.8 cm
Gift of Mr. R.A. Laidlaw
1966.15.18

WOODLAND WATERFALL c. 1916 ▶
Oil on canvas
121.9 × 132.5 cm
Purchased 1977 with funds donated by the
 W. Garfield Weston Foundation
1977.48

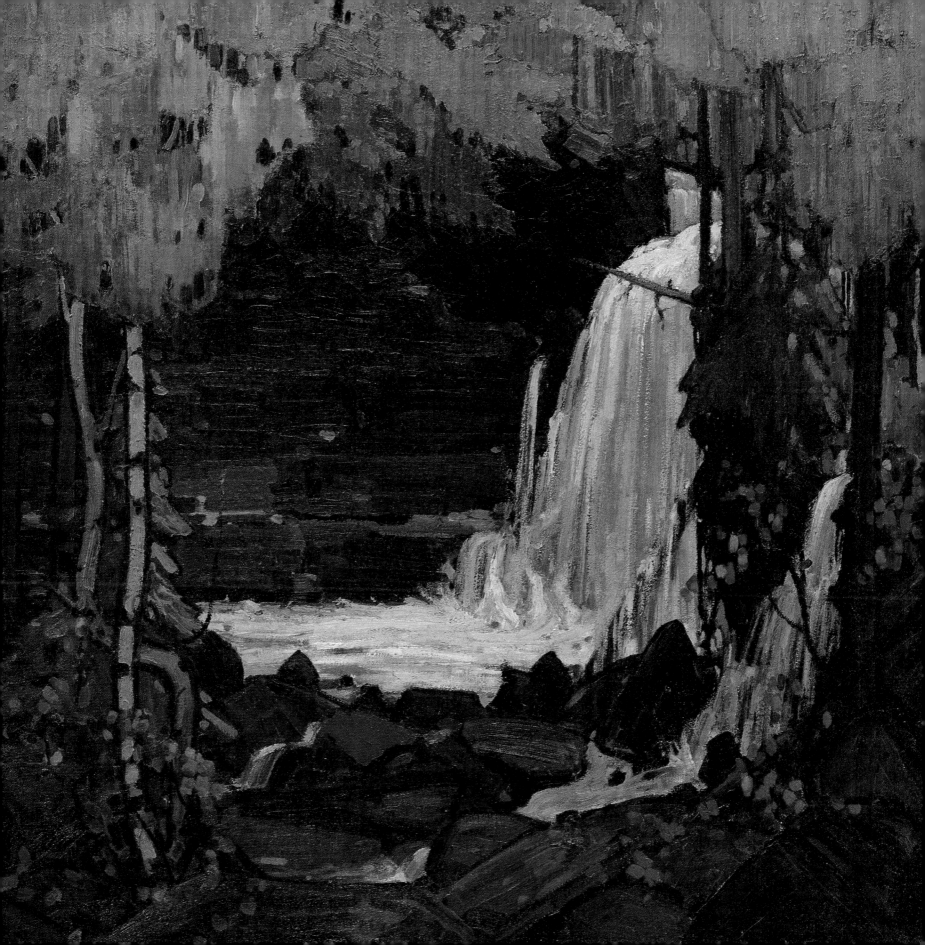

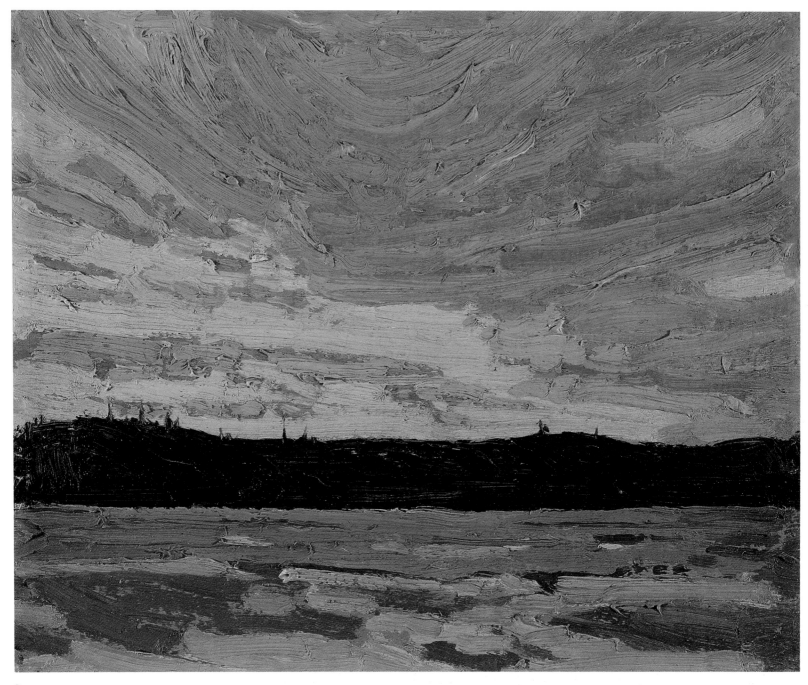

Sunset 1916
Oil on panel
21.3 × 26.7 cm
Anonymous Donor
1966.16.69

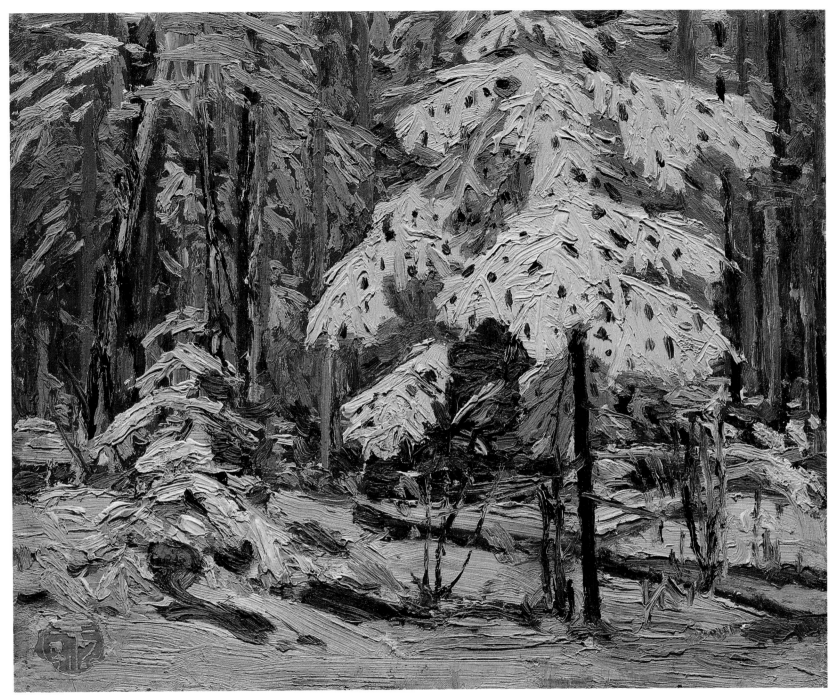

Snow in the Woods 1916
Oil on panel
21.9 × 27.0 cm
Purchased with funds donated by Mr. R.A. Laidlaw
1981.78.1

TOM THOMSON

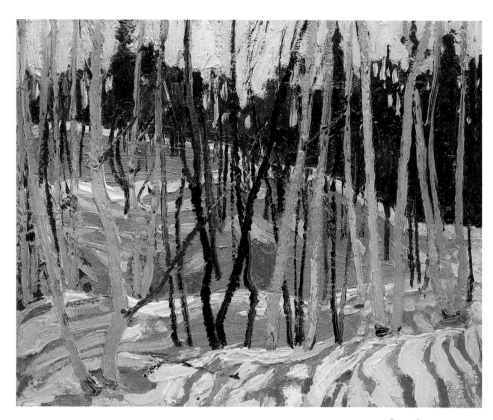

Spring Flood 1917
Oil on panel
21.0 × 26.8 cm
Gift of Mr. R.A. Laidlaw
1966.15.23

Snow Shadows 1917
Oil on panel
21.5 × 26.9 cm
Gift of Mr. R.A. Laidlaw
1968.18

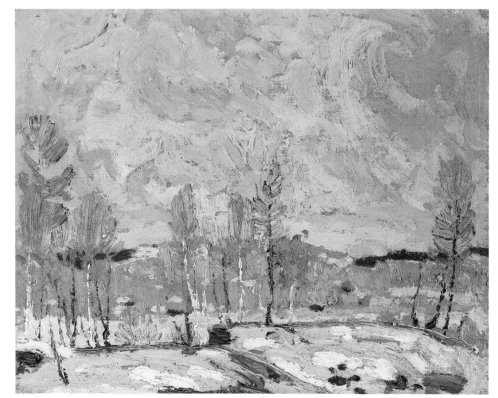

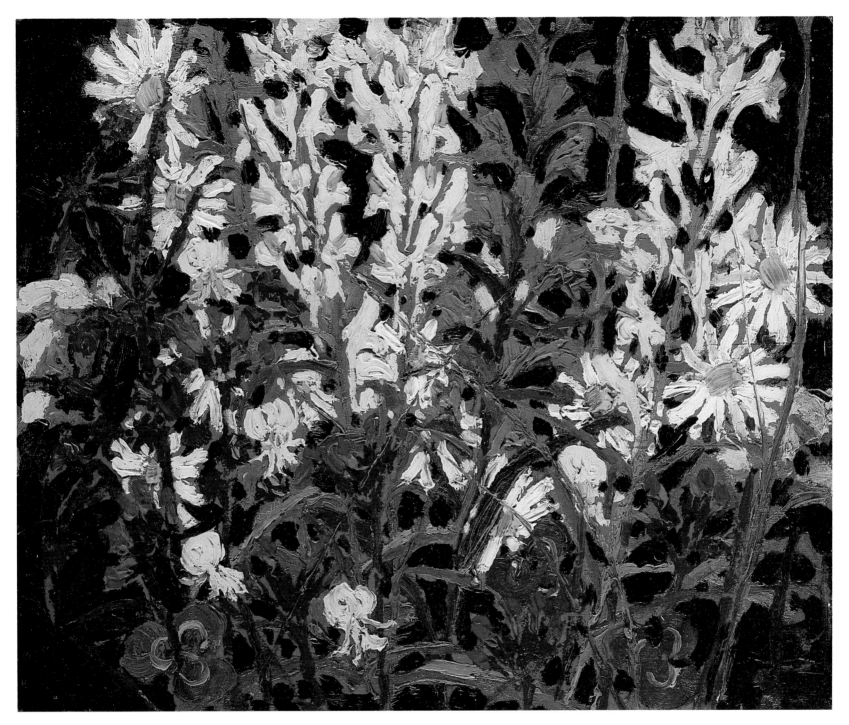

WILDFLOWERS 1917
Oil on panel
21.6 × 26.8 cm
Gift of Mr. R.A. Laidlaw
1970.12.2

TOM THOMSON

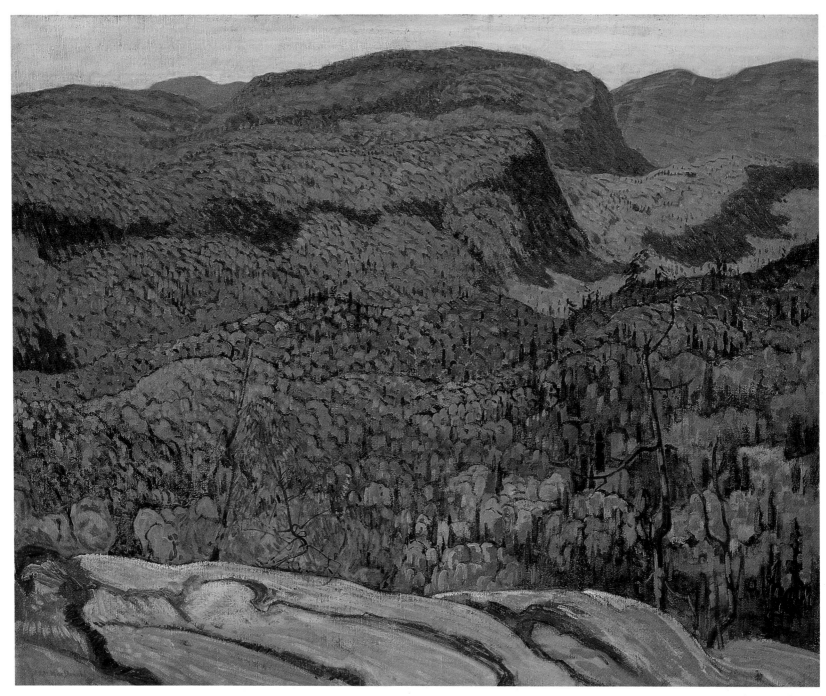

FOREST WILDERNESS 1921
Oil on canvas
122.0 × 152.0 cm
Gift of Col. R.S. McLaughlin
1968.7.1

J.E.H. MacDonald
1873–1932

J.E.H. MacDonald was the oldest member of the Group of Seven. Both his personality and his work are characterized by a dichotomy—between gentle reserve and fierce determination.

Born in England, MacDonald emigrated to this country with his English mother and Canadian father as a teenager. He studied art in Hamilton and Toronto. In 1895 he began work at the Toronto commercial art firm Grip Ltd., where he stayed until 1911, with a four-year hiatus from 1903–7 spent in London, England, with Carlton Studios. He became Grip's art director and today is well known for his superlative commercial design work. MacDonald supervised the work of fellow artists Frank Johnston, Tom Thomson, Arthur Lismer, and Franklin Carmichael. His interest in landscape painting involved him in Grip's weekend sketching trips as well as several other sketching clubs in Toronto.

An exhibition of paintings done in the Toronto area at the Arts and Letters Club in 1911 resulted in his friendship with Lawren Harris. Together these men constituted the driving force behind the formation of the Group of Seven. They held similar strong beliefs in the direction and ideals of art in Canada, and MacDonald often found himself spokesman for the new artistic movement. In 1916 his famous *Tangled Garden*, done from a subject on his own property at Thornhill, provoked one outraged critic to claim that the artist "had flung his paint pots in the face of the public." Offended but articulate, MacDonald pointed out that *Tangled Garden* and other paintings "are but items in a big idea, the spirit of our native land."

In 1917 several factors, including grief at Tom Thomson's death, led to a brief cessation of painting in favour of poetry. A number of these poems were published posthumously in the volume *West by East*, illustrated by his son, Thoreau.

In the spring of 1918 Lawren Harris wrote to MacDonald describing the Algoma region north of Sault Ste. Marie and urging him to join a painting trip to the area. In the fall Harris, MacDonald, Johnston, and Dr. James MacCallum set off on the first of two now-famous boxcar trips on the Algoma Central Railway. The landscape was a revelation for MacDonald and the inspiration for many of his most famous and successful paintings. He wrote to his wife that the area was "the original site of the Garden of Eden." The large canvas *Forest Wilderness* was painted from a small sketch done in the region, and it demonstrates the artist's strong compositional skill in interpreting such a panoramic scene. His works from this period show rich colours and bold treatment, ranging from closer, more intimate views of nature such as *Beaver Pond near Hubert, Algoma Central Railway* and *Beaver Dam and Birches*, to the more complicated landscape of the major canvas *Algoma Waterfall*.

Financially unable to remain a freelance commercial designer, MacDonald returned to full-time employment in 1922 as a teacher at the Ontario College of Art. His major sketching trips were confined from then on to school holidays, but in 1924 he travelled to the Lake O'Hara region of the Rocky Mountains, not far from Banff and Lake Louise. The landscape drew him to return annually until 1930. MacDonald's sensitive observation of colour and form can be seen in the sketch *Lichen Covered Shale Slabs*, and his love of the dramatic vista can be seen in such works as *Cathedral Peak and Lake O'Hara*.

MacDonald suffered a stroke in 1931 and took a convalescent trip to Barbados in early 1932. He died late that autumn. His death, following the formal disbanding of the Group in 1931, signalled the end of the Group of Seven years. Although never robust and always a quiet family man, MacDonald's influence on other artists and his role in the development of the Group of Seven are of profound importance. His nature, both poetic and outspoken, is reflected in his dedicated professionalism in all aspects of his career—his commercial art, his teaching, his writing, and, of course, his individualistic interpretation of the beautiful and the monumental in the Canadian landscape.

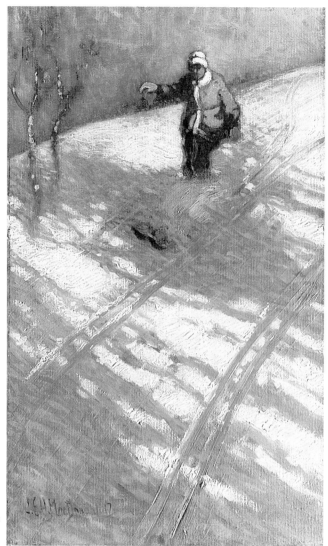

SKIING 1912
Oil on canvas
46.3 × 28.6 cm
Purchase 1984
1984.1

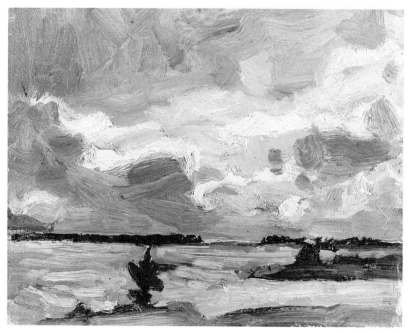

GEORGIAN BAY c.1916
Oil on pressed board
20.2 × 25.4 cm
Anonymous Donor
1966.16.42

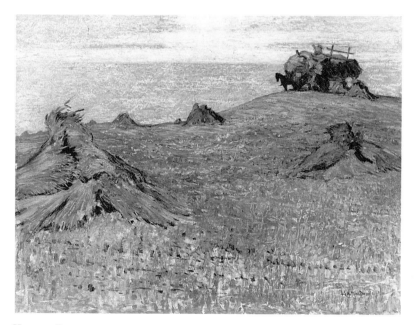

HARVEST EVENING 1917
Oil on board
76.2 × 101.2 cm
Gift of Mrs. M. Stern
1978.31

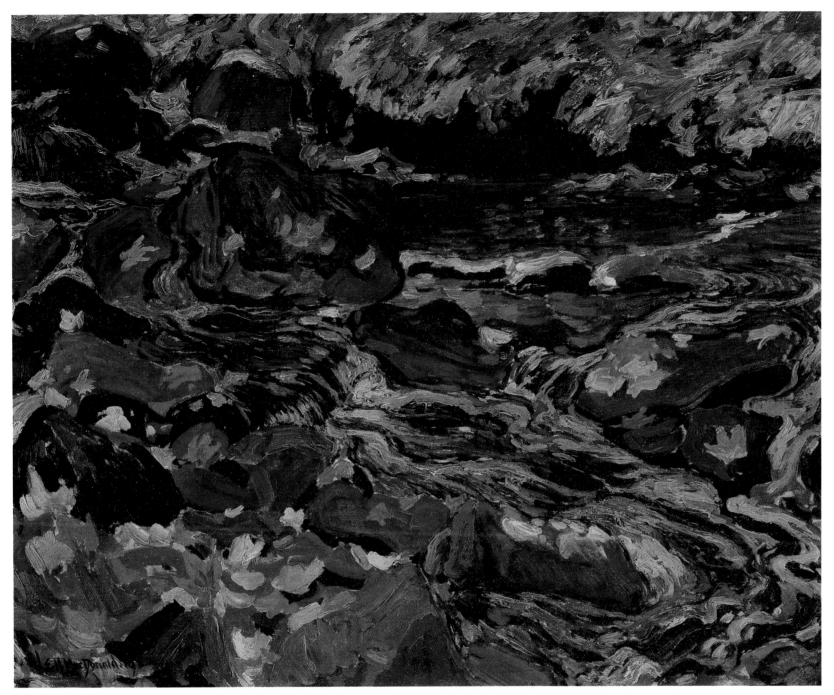

LEAVES IN THE BROOK 1919
Oil on canvas
52.7 × 65.0 cm
Gift of Dr. Arnold C. Mason
1966.16.32

J.E.H. MacDONALD

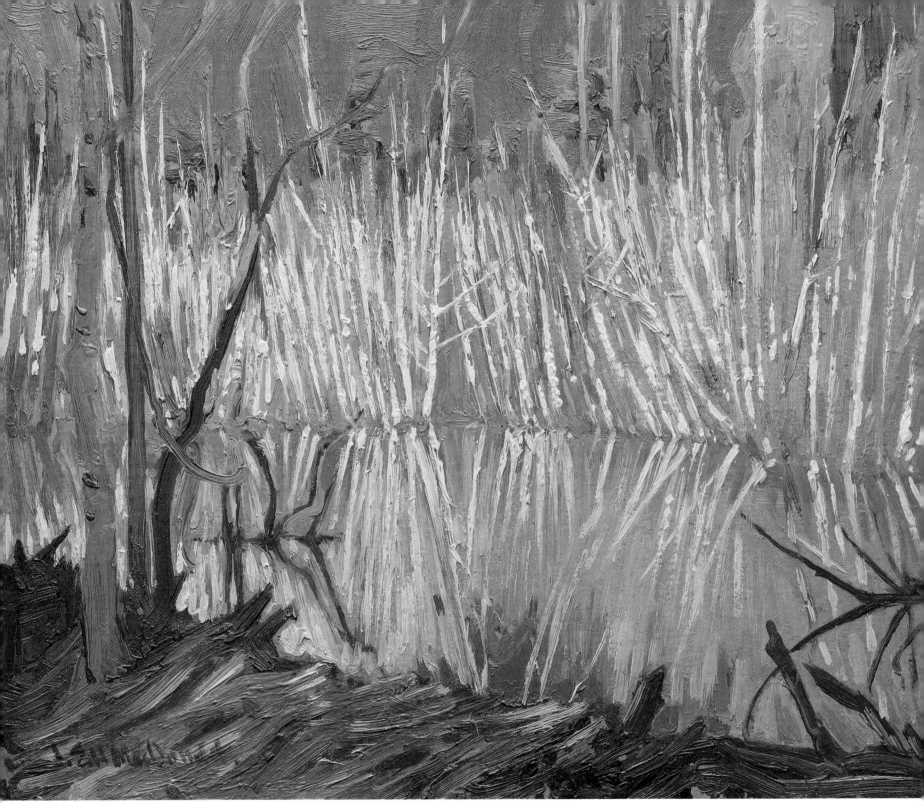

Beaver Dam and Birches 1919
Oil on panel
21.5 × 26.4 cm
Anonymous Donor
1966.16.49

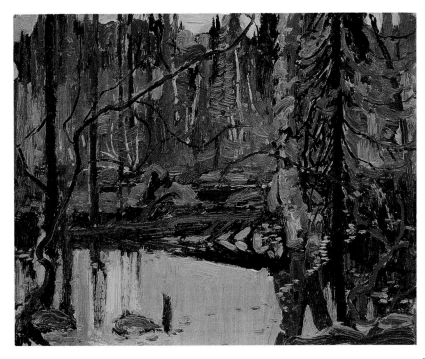

Beaver Pond near Hubert, Algoma Central Railway 1919
Oil on panel
21.4 × 26.6 cm
Anonymous Donor
1972.18.4

Nova Scotia Barn c.1922
Oil on pressed board
10.8 × 12.7 cm
Anonymous Donor
1966.16.53

J.E.H. MacDONALD

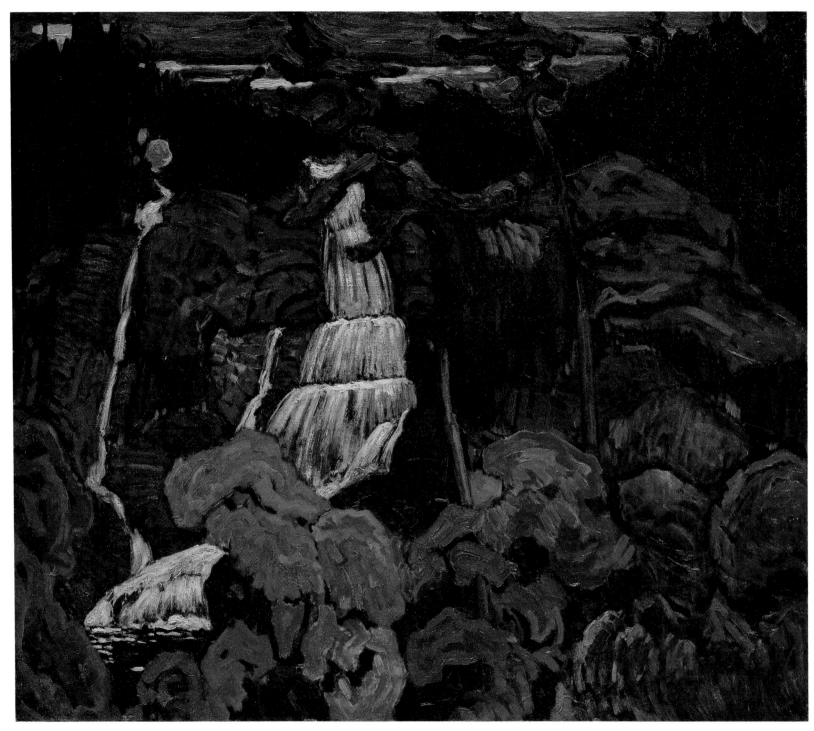

ALGOMA WATERFALL 1920
Oil on canvas
76.3 × 88.5 cm
Gift of Col. R.S. McLaughlin
1968.7.2

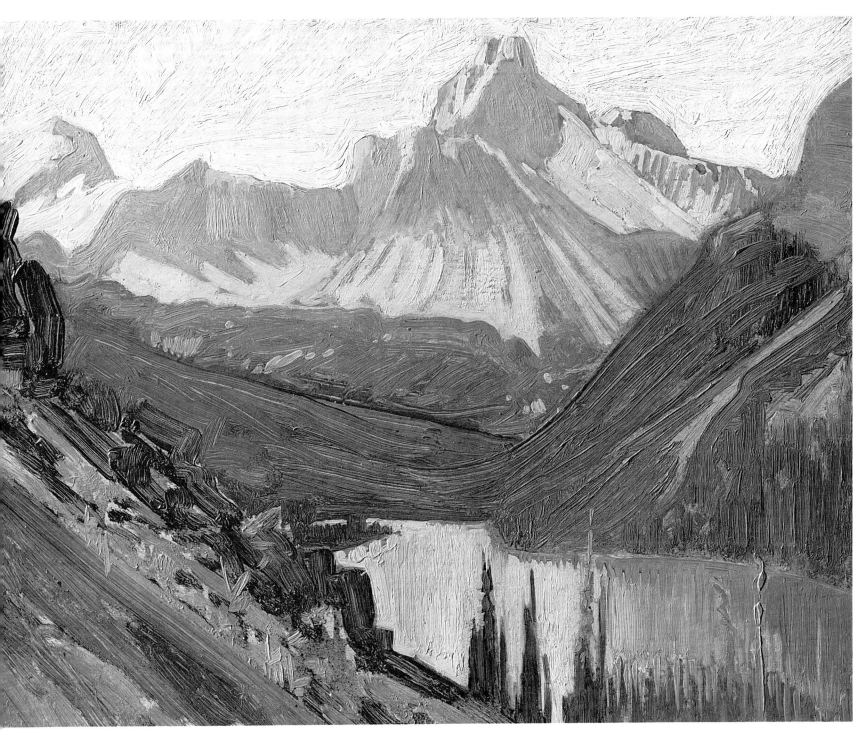

CATHEDRAL PEAK AND LAKE O'HARA 1927
Oil on panel
21.3 × 26.6 cm
Gift of Mr. R.A. Laidlaw
1966.15.9

J.E.H. MacDONALD

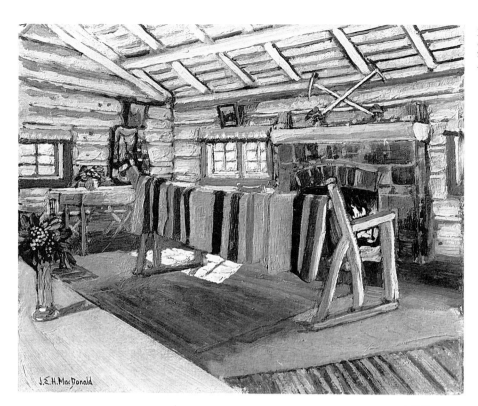

LODGE INTERIOR, LAKE O'HARA c.1925
Oil on pressed board
21.4 × 26.6 cm
Anonymous Donor
1966.16.36

LITTLE TURTLE LAKE 1927
Oil on pressed board
13.3 × 21.5 cm
Anonymous Donor
1966.16.40

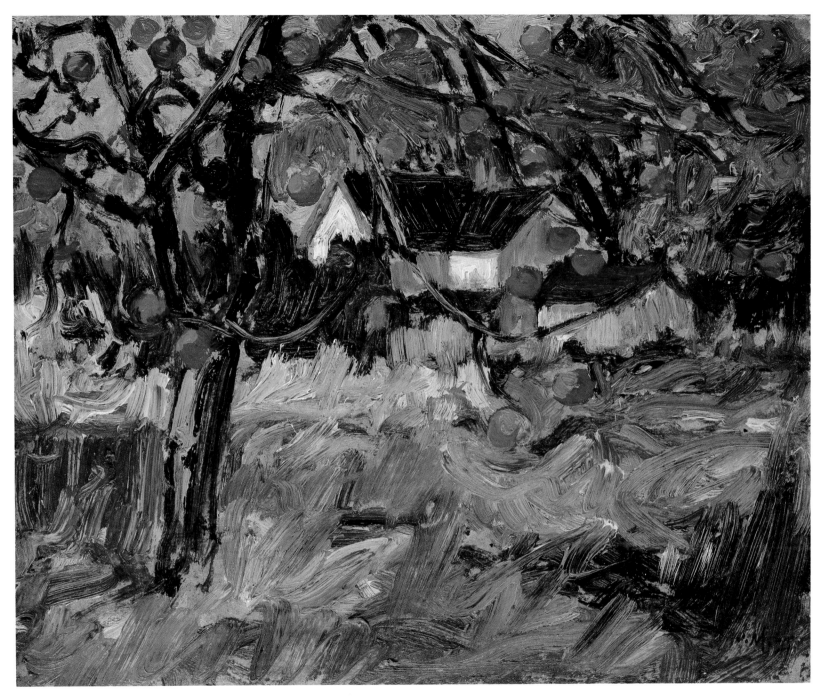

ARTIST'S HOME AND ORCHARD 1927
Oil on panel
21.6 × 26.4 cm
Gift of Mrs. Ruth E. Bond
1969.3

J.E.H. MacDONALD

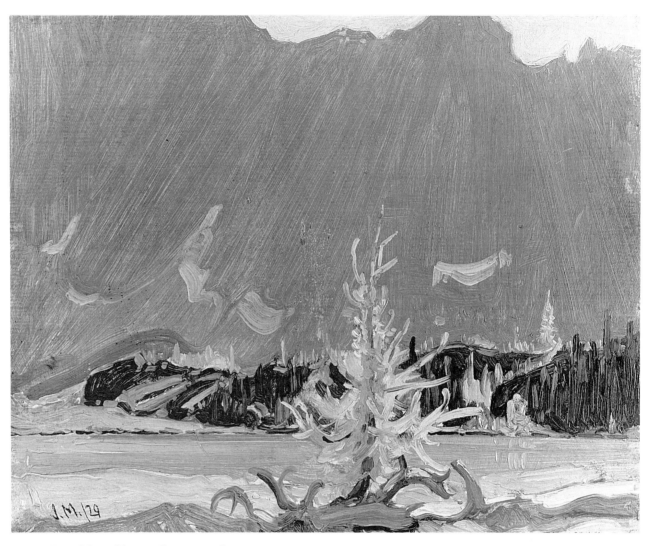

LARCH & LAKE, MARY'S MEADOW, OPHABIN [SIC] PASS 1929
Oil on pressed board
21.5 × 26.6 cm
Gift of Mr. R.A. Laidlaw
1966.15.16

LICHEN COVERED SHALE SLABS 1930 ▶
Oil on panel
21.4 × 26.6 cm
Gift of Mrs. Jean Newman in memory
 of T. Campbell Newman, Q.C.
1969.7.3

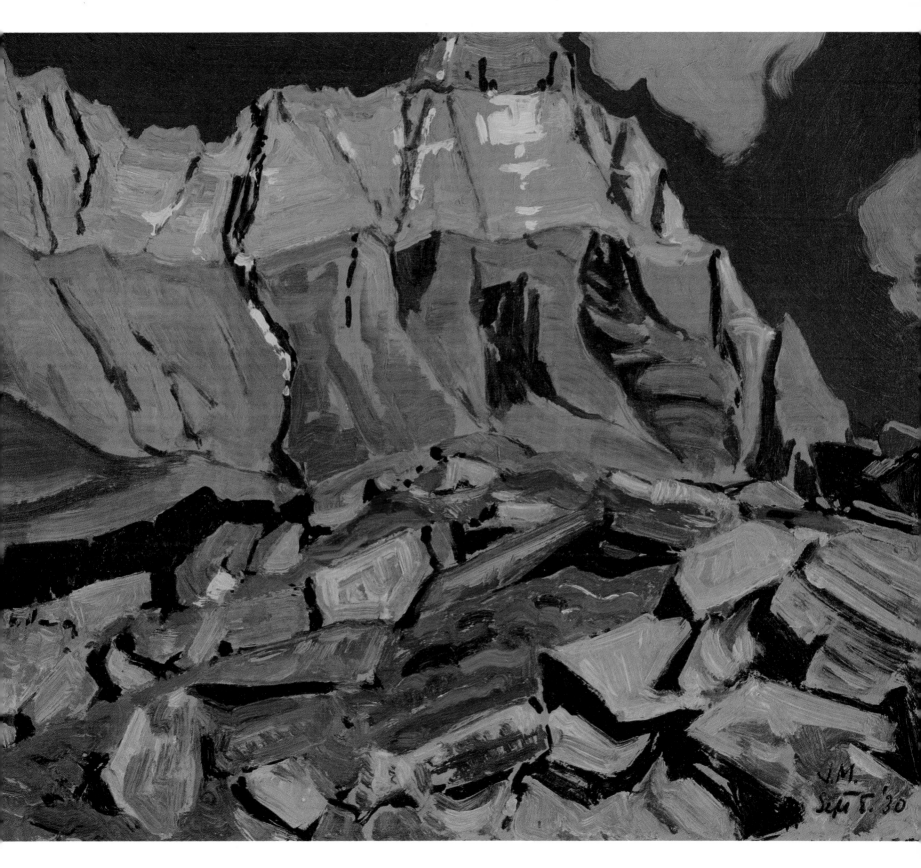

45

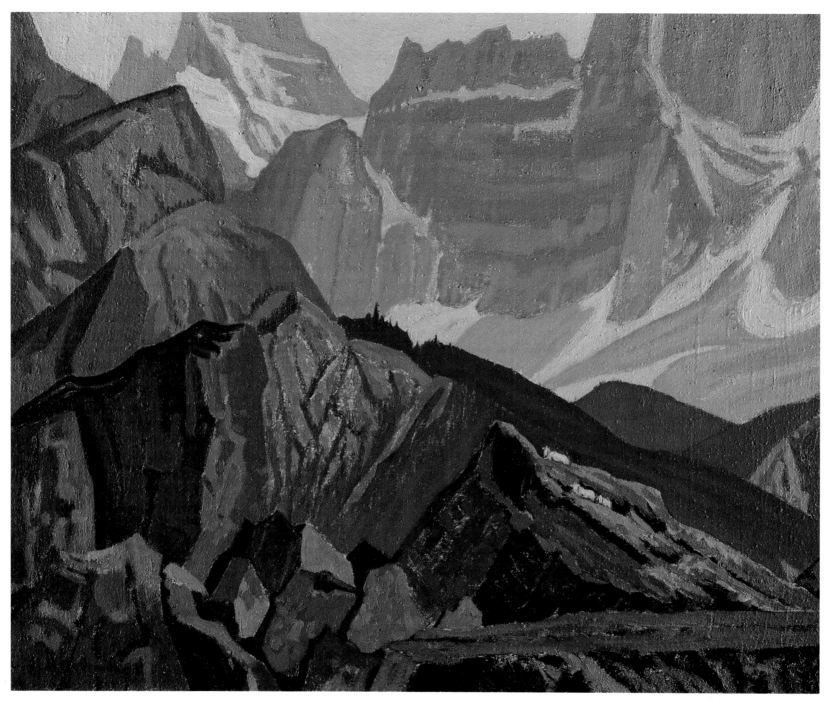

GOAT RANGE, ROCKY MOUNTAINS 1932
Oil on canvas
53.8 × 66.2 cm
Anonymous Donor
1979.35

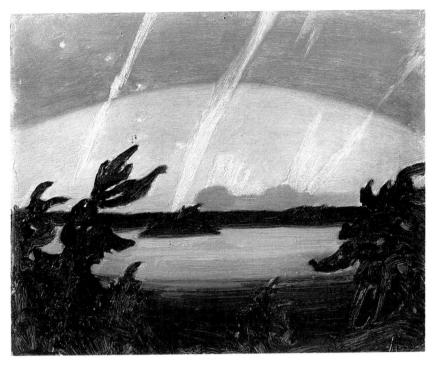

Aurora, Georgian Bay, Pointe au Baril 1931
Oil on pressed board
21.5 × 26.6 cm
Gift of Mr. R.A. Laidlaw
1966.15.13

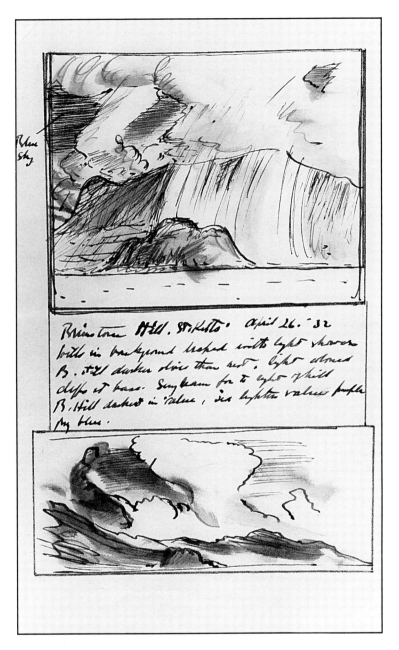

(Brimstone?) Hill, St. Kitts 1932
Ink on paper
20.4 × 12.7 cm
Gift of Mrs. Doris Huestis Speirs
1988.5.4

J.E.H. MacDONALD

PIC ISLAND c.1924
Oil on canvas
123.3 × 153.9 cm
Gift of Col. R.S. McLaughlin
1968.7.4

LAWREN HARRIS
1885–1970

Lawren Harris was the artist singly most responsible for the formation of the Group of Seven. A determined believer in the idea of a Canadian art movement, he sought out J.E.H. MacDonald's acquaintance and was influential in convincing A.Y. Jackson to move to Toronto. He lent intellectual as well as financial support to fellow artists.

Born in Brantford, Ontario, into a wealthy family, cofounders of the Massey-Harris farm machinery company, he was freed from the necessity of making a living and could concentrate on painting. His financial independence allowed him to make several important and practical contributions to the development of the Group's new ideas. In 1913, with his friend Dr. James MacCallum, he financed the construction of the still existing Studio Building on Severn Street in Toronto, providing artists with cheap or free space where they could live and work. It brought them closer to each other, and the exchange of ideas must have been stimulating and encouraging for all. In 1918 and 1919 Harris financed two now-famous boxcar trips for artists to the Algoma region north of Sault Ste. Marie. For J.E.H. MacDonald in particular, this landscape was inspirational.

In his life and his painting Harris displayed an inclination toward the intellectual and the spiritual. Since his student days in 1904–7 in Berlin he had been interested in philosophy and Eastern thought. He became involved in Theosophy, eventually joining the Toronto Lodge of the International Theosophical Society.

Harris's painting into the early 1920s was characterized by rich, decorative colours applied in a thick, painterly impasto. His subjects included the landscapes around Toronto and the rowhouses of that city's poorer streets, as well as Georgian Bay and, after the war, the Algoma region. In 1921, after an autumn painting trip to Algoma, Harris and Jackson continued on to Lake Superior's North Shore. Fascinated by the Theosophical concept of an essential and universal truth and a oneness of all nature, Harris was captivated by the stark and monumental landscape of the North Shore. He returned to the area annually for the next seven

years, developing the style for which he is now best known.

Pic Island of 1924 demonstrates his artistic concerns. The colour scheme and composition reflect Theosophical symbolism, in which the purity of truth is compared to a white ray of light; blues indicate various states of religious feeling, and clarity of outline and shapes such as the pyramid reflect the spiritual state. Harris did not simply apply Theosophical criteria to his paintings; for him, Nature and her forms were synonymous with the experience and interpretation of nature. As he later wrote:

The artist moves slowly but surely through many transitions toward a deeper and more universal expression. From his particular love, and in the process of creating from it, he is led inevitably to universal qualities and toward a universal vision and understanding.

Harris's search for "a deeper and more universal expression" took him farther afield not only geographically but also artistically, eventually to a complete abstraction. His first visit to the Rockies was in 1924; it was a journey he repeated annually for the next three years. In 1930 he sailed for the Arctic with A.Y. Jackson aboard a supply ship. His paintings of the mountains and of icebergs show the realization of his painterly and religious ideals: the landscape is simplified to its basic forms, dominant and massive. In *Mt. Lefroy* the diagonal lines of the mountain's shape draw the viewer's eye toward the white peak and the light surrounding it. Harris's emphasis on the spiritual was the quality in his work that so impressed Emily Carr (See Part II). The two artists were deeply empathetic with each other's personal visions.

In 1934 Harris moved to the United States, first to New England and then to the Southwest. By 1940 he had settled in Vancouver. The last half of his painting career was devoted to an exploration of the abstract based on his beliefs. For him, art was not simply the straightforward depiction of reality but "a realm of life between our mundane world and the world of the spirit."

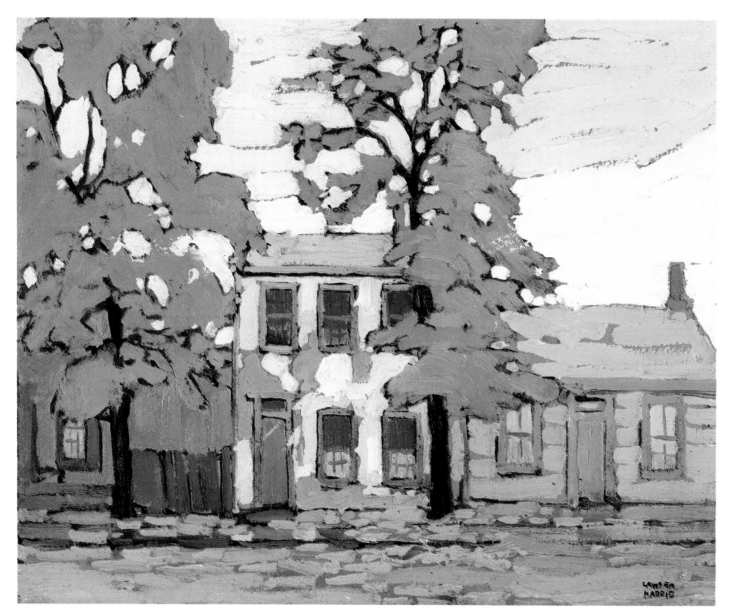

EARLY HOUSES 1913
Oil on heavy laminated card
27.0 × 33.5 cm
Anonymous Donor
1976.25.5

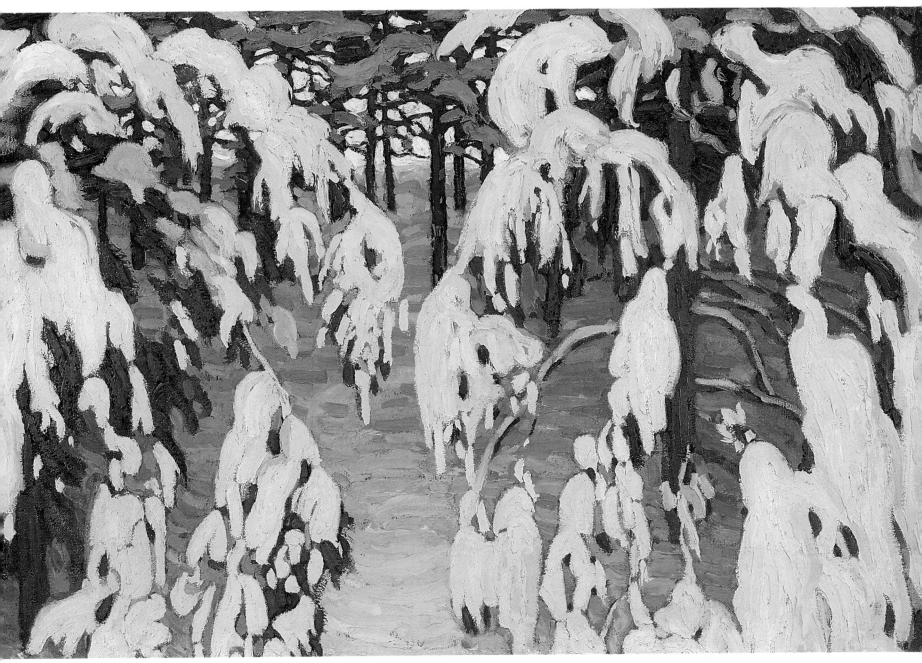

SNOW c.1917
Oil on canvas
69.7 × 109.0 cm
Gift of Mr. and Mrs. Keith MacIver
1966.16.88

LAWREN HARRIS

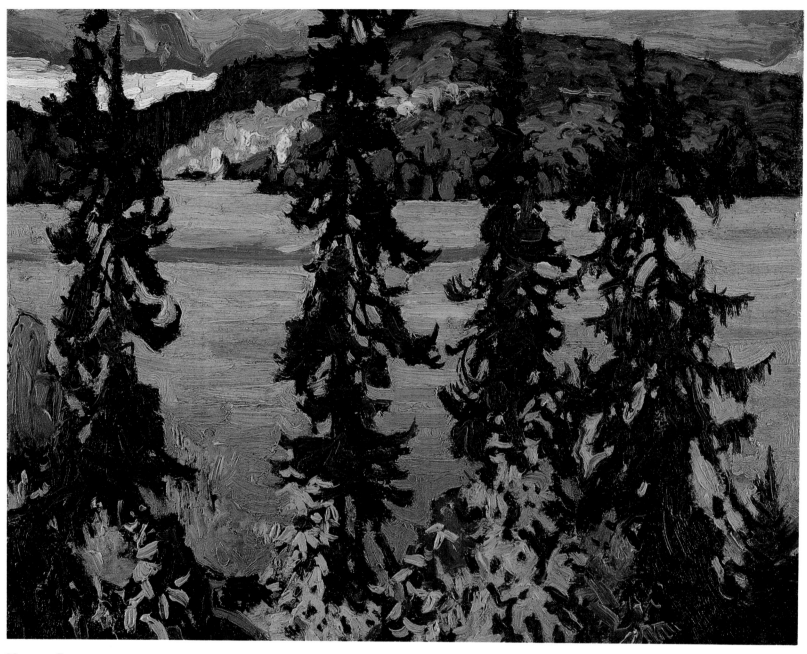

Montreal River c.1920
Oil on pressed board
27.0 × 34.7 cm
Anonymous Donor
1966.16.77

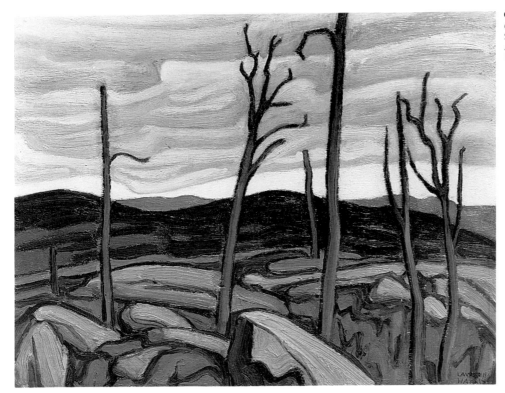

COUNTRY NORTH OF LAKE SUPERIOR, #2 c.1921
Oil on panel
26.2 × 35.1 cm
Anonymous Donor
1974.11.1

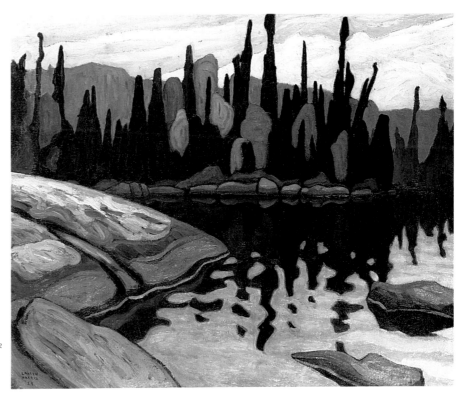

SHIMMERING WATER, ALGONQUIN PARK 1922
Oil on canvas
82.3 × 102.0 cm
Anonymous Donor
1966.16.87

LAWREN HARRIS

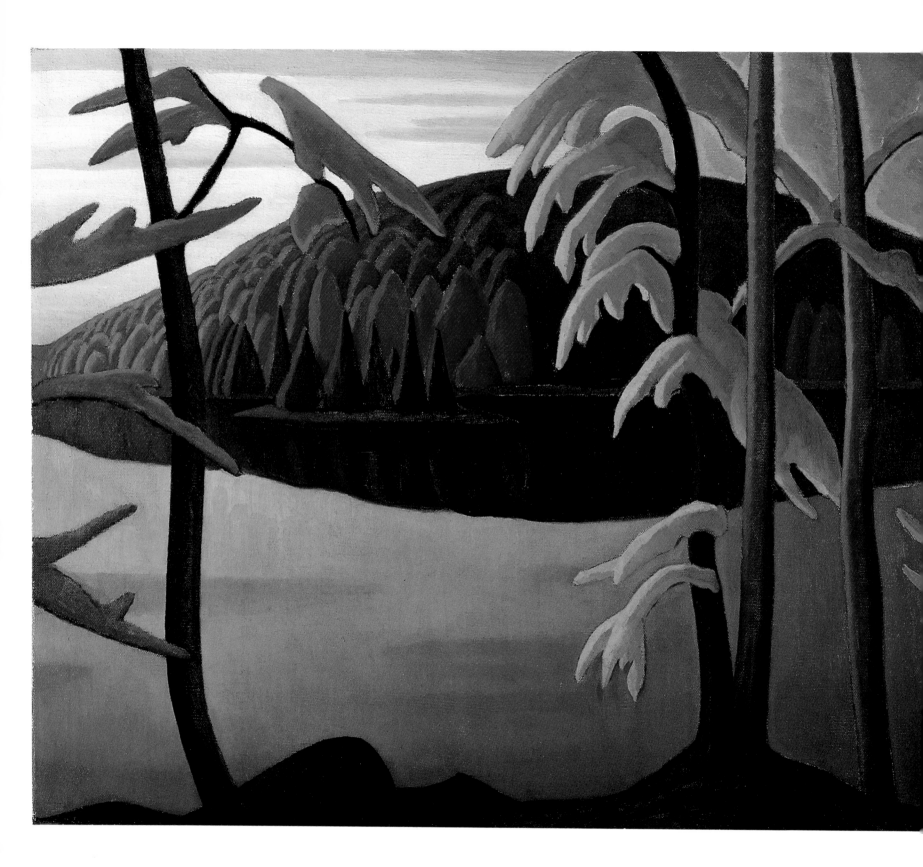

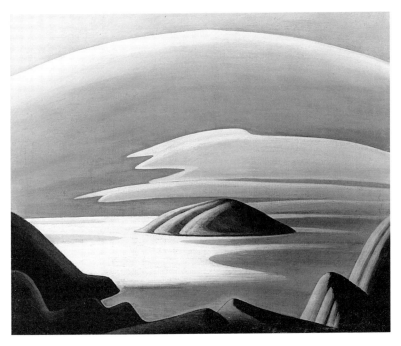

Lake Superior Island c.1923
Oil on canvas
74.2 × 89.0 cm
Gift of Mrs. F.B. Housser
1966.5.3

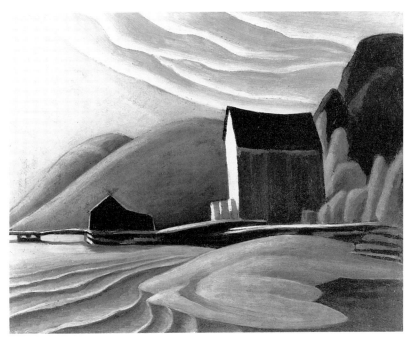

The Ice House c.1923
Oil on laminated card
30.1 × 38.0 cm
Gift of Mr. R.A. Laidlaw
1966.16.85

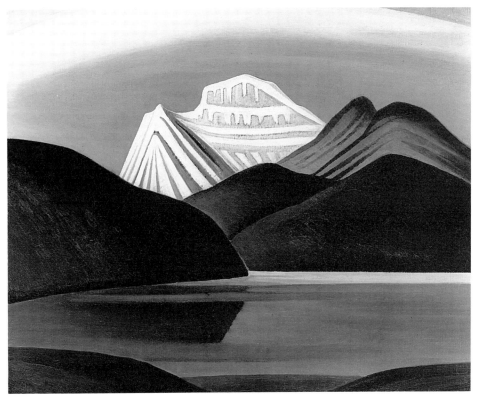

◀**Northern Lake** c.1923
Oil on canvas
82.5 × 102.8 cm
Gift of Col. R.S. McLaughlin
1968.7.5

Mountains and Lake 1929
Oil on canvas
92.0 × 114.8 cm
Gift of Mr. R.A. Laidlaw
1970.1.1

LAWREN HARRIS

PREPARATORY DRAWING FOR MT. LEFROY c.1930
Pencil on paper
19.3 × 25.5 cm
Gift of Mr. and Mrs. L.P. Harris
1975.64

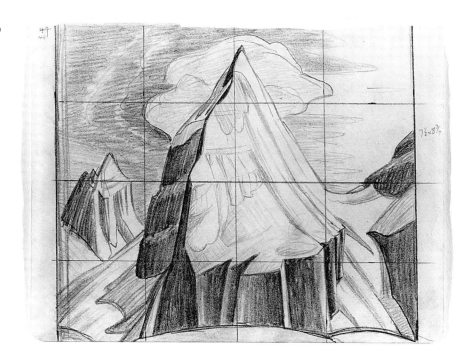

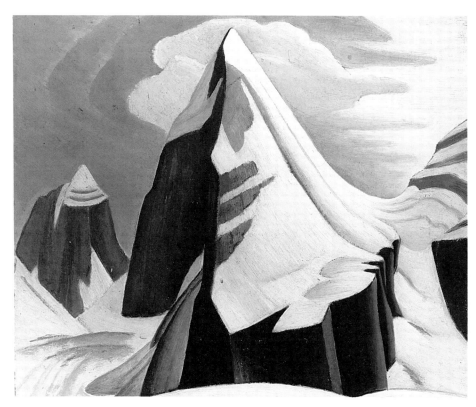

MOUNT LEFROY c.1925
Oil on panel
30.2 × 37.5 cm
Purchase 1986
1986.1

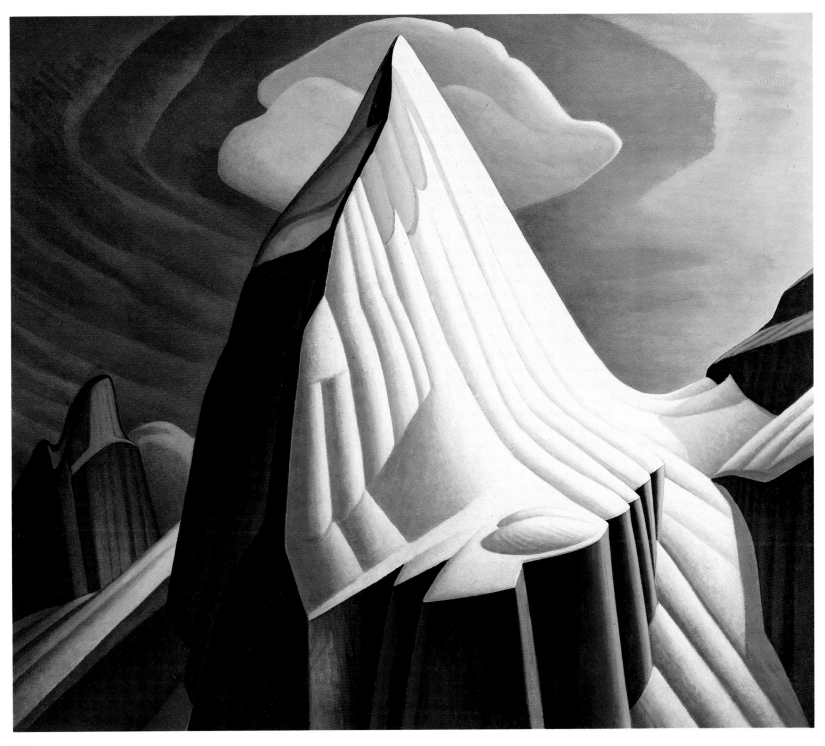

Mt. Lefroy 1930
Oil on canvas
133.5 × 153.5 cm
Purchase 1975
1975.7

LAWREN HARRIS

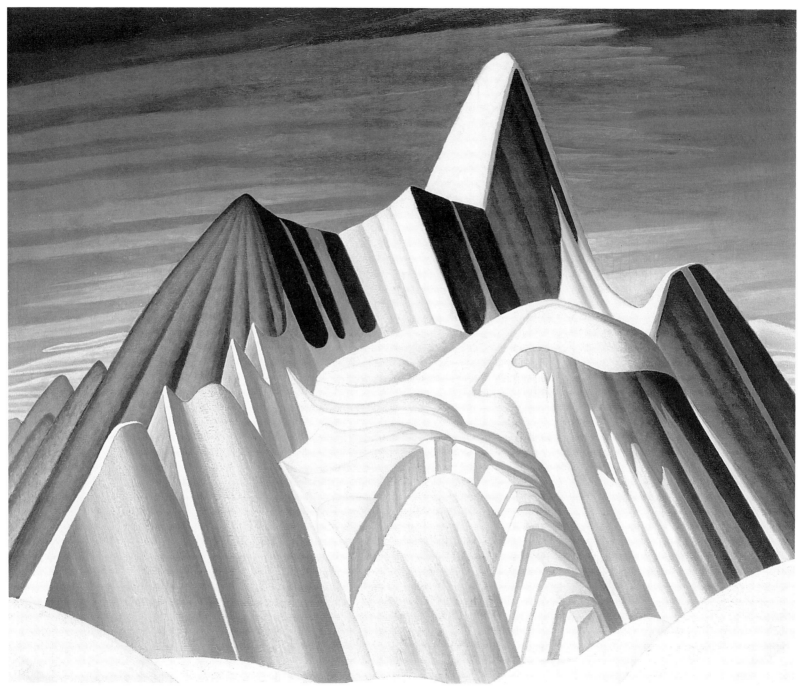

MOUNT ROBSON c.1929
Oil on canvas
128.3 × 152.4 cm
Purchase 1979
1979.20

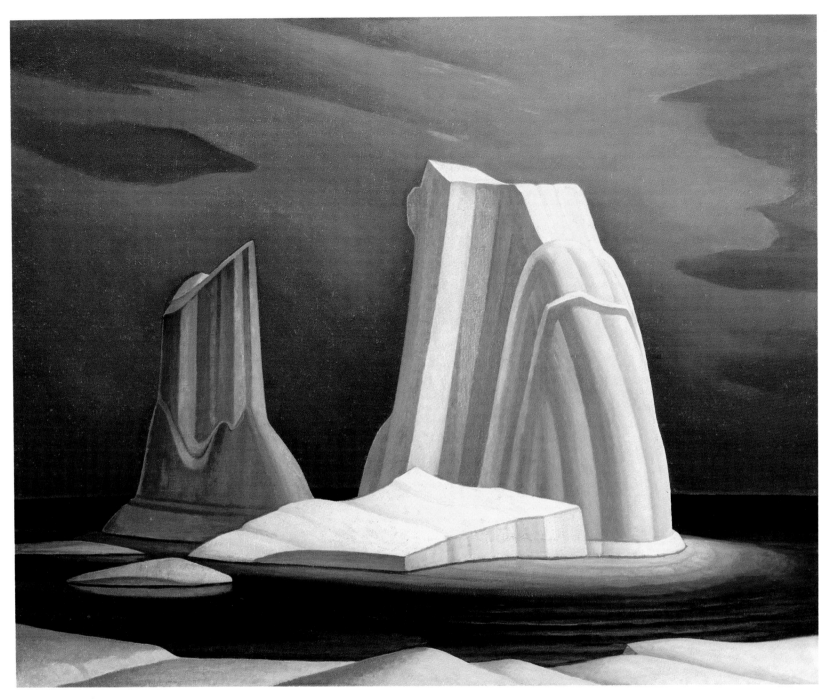

ICEBERGS, DAVIS STRAIT 1930
Oil on canvas
121.9 × 152.4 cm
Gift of Mr. and Mrs. H. Spencer Clark
1971.17

LAWREN HARRIS

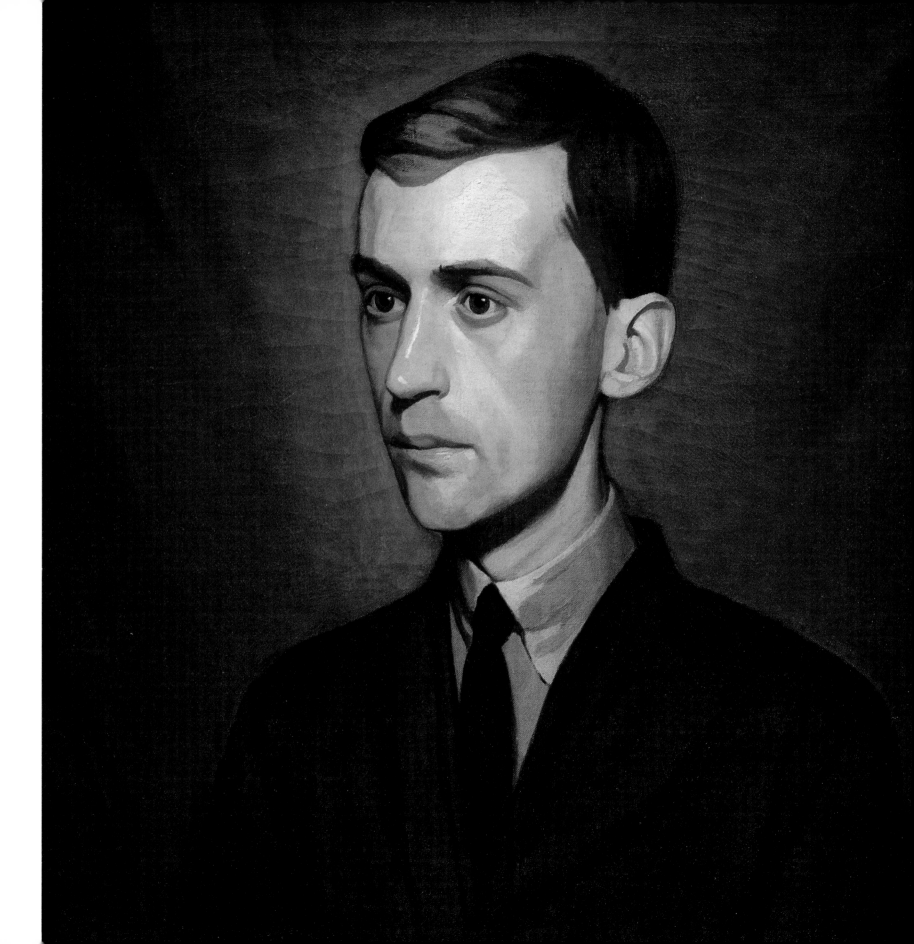

PAINTING NO. 2 1939–41
Oil on canvas
130.5 × 91.9 cm
Purchase 1984
1984.25.2

◀ **PORTRAIT OF THOREAU MACDONALD** c.1927
Oil on canvas
57.1 × 56.7 cm
Purchased with the assistance of the
　Department of Communications, Ottawa
1987.33

LAWREN HARRIS

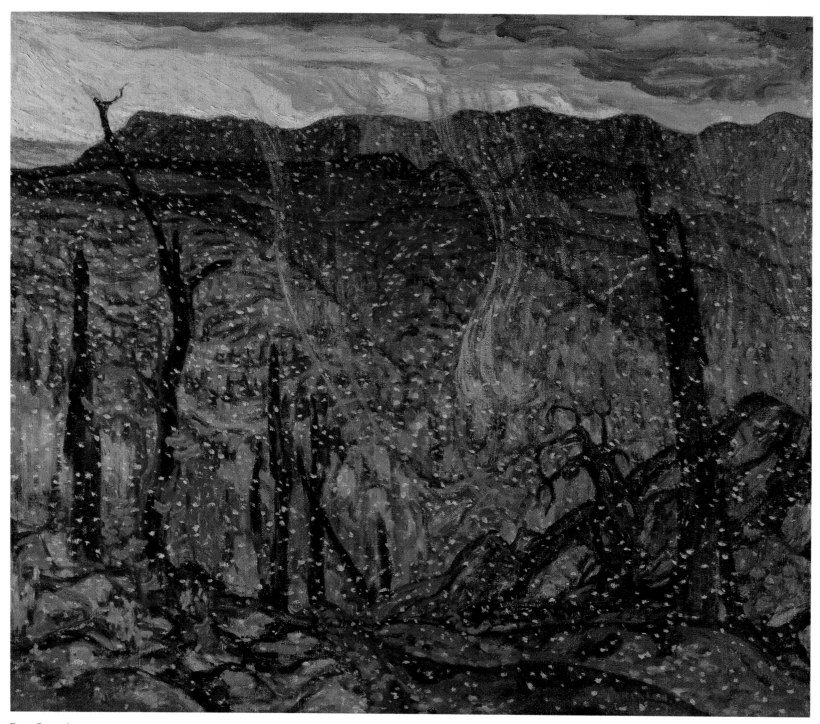

FIRST SNOW, ALGOMA c.1919–20
Oil on canvas
107.1 × 127.7 cm
In memory of Gertrude Wells Hilborn
1966.7

CHAPTER FOUR

A. Y. JACKSON
1882–1974

A.Y. Jackson's travels across the country are legendary—he painted the Rocky Mountains, the Alberta foothills, the Arctic, the sub-Arctic, Ontario, Quebec, and the Maritimes. He has a special connection with the McMichael Canadian Art Collection because for the last six years of his long and adventurous life he lived in the McMichael home. Many visitors to the gallery from 1968 to his death in 1974 recall meeting him.

Jackson's early years were spent in Montreal, where he first studied under William Brymner (also the teacher of later Group member Edwin Holgate), and he retained throughout his life an affinity for the Quebec landscape and its people. He continued his education in Paris at the Académie Julian. Discouraged by the Montreal art scene, in 1913 he moved to Toronto at the behest of J.E.H. MacDonald and Lawren Harris. He brought with him an enthusiasm for current European artistic ideas; an Impressionist style is evident in his early works, such as *Hills of Assisi, Italy*.

With his sophisticated knowledge, Jackson must have opened up a whole new world for Tom Thomson when in 1914 the two artists shared space in the new Studio Building on Severn Street. Thomson in turn conveyed to Jackson his excitement about Ontario's north country. Jackson first visited Algonquin Park early in 1914, returning in the fall of that year with Thomson, Arthur Lismer, and F.H. Varley. After the trip Jackson returned to Montreal and eventually enlisted in the army. He never saw Thomson again.

After being wounded in 1917 Jackson became an official war artist, a post he held until 1919, when he returned to Toronto. There, despite the death of Thomson in 1917, the artists were once again working toward their goal of a truly Canadian art. Lawren Harris had arranged a painting trip to Algoma in 1918; Jackson accompanied Harris, MacDonald, and Frank Johnston on the second such excursion in the fall of 1919. He returned to the area in 1920 and in 1921. *First Snow, Algoma* is a large canvas worked up from a sketch done on one of these trips. Its style is typical of Jackson's work in the first Group of Seven exhibition in 1920, at the Art Gallery of Toronto (now the Art Gallery of Ontario); the strong colours of an Ontario autumn create a backdrop for the stark, burnt tree trunks in the foreground, and the image is unified by the overall pattern of falling snow.

From his base at the Studio Building—which he did not leave until 1955, when he moved to Manotick, near Ottawa—Jackson roamed Canada's back roads and remote terrain. He returned many times to Quebec, particularly to Charlevoix County, east of Quebec City on the north shore of the St. Lawrence. *Road to Baie St. Paul* is characteristic of his mature style, with its emphasis on the undulating, receding hills of the landscape: so often in his work a road winds away from the viewer through a scattering of rural dwellings. In 1926 Jackson visited the Skeena River area in British Columbia with Edwin Holgate and anthropologist Marius Barbeau. In 1927, accompanied by Dr. Frederick Banting, the codiscoverer of insulin, he explored the Arctic aboard the supply ship *Beothic*, a trip he repeated in 1930. Jackson's last visit to the Arctic was in 1965, when he was eighty-three.

Through the generosity of the artist's niece, the McMichael has an especially rich collection of his drawings and archival material, such as books and letters. The drawings span his career and display the animated line of the artist's spontaneous response to the scene before him.

Through his travels, his friendships with people all across the country, his teaching and lectures, and his belief in the possibility of a Canadian identity through its art, A.Y. Jackson came to symbolize Canadian art itself. His remarkable career is recounted in his autobiography, *A Painter's Country*, published in 1958. He ended the book with these words: "We do not strive to produce a national art. But if we have the will and the vision and the courage to work out our own national destiny we may create a climate in which the arts will flourish."

HILLS OF ASSISI, ITALY 1912
Oil on canvas
64.0 × 80.7 cm
Gift of Dr. and Mrs. Max Stern,
 Dominion Gallery, Montreal
1980.18.3

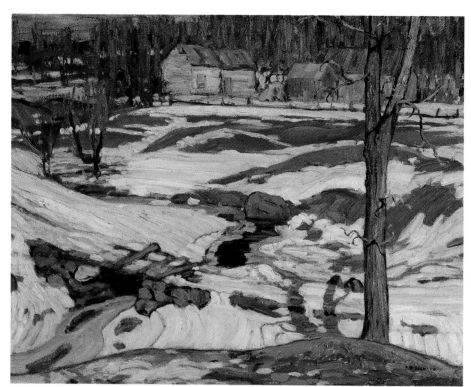

EARLY SPRING, EMILEVILLE, QUEBEC 1913
Oil on canvas
63.5 × 82.5 cm
Gift of Dr. Max Stern
1978.23

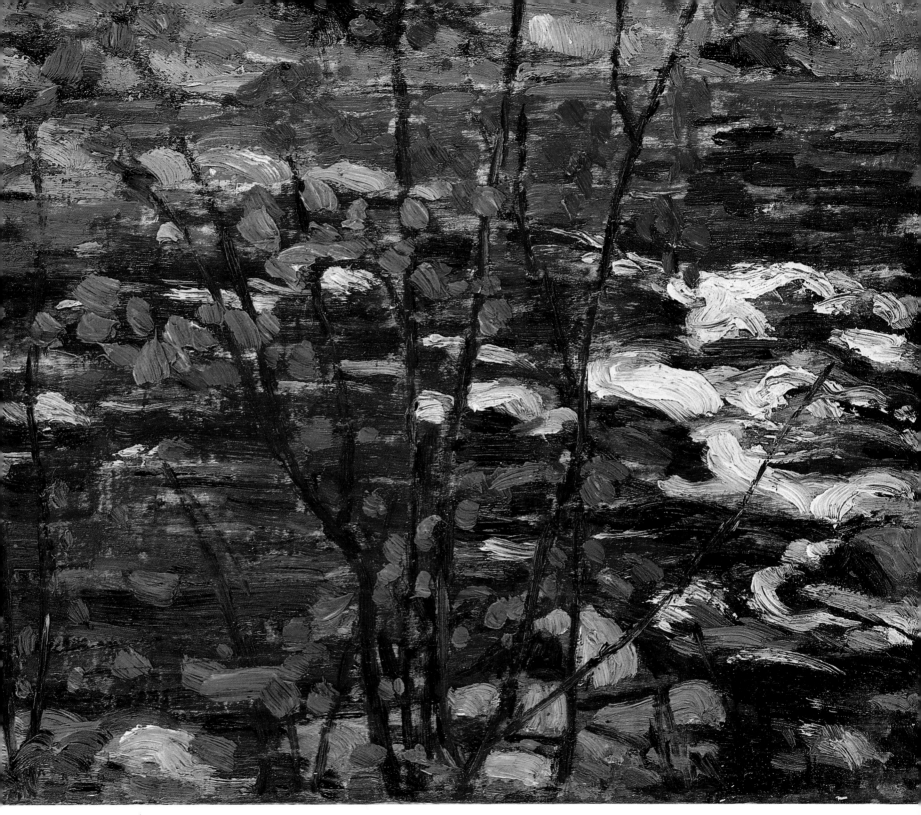

THE RED MAPLE 1914
Oil on panel
21.6 × 26.9 cm
Gift of Mr. S. Walter Stewart
1968.8.18

A.Y. JACKSON

PÈRE RAQUETTE c.1921
Tempera on pressed board
80.2 × 64.5 cm
Gift of Mr. S. Walter Stewart
1968.8.25RV

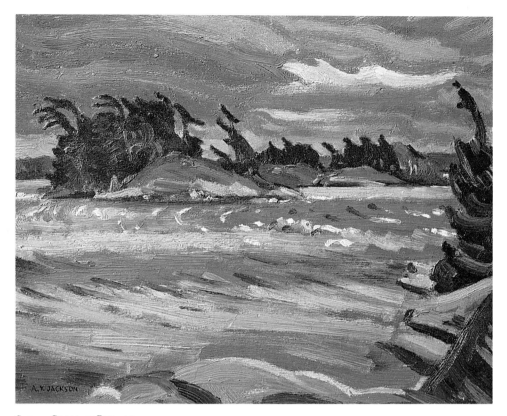

STORM, GEORGIAN BAY c.1920
Oil on panel
21.5 × 26.7 cm
Anonymous Donor
1966.16.101

LAKE IN THE HILLS c.1922
Oil on canvas
64.9 × 82.8 cm
Gift of Mr. and Mrs. R.E. Dowsett
1968.9

A.Y. JACKSON

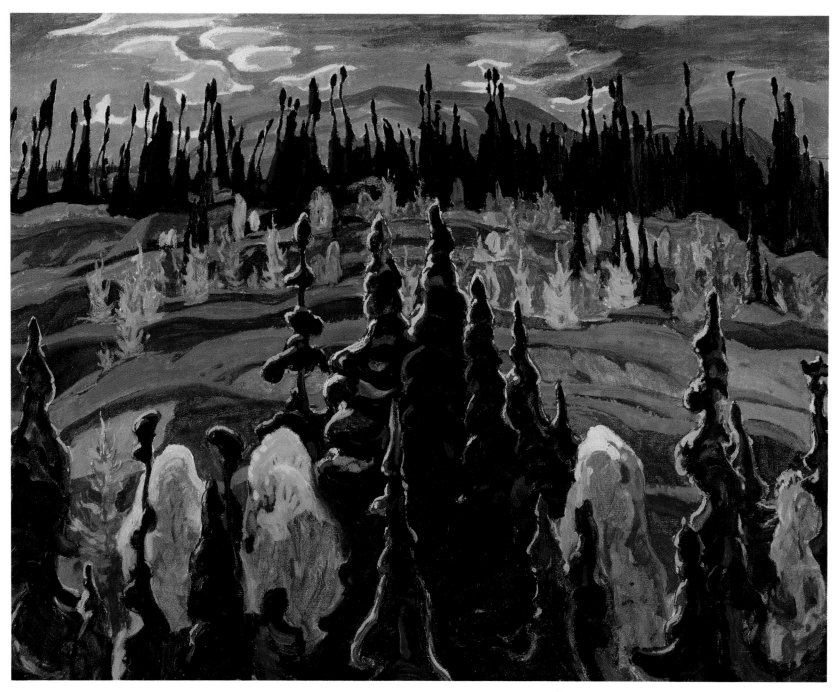

LAKE SUPERIOR COUNTRY 1924
Oil on canvas
117.0 × 148.0 cm
Gift of Mr. S. Walter Stewart
1968.8.26

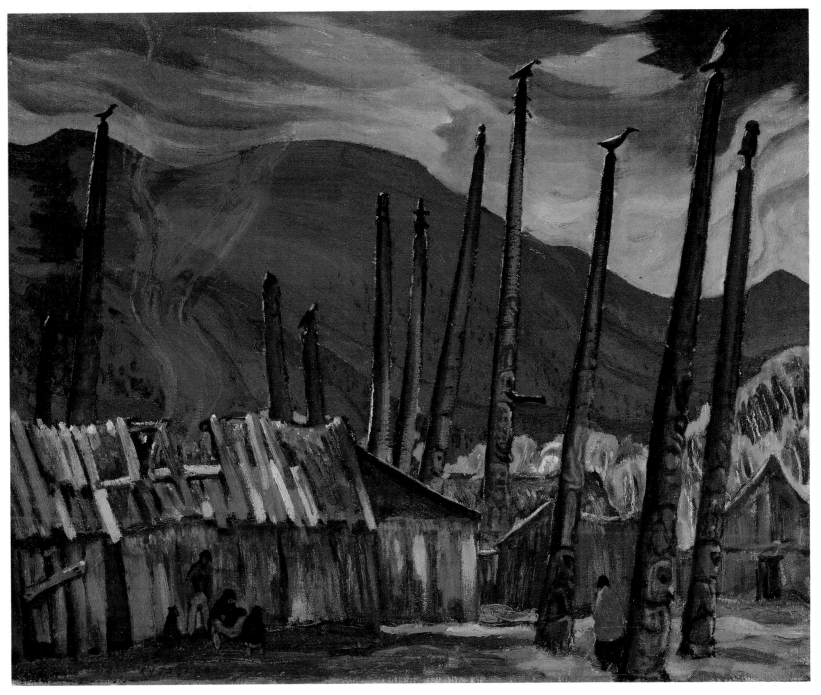

SKEENA CROSSING, B.C. (GITSEGYUKLA) c. 1926
Oil on canvas
53.5 × 66.1 cm
Gift of Mr. S. Walter Stewart
1968.8.27

A.Y. JACKSON

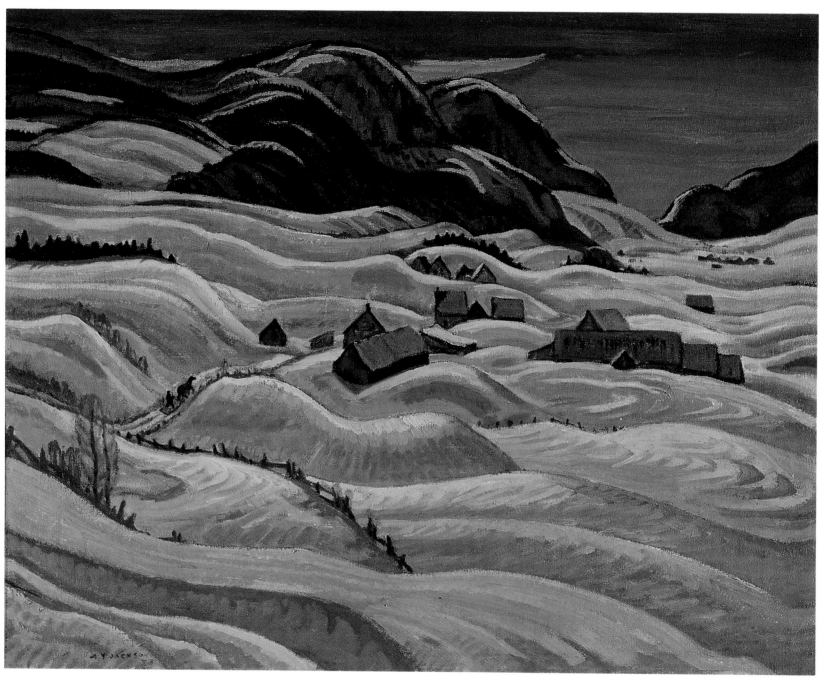

ROAD TO BAIE ST. PAUL 1933
Oil on canvas
64.4 × 82.2 cm
Purchase 1968
1968.20

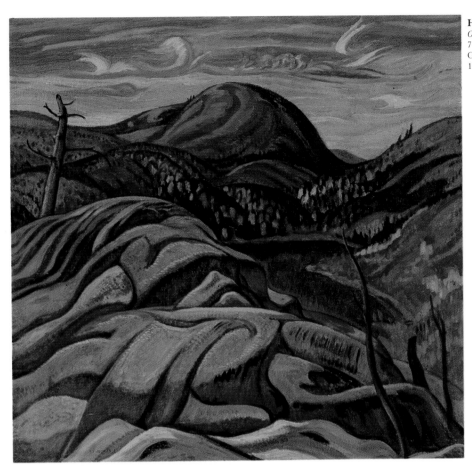

HILLS, KILLARNEY, ONTARIO (NELLIE LAKE) c.1933
Oil on canvas
77.3 × 81.7 cm
Gift of Mr. S. Walter Stewart
1968.8.28

ALGOMA, NOVEMBER 1934
Oil on wood panel
26.7 × 34.8 cm
Anonymous Donor
1966.16.99

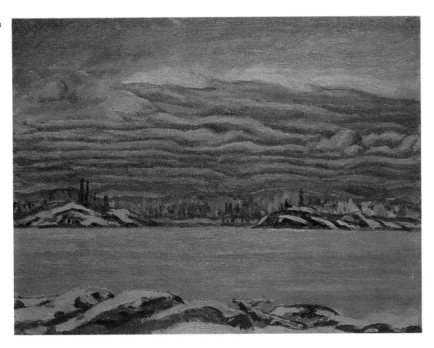

A.Y. JACKSON

MARCH DAY, LAURENTIANS c.1933
Oil on canvas
54.0 × 66.9 cm
Gift of Mrs. H.P. de Pencier
1966.2.6

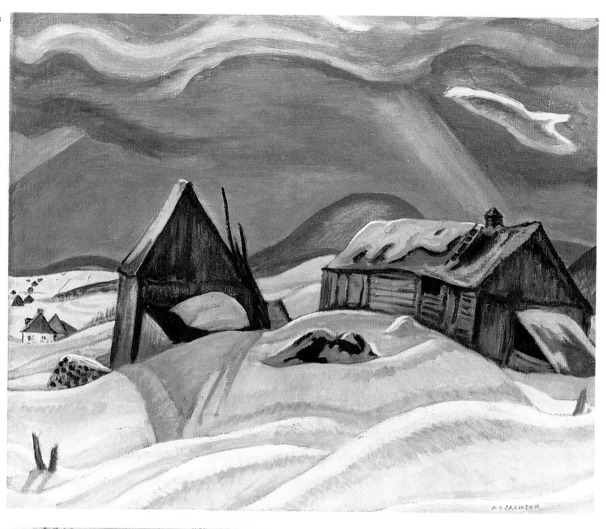

ON BOARD THE BEOTHIC AT NIGHT 1930
Pencil on paper
21.9 × 29.1 cm
Anonymous Donor
1970.14.5

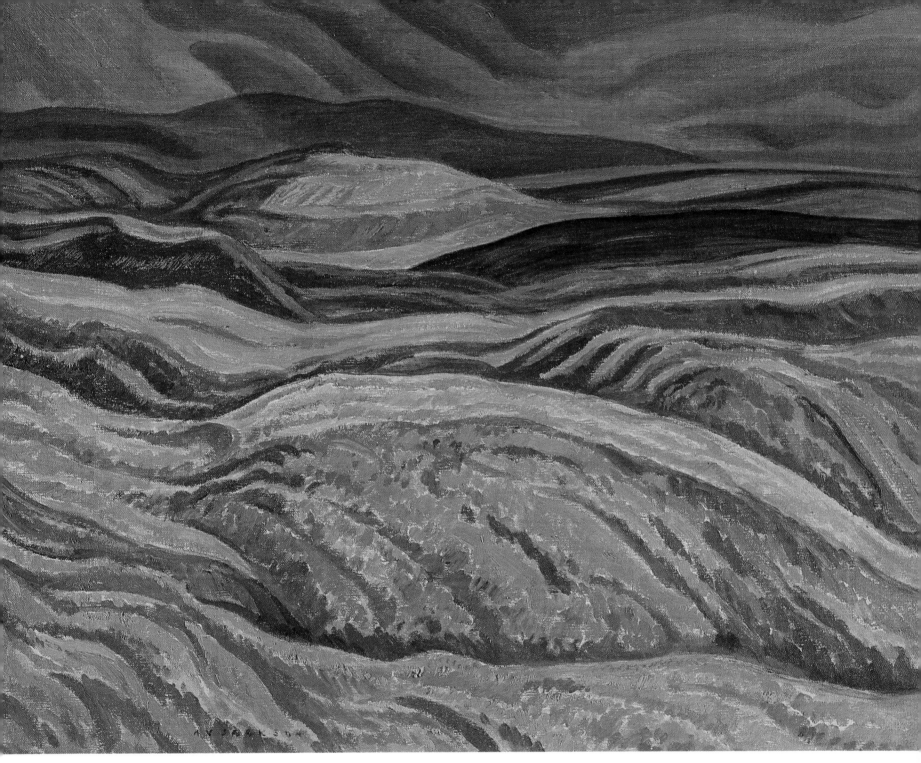

ALBERTA FOOTHILLS 1937
Oil on canvas
64.0 × 81.2 cm
Anonymous Donor
1971.13.8

A.Y. JACKSON

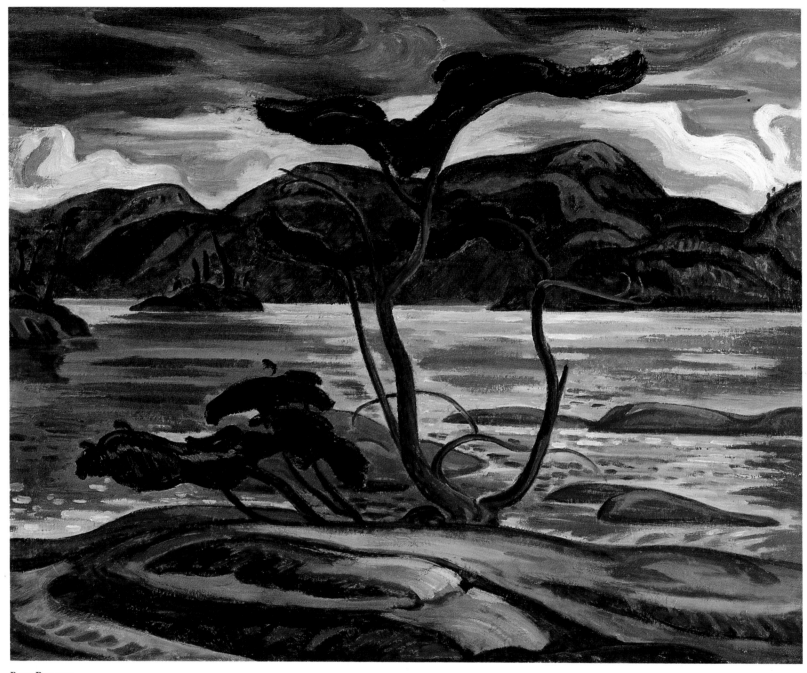

BENT PINE 1948
Oil on canvas
81.3 × 102.0 cm
Gift of Mrs. N.D. Young
1971.6

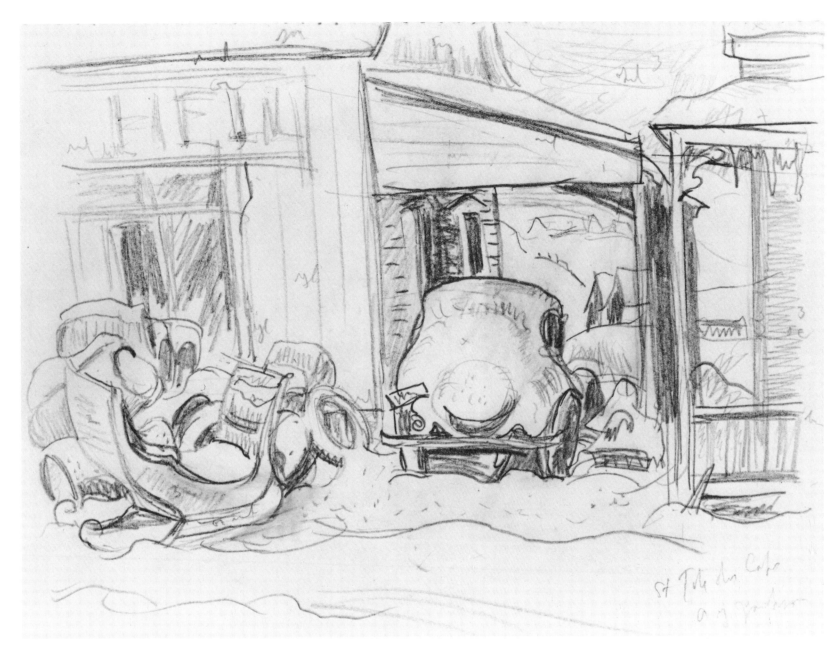

Street Scene on St. Tite des Caps, Quebec c.1940
Pencil on paper
21.0 × 29.2 cm
Anonymous Donor
1972.18.10

A.Y. JACKSON

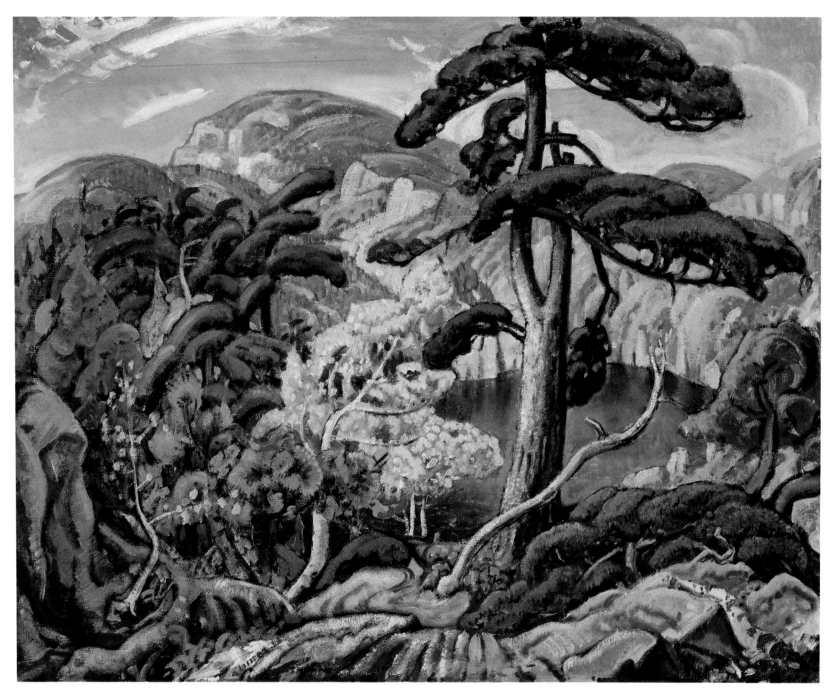

Bright Land 1938
Oil on canvas
81.1 × 101.5 cm
Gift of Col. R.S. McLaughlin
1968.7.9

ARTHUR LISMER
1885–1969

Arthur Lismer's immense contribution to Canadian art is twofold: as a painter and as an influential and dedicated art educator. A man of tireless energy, his active career took him throughout Canada and around the world. He saw art as a universal form of expression, profoundly rewarding for all who took the time to enjoy it.

Inside each one of us is an artist... And that's what an artist is, a child who has never lost the gift of looking at life with curiosity and wonder. Art is not the exclusive possession of those who can draw, write poems, make music or design buildings. It belongs to all those who can see their way through all things with imagination.

Born in Sheffield, England, Lismer credited his Yorkshire environment with playing "a strong and memorable part in the early experience" of drawing and painting. Apprenticed at age thirteen to a photo-engraving firm, he spent the next seven years producing black-and-white art for the local newspaper while studying at the Sheffield School of Art. Further courses at Antwerp's Académie des Beaux-Arts, combined with trips to London and Paris, gave the young student a thorough background in both art history and in the traditions of the day.

However, Lismer held little hope for his own professional future in Sheffield. Encouraged by F.H. Brigden—who was from the Canadian commercial art firm Brigden's and was himself a painter—Lismer sailed for Canada in January 1911. In Toronto he joined the design house of Grip Ltd., where he met artists Frank Johnston, J.E.H. MacDonald, and Tom Thomson.

Lismer first visited the Georgian Bay area in September 1913, when he was offered the use of a cottage owned by Lawren Harris's friend Dr. James MacCallum. It was an initiation to a landscape favoured by the artist for the rest of his life. He called Georgian Bay "the happy isles, all different but bound together in a common unity of form, colour and design. It is a paradise for painters." The following May Lismer journeyed for the first time to Algonquin Park, where he and Thomson sketched together. He later wrote that that "first night spent in the north and the thrilling days after were turning points in my life." Lismer's impres-

sionistic style of these early years seemed inappropriate for the rugged landscape, and throughout the 1910s, he developed a technique of stronger colour and compositional design.

Lismer's teaching career began in Toronto in 1915, but the next year he moved with his wife and young daughter to Nova Scotia to become principal of the Victoria School of Art and Design in Halifax, where he developed a lifelong fascination with the sea. After World War I he returned to Toronto, where he was appointed vice-principal of the Ontario College of Art, a post he held until 1927. In that year he moved to the Art Gallery of Toronto (now the Art Gallery of Ontario), where he began a distinguished career in innovative gallery programs that took him briefly to Ottawa and then to Montreal in 1940. Lismer retired as principal of the Montreal Museum of Fine Arts' school in 1967.

During his career Lismer lectured across Canada and in New York, Europe, South Africa, and the South Pacific. Over the years he touched thousands, no doubt altering their outlooks forever. He believed passionately that the pursuit of art and education made life richer with the ability to "see further and deeper than others into the meaning and beauty of life."

As well as his painting, Lismer made many drawings, caricatures, and cartoons. Never without pencil and paper, he demonstrated his wit and imagination in his rapid sketches of fellow artists, sketching trips, travels, and galleries. He even satirically described moments in the history of the Group of Seven.

Such a full schedule limited Lismer's time for painting trips. However, he never gave up his interest in exploring the Canadian landscape of northern Ontario and Quebec, and along the two great coastlines of Nova Scotia and British Columbia. For Lismer, Canada provided "a background of epic grandeur." He interpreted the natural world with a style suitable to the ruggedness of the landscape. There is in his work a love of paint itself, a full-bodied texture and brush stroke, a use of rich, saturated colours. In his later works, Lismer often focussed on a small part of the scene—the patterns of dense undergrowth or fishing gear on a dock—for "even in such minute forms there is a vastness."

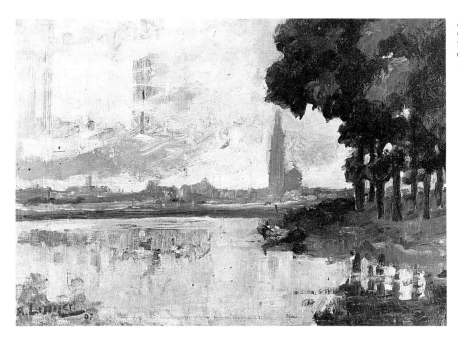

ANTWERP HARBOUR 1907
Oil on canvas
26.4 × 37.8 cm
Gift of Mrs. Marjorie Lismer Bridges
1981.86

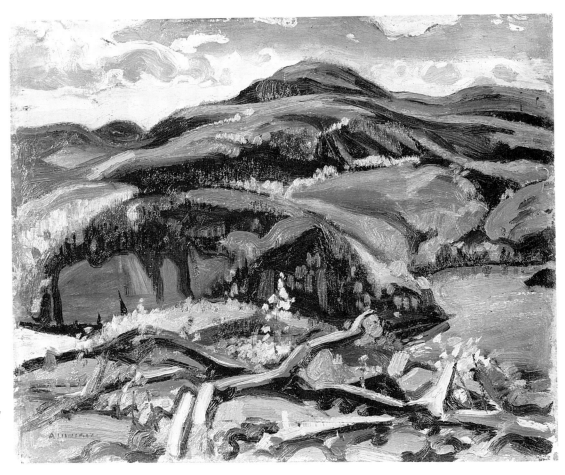

OCTOBER ON THE NORTH SHORE 1927
Oil on panel
32.4 × 40.9 cm
Anonymous Donor
1970.14.9

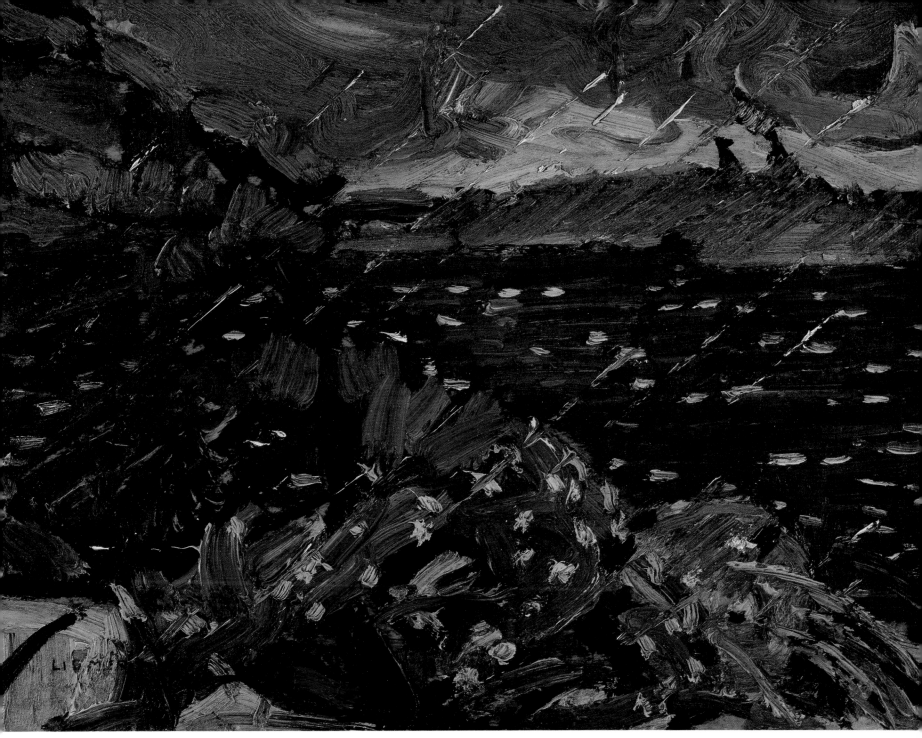

RAIN IN THE NORTH COUNTRY 1920
Oil on panel
22.3 × 30.0 cm
Anonymous Donor
1966.16.112

ARTHUR LISMER

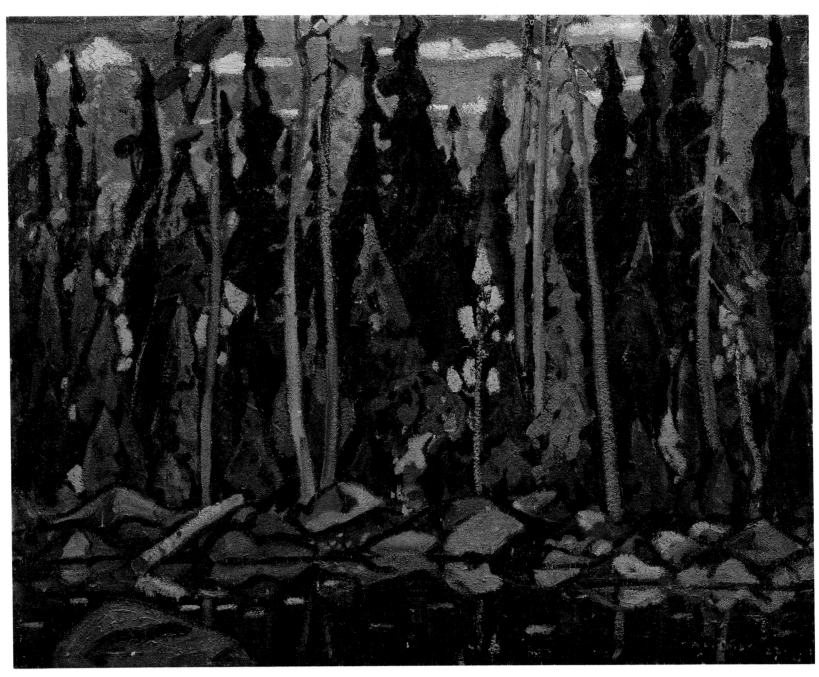

FOREST, ALGOMA 1922
Oil on canvas
71.0 × 90.8 cm
Anonymous Donor
1966.16.104

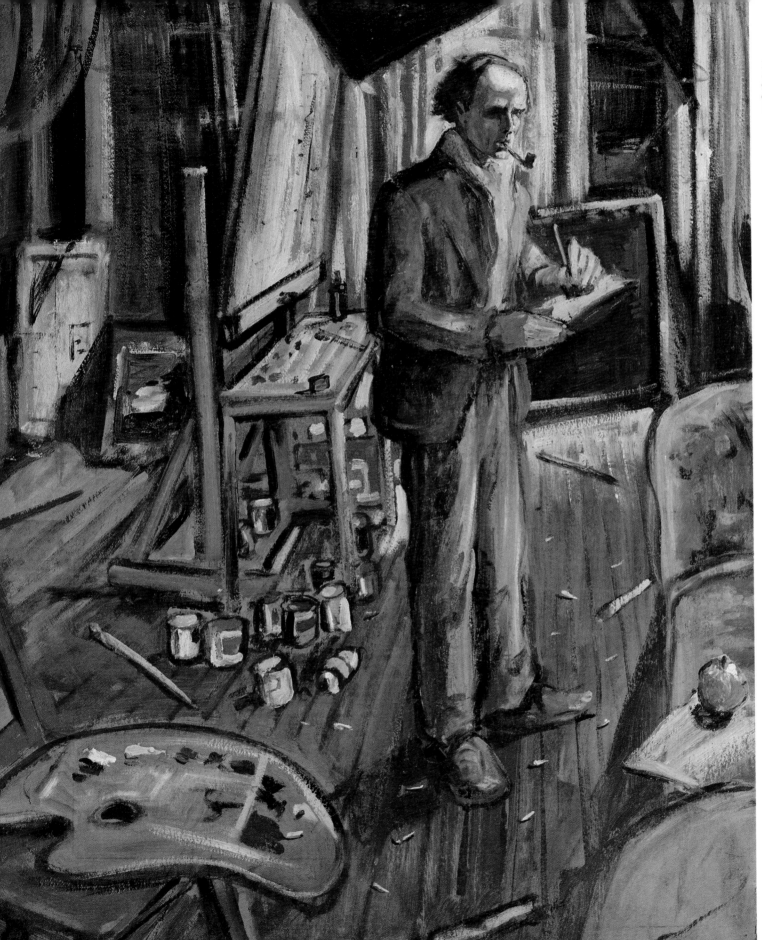

In My Studio 1924
Oil on canvas
91.0 × 76.3 cm
Gift of Mr. A.J. Latner
1971.10

McGregor Bay 1933
Oil on panel
30.0 × 40.6 cm
Gift of Mrs. Marjorie Lismer Bridges
1981.27.1

Evening Session 1927
Pencil on paper
18.4 × 23.5 cm
Gift of Mrs. James H. Knox
1984.27.15

PINE WRACK 1939
Watercolour on paper
55.9 × 75.5 cm
Anonymous Donor
1966.16.111

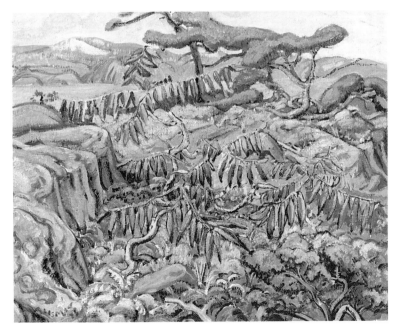

SUMACH PATTERN, GEORGIAN BAY c.1933
Oil on canvas
52.9 × 65.6 cm
Purchase 1986
1986.54.2

ARTHUR LISMER

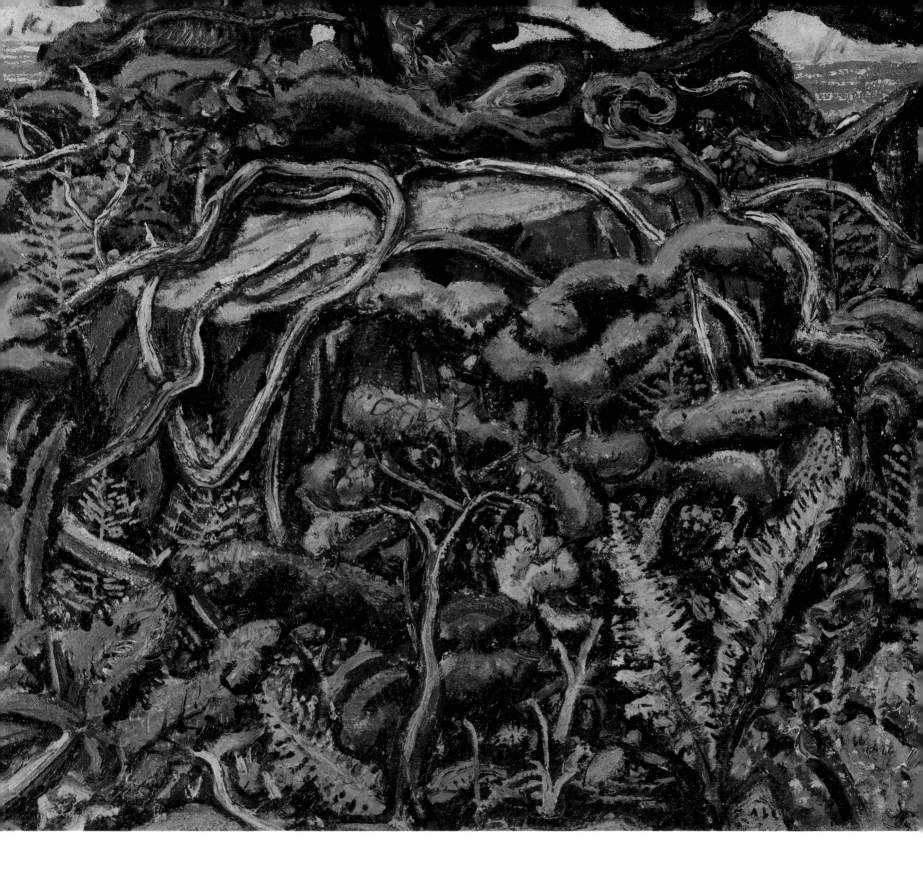

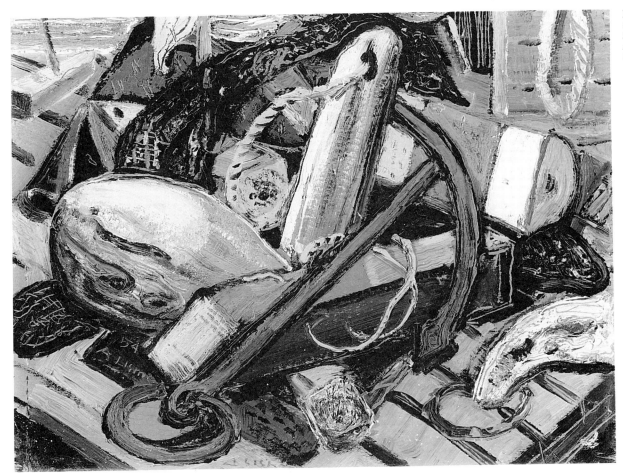

RED ANCHOR 1954
Oil on plywood
30.1 × 40.1 cm
Anonymous Donor
1966.16.109

◄**CANADIAN JUNGLE** 1946
Oil on canvas
44.8 × 53.7 cm
Anonymous Donor
1966.16.107

ARTHUR LISMER

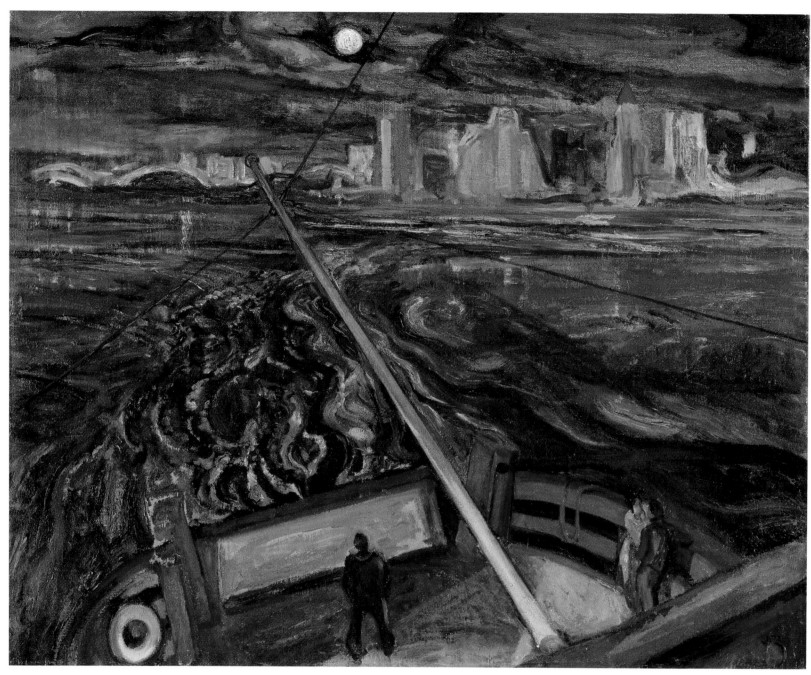

Night Ferry, Vancouver 1937
Oil on canvas
81.9 × 102.2 cm
Purchase 1983
1983.10

CHAPTER SIX

F.H. VARLEY
1881–1969

Of all the members of the Group of Seven, Varley was the most restless in his life and personality. His moves to various parts of the country seemed predicated on the hope that life would be more fulfilling in a new environment. Not solely interested in landscape, he was fascinated with the human form, whether as a portrait, a facial study, or a figure in the landscape, and he has a lasting reputation as both a landscapist and a portrait artist.

Born in Sheffield, England, Varley studied—as did his childhood friend Arthur Lismer—at the Sheffield School of Art and at Antwerp's Académie des Beaux-Arts. After graduation he worked in London as a magazine illustrator, but when work became scarce, he returned to Sheffield. Lismer, on a return trip to his hometown from Canada, spoke to Varley of the opportunities in the new country. Varley emigrated to Toronto in 1912.

In Toronto Varley first worked briefly for the commercial art firm Grip Ltd. but soon moved to Rous and Mann, where other Grip artists, such as Tom Thomson and Franklin Carmichael, had already gone. Through Varley's friendship with Lismer, his employment, and his membership in the Arts and Letters Club, he became part of a circle of artists that included J.E.H. MacDonald and Lawren Harris. He found the artistic life in Toronto refreshing and exciting—"a strong lusty child unfettered with rank, musty ideas," as Varley wrote to his sister in 1913. Soon he was discovering and sketching the landscapes now synonymous with the Group of Seven, the Georgian Bay area and Algonquin Park.

As an official war artist, Varley was deeply affected by the carnage and devastation of World War I. When he returned to civilian life, he knew that he did not want to continue with commercial art. In the years following the war he was employed at a variety of jobs, and his connection with the other artists in Toronto was renewed. In 1920, at the Art Gallery of Toronto (now the Art Gallery of Ontario), he exhibited as one of the Group of Seven.

Five years later Varley accepted a full-time teaching position with the Ontario College of Art, but the following year he became an instructor of drawing and painting at the Vancouver School of Decorative and Applied Arts. Although he found the art community on the West Coast conservative and had differences with the school, his decade there was a happy one. He enjoyed teaching, made good friends, and found the mountainous landscape inspiring. "British Columbia is heaven . . . It trembles within me and pains me with its wonder as when a child I first awakened to the song of the earth at home," he wrote to a friend.

The paintings of this period also reflect Varley's increasing interest in a symbolic colour theory related to Buddhist spiritual values. In works such as *Night Ferry, Vancouver* and *Early Morning, Sphinx Mountain* the colours are unearthly, evoking the emotional and spiritual associations of the scene.

By 1936 Vancouver was no longer a viable home for Varley. The independent art school he had founded with J.W.G. (Jock) Macdonald had failed financially and his marriage had ended. He returned to central Canada, where he hoped to re-establish himself as a teacher and portraitist. However, the years spanning World War II were difficult ones for the artist, and, dissatisfied, he eventually settled in the Toronto area, which remained his base for the last twenty-five years of his life. He had followed in Jackson's and Harris's footsteps with a trip to the Arctic in 1938, and he visited the western mountains in the 1950s and the Soviet Union in 1954. Many of his later portraits remain haunting evocations of the sitters.

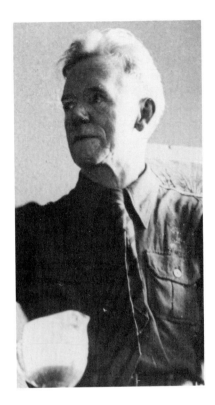

MARY KENNY c.1920-1
Charcoal and crayon on paper
36.7 × 28.7 cm
Gift of Mrs. E.J. Pratt.
1969.9.1

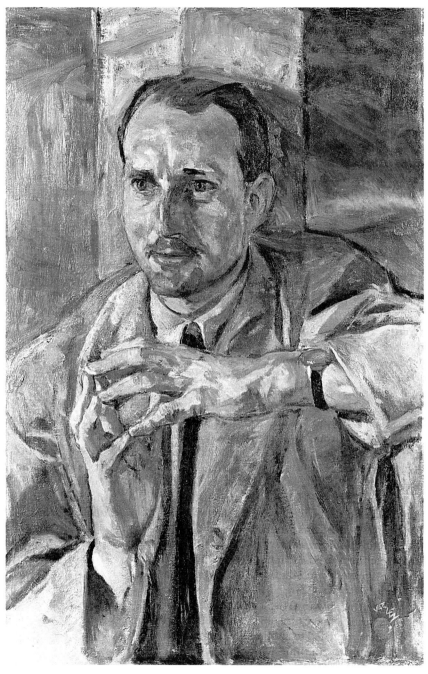

PORTRAIT OF A MAN c.1950
Oil on canvas
69.3 × 45.5 cm
Anonymous Donor
1966.16.138

GIRL IN RED 1920-1 ▶
Oil on canvas
53.2 × 51.6 cm
In memory of H. Laurence Rous
1968.15

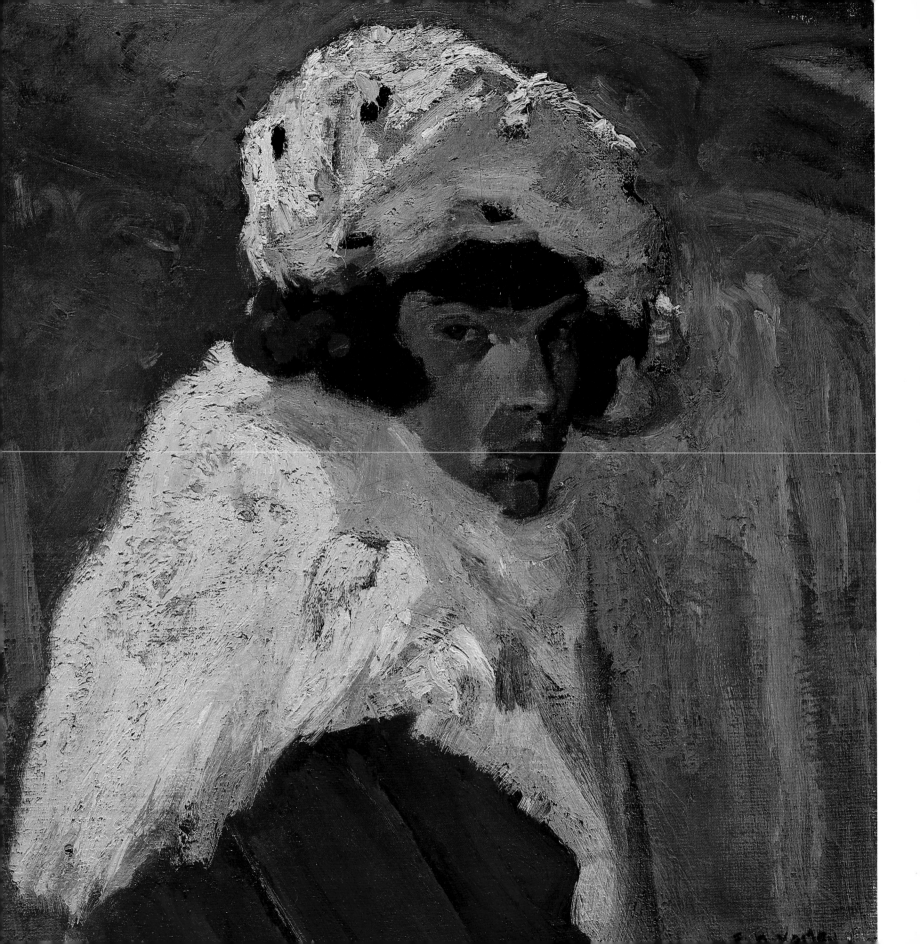

MEADOWVALE 1923
Oil on panel
21.2 × 25.4 cm
Anonymous Donor
1977.37.10

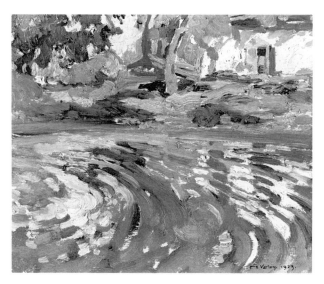

DEAD TREE, GARIBALDI PARK c.1928
Oil on panel on plywood
30.3 × 38.1 cm
Anonymous Donor
1966.16.142

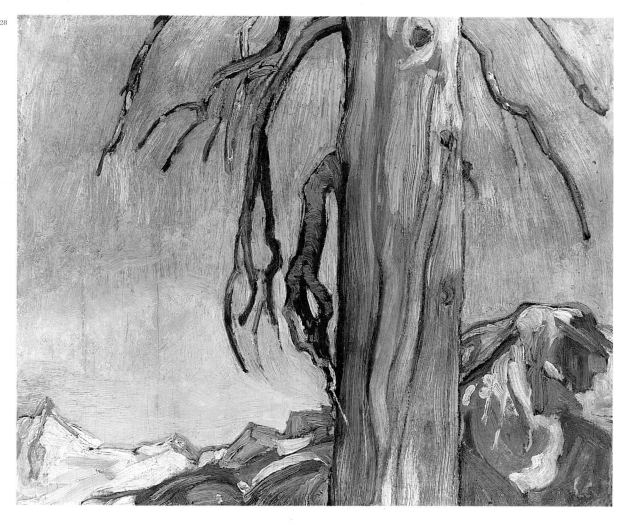

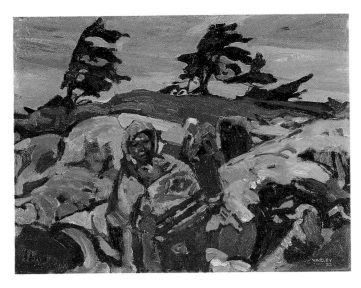

A WIND-SWEPT SHORE 1922
Oil on panel
30.0 × 40.6 cm
Gift of Mrs. E.J. Pratt
1969.9.3

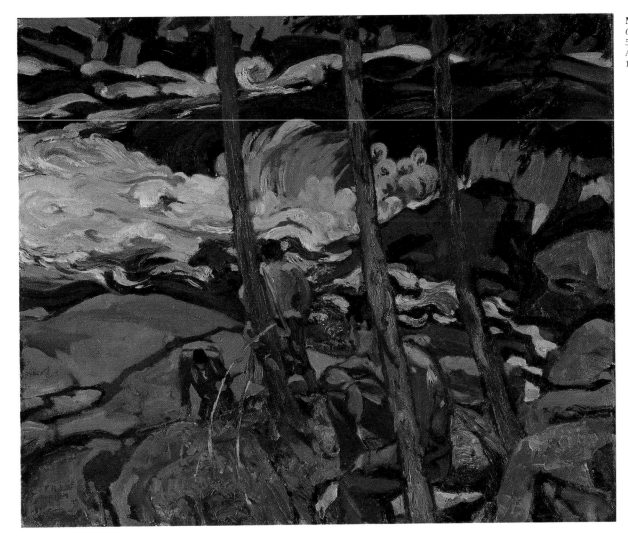

MOUNTAIN PORTAGE 1925
Oil on canvas
50.5 × 61.0 cm
Anonymous Donor
1966.16.141

F.H. VARLEY

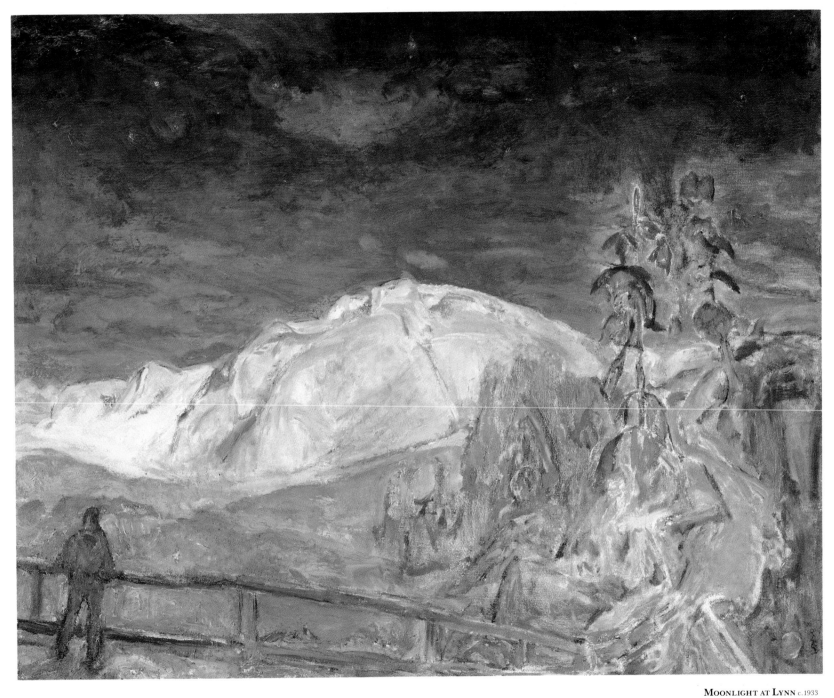

MOONLIGHT AT LYNN c.1933
Oil on canvas
61.0 × 76.4 cm
Bequest of the C.S. Band Estate
1969.24.1

◀**EARLY MORNING, SPHINX MOUNTAIN** 1927–28
Oil on canvas
119.4 × 139.8 cm
Purchase 1972
1972.11

F.H. VARLEY

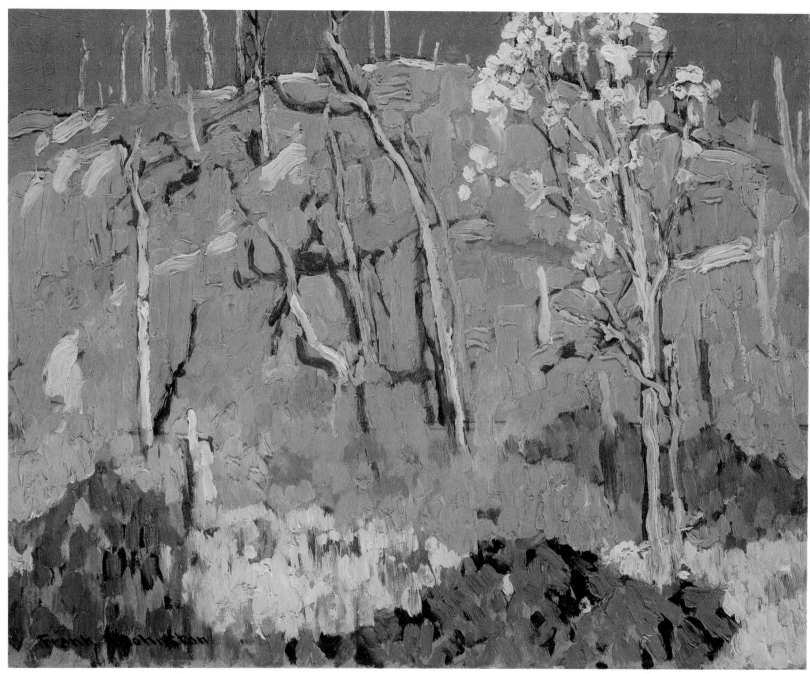

PATTERNED HILLSIDE 1918
Oil on panel
26.7 × 33.6 cm
Anonymous Donor
1977.37.8

FRANK JOHNSTON
1888–1949

Frank Johnston's official association with the Group of Seven was brief, but his friendship with the artists dated back over a much longer period. As a commercial artist at Grip Ltd. he was involved with the circle of young artists working there whose ideas about Canadian art led to the formation of the Group. When he joined the firm around 1908 his fellow Grip workers included J.E.H. MacDonald and Tom Thomson, and later Arthur Lismer and Franklin Carmichael signed on. Through these men and as a member of the newly founded Arts and Letters Club he met other artists, including Lawren Harris—all painters with new and exciting ambitions for Canadian art.

Johnston had much in common with these artists. Like them, in the years before World War I he used his spare time to pursue landscape painting, through sketching trips around Toronto and farther north to Bon Echo near Algonquin Park and to Hearst, north of Lake Superior. Also like several of them, he was later engaged to paint for the Canadian War Records Office, documenting the activities of the Royal Air Force in Canada in the last year of the war. As it had been for MacDonald, the Algoma region north of Sault Ste. Marie was a source of inspiration for Johnston. He was invited on the autumn painting excursions to the region, organized by Lawren Harris in 1918 and 1919. *Patterned Hillside* is typical of Johnston's style in this period. He did not use the techniques of Harris and MacDonald but, employing tempera rather than oil paint, he searched out the pattern and texture of his subject. The effect is more linear and decorative than that of his fellow artists, yet Johnston's paintings show the viewer the subtle colour relationships and interplay of forms in the foliage, rocks, and sky. *Approaching Storm, Algoma* evokes the darkening atmosphere of the scene.

In 1921 Johnston left Toronto to become principal of the Winnipeg School of Art, a post he held until 1924. There the influence of his ideas was felt among young artists, including L.L. FitzGerald and Charles Comfort. Before he left, Johnston travelled west, painting the spectacular mountain scenery of Jasper and Lake Louise. He had extensive influence as a teacher not only in Manitoba but in Ontario, where he taught privately and at the Ontario College of Art upon his return to Toronto. In 1939 he moved to Wyebridge, Ontario, near Georgian Bay, and established a private art school.

Johnston exhibited with the Group of Seven only once, in their first show at the Art Gallery of Toronto (now the Art Gallery of Ontario) in May 1920. His decision to resign from the Group was announced to the press in October 1924. The reason for his departure may have been a wish to escape association with artists whom some critics saw as too radical; it may have been, as suggested by his son, that he simply preferred to work independently.

Johnston's style became increasingly realistic throughout his life, evincing a particular fascination for the qualities of light reflected from snow. This theme recurred often in later works, in large narrative paintings of the 1930s and 1940s as well as in more intimate examinations of a river valley, the bright blue of the water bending between snowladen banks. His subjects range from the pastoral countryside of the Wyebridge area to the rugged wilderness of the Nipigon area, northern Quebec, and the Northwest Territories. He had begun in the 1920s to hold regular solo exhibitions and his paintings found a great following among the public. Johnston achieved considerable financial success in his own lifetime, and his work continues to be popular to this day.

SUNSET IN THE BUSH c.1918
Oil on canvas and stretcher
102.2 × 78.9 cm
Gift of the Paul Rodrik Estate
1987.6.2

APPROACHING STORM, ALGOMA 1919
Tempera on board
30.7 × 30.7 cm
Gift of the Paul Rodrik Estate
1987.6.3

DROWNED LAND, ALGOMA 1918
Tempera on board
45.9 × 54.8 cm
Gift of Mr. R.A. Laidlaw
1966.15.1

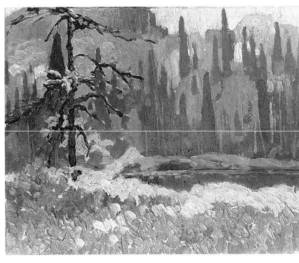

MOOSE POND 1918
Oil on panel
26.5 × 33.8 cm
Anonymous Donor
1972.18.14

WOODLAND c.1925
Oil on panel
21.6 × 14.3 cm
Purchase 1982
1982.7

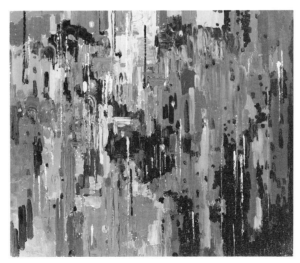

DEBUSSY c.1945
Oil on Masonite
50.5 × 61.0 cm
Gift of the Paul Rodrik Estate
1987.6.1

FRANK JOHNSTON

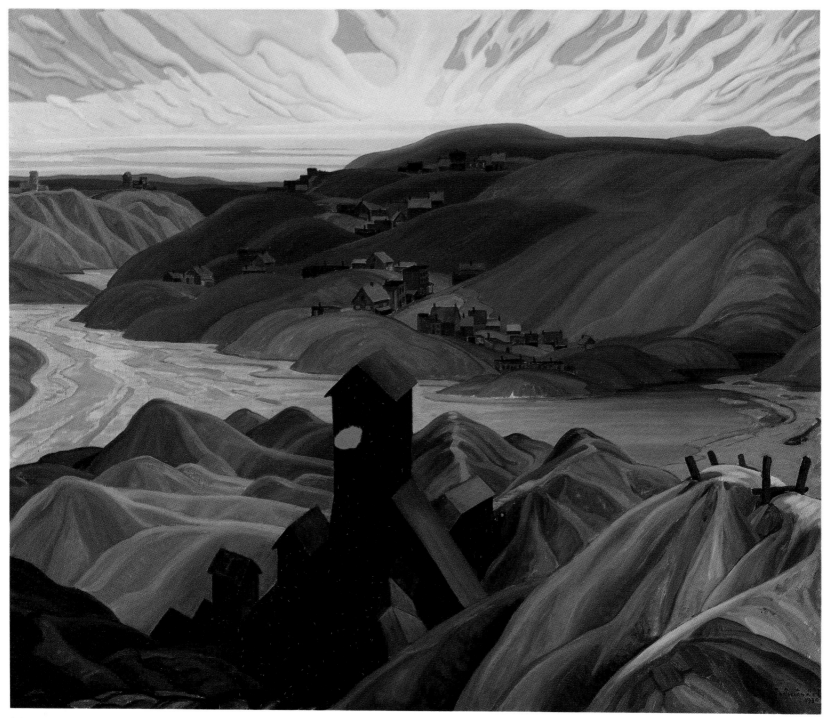

A NORTHERN SILVER MINE 1930
Oil on canvas
101.5 × 121.2 cm
Gift of Mrs. A.J. Latner
1971.9

FRANKLIN CARMICHAEL
1890–1945

Despite their extensive travels across Canada, many members of the Group of Seven are strongly associated with specific areas of the country: A.Y. Jackson with Quebec, Lawren Harris with the North Shore of Lake Superior, J.E.H. MacDonald with Algoma. For Franklin Carmichael, the La Cloche region north of Georgian Bay proved a continuing source of inspiration. The artist first visited the area in 1926 and built a summer cottage there for himself and his family in 1934. La Cloche is the area depicted in the artist's mature work, strongly designed and delineated vistas of rolling hills, lakes, and expansive skies.

The youngest original member of the Group of Seven, Carmichael was born in Orillia, Ontario, where he first worked in his father's carriage shop. His interest in art took him to Toronto in 1911, where he studied at Central Technical School and the Ontario College of Art. He was employed by the commercial art firms of Grip Ltd. and later Rous and Mann, where his colleagues included Mac-Donald, Tom Thomson, Frank Johnston, Arthur Lismer, and F.H. Varley. Carmichael left for Europe in 1913 to enroll at the Académie des Beaux-Arts in Antwerp, a school that charged no tuition fees and was recommended by both Lismer and Varley, who had studied there a few years before. His studies cut short by World War I, he returned to Toronto a year later. He found space in the new Studio Building on Severn Street, sharing work room with Tom Thomson and mingling with the other artists there.

With his marriage in 1915, responsibilities to family and work prevented Carmichael from joining in the extended sketching trips to Algonquin Park and Algoma undertaken by the others in the late years of the decade. His paintings were drawn from weekend sketching trips to areas not far from Toronto or from his family home in Orillia. *October Gold* of 1922 was based on a sketch done at Lansing, a village now part of North York near Toronto, yet it reveals the interests and interpretation typical of the Group of Seven: it could represent a scene of northern wilderness, for there is no hint of nearby urbanization, and autumn colours are played against distant hills.

Carmichael's later works often depict a more panoramic landscape. His technique in the 1930s shows a smoother application of paint and a simplification of forms and textures. *A Northern Silver Mine* demonstrates his interest in human interrelationship with the wild environment. An avid watercolourist, Carmichael produced many fine works in this medium throughout his life. In 1925 he, A.J. Casson, and F.H. Brigden, a commercial artist and painter, founded the Canadian Society of Painters in Watercolour.

Carmichael left his job as a commercial artist in 1932 to teach at the Ontario College of Art and eventually became head of the Commercial and Graphic Arts Department. His reputation as a teacher was enhanced by his work as a highly acclaimed designer and illustrator. One of several books he designed was *The Thornapple Tree*, published in 1942, the first book for the popular market in Canada entirely designed by an artist, including typography and illustrations. Its black-and-white drawings reveal Carmichael's strong graphic design skills. His considerable contributions as a commercial artist, graphic designer, illustrator, and wood engraver are well represented in the McMichael permanent collection.

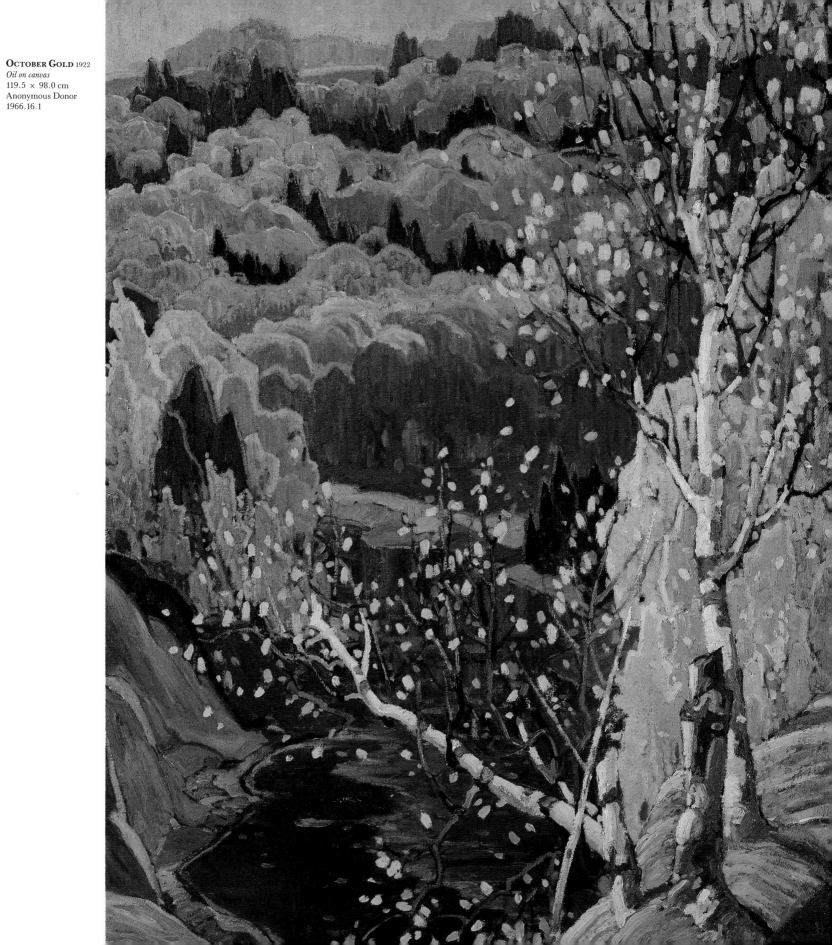

OCTOBER GOLD 1922
Oil on canvas
119.5 × 98.0 cm
Anonymous Donor
1966.16.1

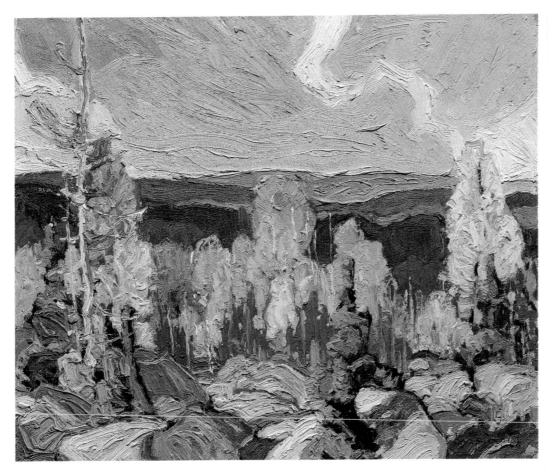

AUTUMN, ORILLIA 1926
Oil on panel
25.1 × 30.4 cm
Anonymous Donor
1966.16.3

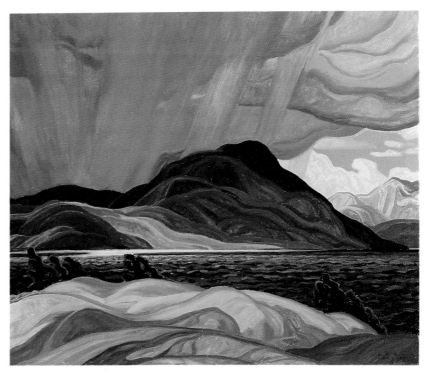

SUMMER STORM 1928
Oil on canvas
101.5 × 122.0 cm
Gift of Shulton of Canada Ltd.
1976.11

FRANKLIN CARMICHAEL

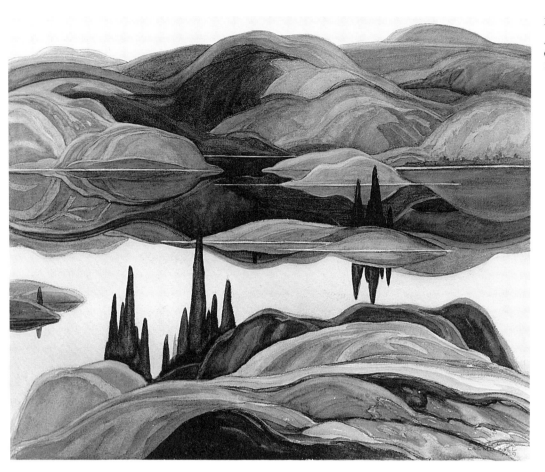

MIRROR LAKE 1929
Watercolour on paper
44.0 × 54.5 cm
Gift of Mrs. R.G. Mastin
1976.8

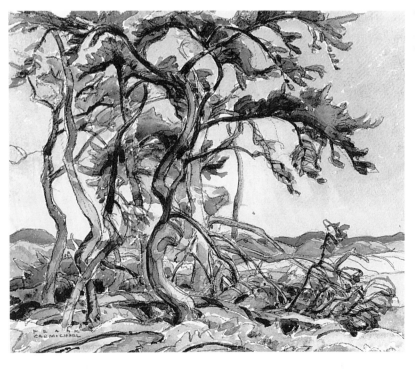

TWISTED JACK PINE n.d.
Watercolour on paper
28.0 × 33.0 cm
Gift of Mrs. R.G. Mastin
1988.4.2

UNTITLED c.1944
Wood engraving on paper
8.0 × 9.7 cm
Gift of Mr. R.G. Mastin
1974.8.3.3

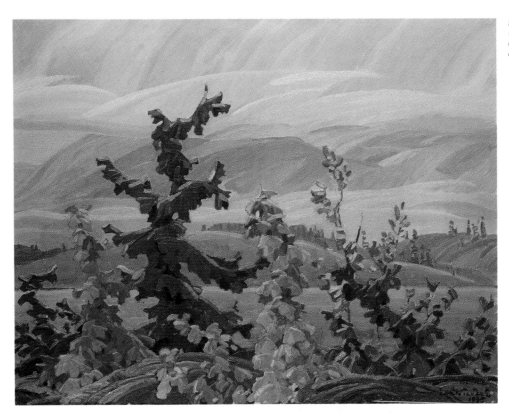

SCRUB OAKS AND MAPLES 1935
Oil on Masonite
60.6 × 78.7 cm
Gift of Mr. and Mrs. R. Mastin
1977.44

AUTUMN 1940
Oil on board
96.5 × 122.0 cm
Anonymous Donor
1980.17

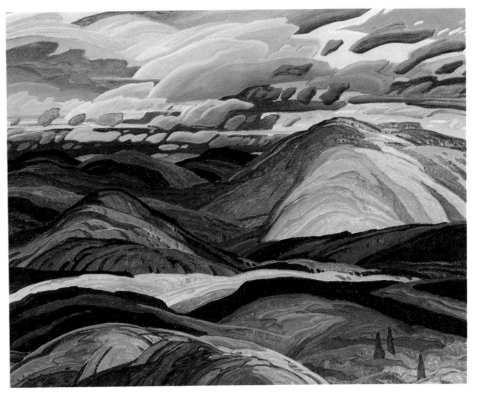

FRANKLIN CARMICHAEL

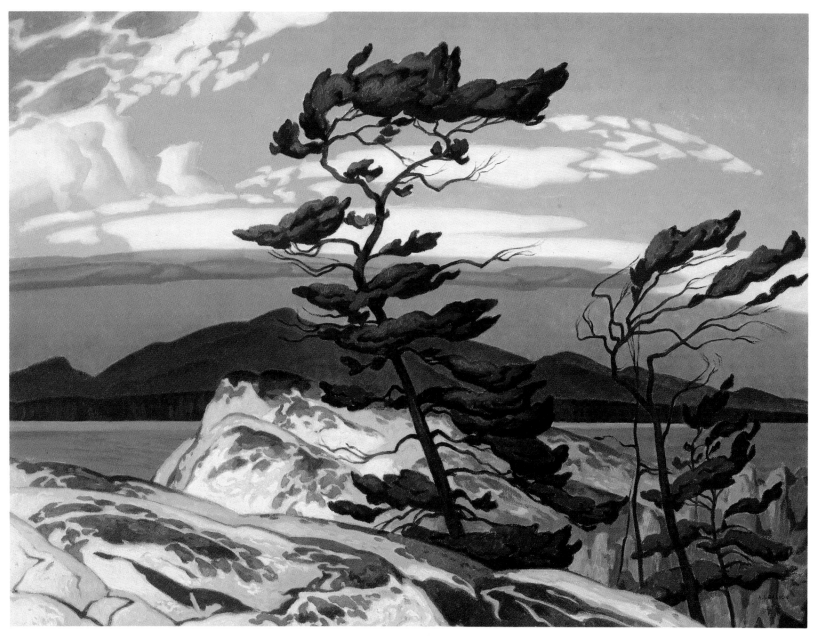

White Pine c. 1957
Oil on canvas
76.0 × 101.3 cm
Anonymous Donor
1966.16.119

A.J. Casson
b. 1898

If I have to define my own contribution to the Canadian art scene, what was particularly mine were really the rural villages and houses. In a way, it is a record of a disappearing society and a disappearing world . . . For me it was always an Ontario quest.
A.J. Casson, quoted in *A.J. Casson* (Art Gallery of Windsor, 1978)

A.J. Casson is known for his depiction of the gentler, more civilized areas of southern Ontario, areas of small villages and farms, the forests and rolling hills of "cottage country." He deliberately sought subjects in contrast to the preferred material of other Group members; his interpretation of the subtle variations of summertime green has become a trademark of his work.

Casson was born in Toronto, but as a child he moved with his family to Guelph and Hamilton before moving back to Toronto at the age of seventeen. Like so many of his generation he started work at an early age, finding employment as an apprentice at a Hamilton lithography company. In 1919 Casson was taken on by the commercial art firm of Rous and Mann in Toronto, a move that was of great significance for him. Apprenticed to Franklin Carmichael, he was encouraged by the older man to continue sketching and painting on his own. Casson openly admits his immense debt to Carmichael as a designer and painter. Carmichael also introduced his new employee to the Arts and Letters Club, where he met many of the era's most prominent artists, including members of the Group of Seven. Encouraged by Carmichael and others, Casson continued to paint seriously in his spare time throughout the 1920s, and his subject matter reflects the interests of the Group of Seven. *At Rosseau, Muskoka*, of 1920, executed on an extended sketching trip urged by Carmichael, is typical of his work produced during these years.

The watercolour medium fascinated Casson throughout his career, and in 1925 he, Carmichael, and F.H. Brigden, also a commercial artist and painter, founded the Canadian Society of Painters in Watercolour, an association that continues actively to this day. In a work such as *Fog Lifting*, one sees Casson's close attention to the organization of colours and forms and to the subtle tonalities of colour.

The following year, Casson was invited to join the Group of Seven, while the two were walking to Lawren Harris's, Carmichael simply turned to Casson and said, "How would you like to be a member of the Group?" The Group's numbers had been depleted by Frank Johnston's departure in 1922, and Casson, as an invited contributor to Group shows, seemed the appropriate replacement. Casson enthusiastically agreed, later commenting, "That's the way they did things. No fuss."

Casson continued at Rous and Mann until 1927, when he joined Sampson-Matthews, eventually becoming their art director and vice-president until his retirement in 1957. In his spare time he continued his paintings, as well as his involvement with various art societies and associations. Upon the dissolution of the Group of Seven, he became a founding member of the Canadian Group of Painters in 1933.

Casson developed a painting style distinctly his own. His design background is evident in the clear lines and well-thought-out compositions of his mature work, such as *The White Pine* of 1957. He depicted the pastoral pioneering Ontario that has now vanished in the face of a noisier urban world. His work has become much loved by the Canadian public, and his accomplishments have been recognized with honours from many organizations. In 1974 a lake and a township were named in his honour, and in 1988, on the occasion of his ninetieth birthday, a mountain. His work reflects the ideals of the Group of Seven, yet it has provided insight into a part of Canada he knew and loved well.

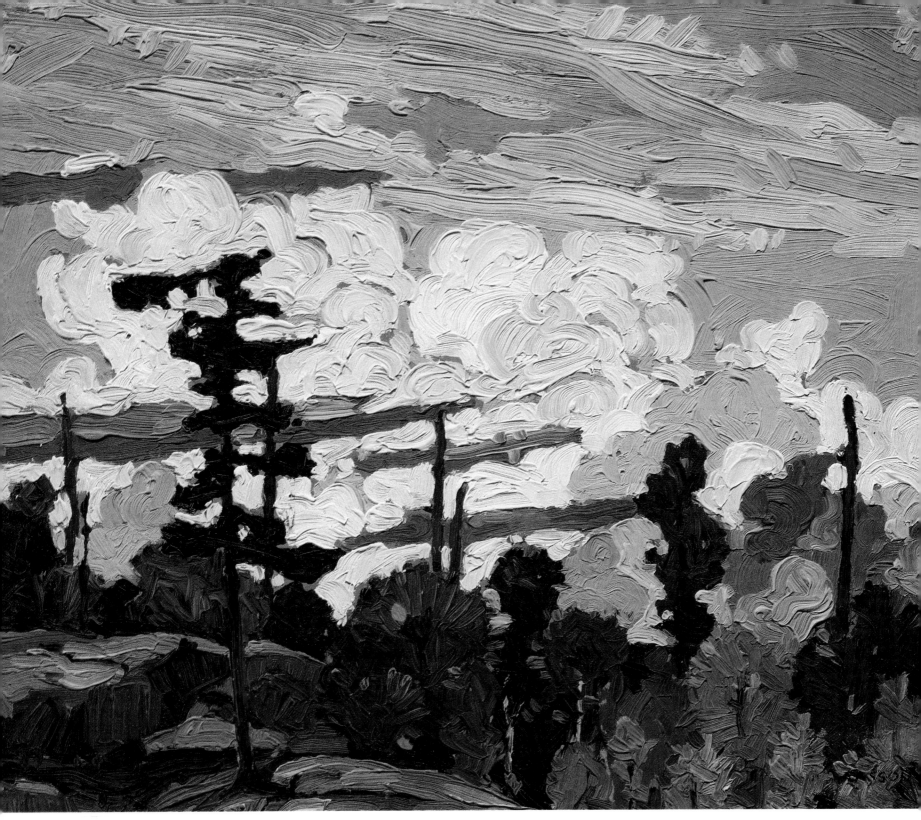

AT ROSSEAU, MUSKOKA 1920
Oil on board
23.3 × 28.4 cm
Gift of the Artist
1989.10

TOM THOMSON AND THE GROUP OF SEVEN

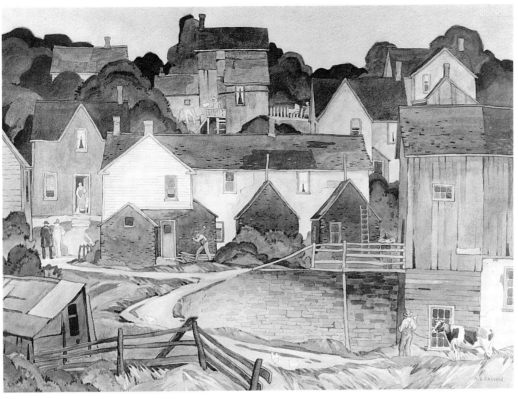

SATURDAY AFTERNOON c.1927
Watercolour on paper
43.0 × 59.0 cm
Gift of Mr. and Mrs. C.A.G. Matthews
1974.13.2

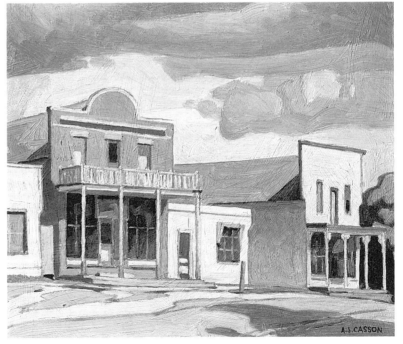

KLEINBURG c.1929
Oil on panel
24.0 × 28.5 cm
Anonymous Donor
1966.16.124

A.J. CASSON

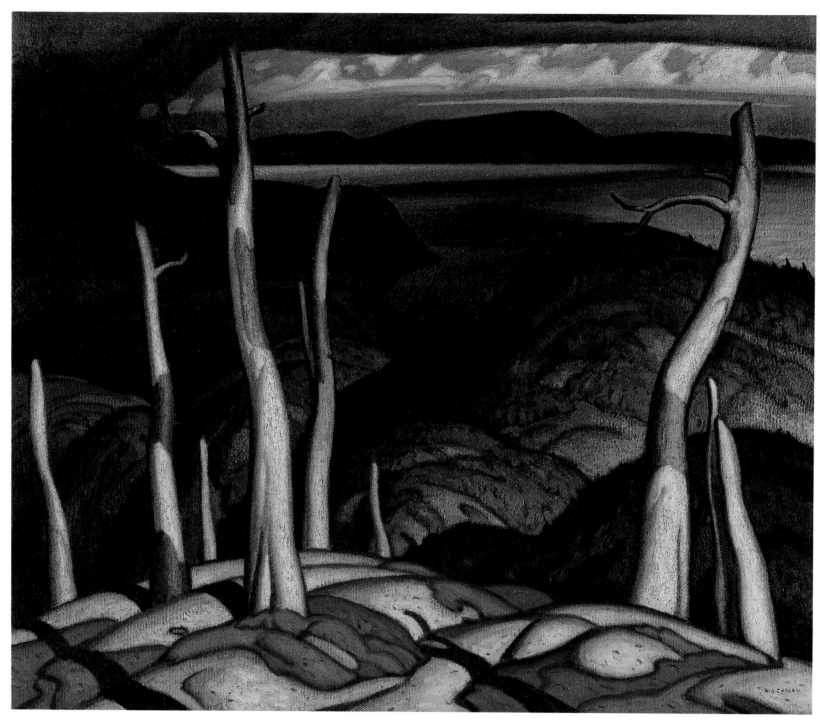

OCTOBER, NORTH SHORE 1929
Oil on canvas
76.4 × 91.8 cm
Purchase 1985
1985.15

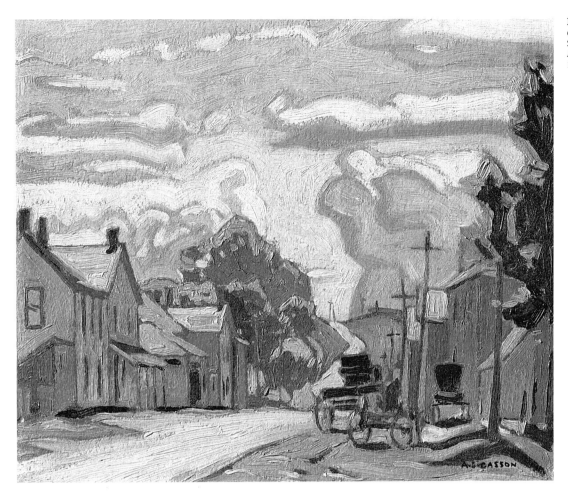

NORVAL c.1929
Oil on panel
23.7 × 28.3 cm
Anonymous Donor
1966.16.123

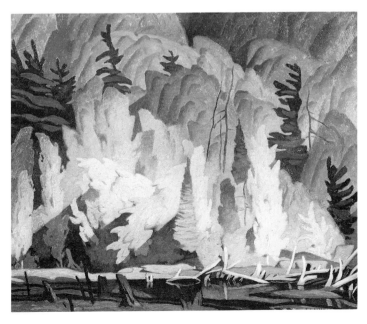

SUMMER HILLSIDE 1945
Oil on Masonite
50.7 × 61.1 cm
Gift of Mr. W.A. Norfolk
1972.9

A.J. CASSON

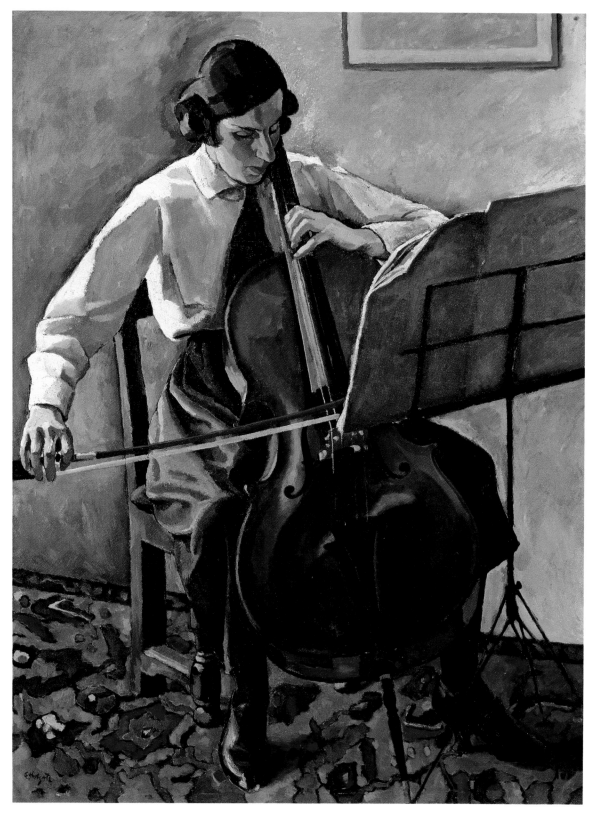

THE CELLIST 1923
Oil on canvas
128.0 × 97.5 cm
Anonymous Donor
1972.18.2

EDWIN HOLGATE
1892–1977

In 1930 the Group of Seven broadened the geographical base of its membership by inviting Montreal artist Edwin Holgate to join. The move signalled a new direction for the Group, whose number now was increased to eight. Although the Group had invited contributors from outside Toronto, including Holgate, to show with them throughout the 1920s, the Montreal artist was their first member to reside outside Ontario. As well, Holgate's artistic interests did not lie solely with landscape. Indeed, his reputation is largely founded on his fine portraiture and interpretation of the human figure.

Born in Ontario, Holgate was raised in Montreal after his family moved there about 1901. He showed an early interest in art and began full-time study in 1910 at the Art Association of Montreal under William Brymner. Two years later he sailed for Paris to continue his studies. Trapped on summer travels in the Ukraine by the outbreak of World War I, Holgate reached home by travelling east across Siberia, the Pacific, and Canada. He enlisted in the army in 1916; although he never became an official war artist, he drew and painted the scenes around him.

After the war Holgate returned to France, this time with his new bride. There he pursued his formal studies and came to know expatriate Montreal painter James Wilson Morrice (see Part II), with whose work he was already familiar. Back in Montreal in 1922 he renewed his contacts with many of the other young artists of the city. His world was that of the Montreal cultural intelligentsia, both French- and English-speaking. The Quebec people and landscape were Holgate's constant inspiration, although he travelled with A.Y. Jackson and renowned anthropologist Marius Barbeau to the Skeena River region of British Columbia in 1926 and visited Jamaica twice in the 1920s.

Holgate exhibited only twice as an official member of the Group of Seven, in their final exhibitions of 1930 and 1931, but he continued his association as a founding member of the Canadian Group of Painters. His strongly individualistic style and his interest in the depiction of people gave the Group an added dimension. In 1946 Holgate and his wife left the urban surroundings of Montreal for the quieter countryside of Morin Heights, where his interest in the landscape was renewed.

Holgate is, however, best known for his depiction of the human figure, and the relationship of the human body to the landscape intrigued him all his life. This concern marks a departure from those of all other Group of Seven members except F.H. Varley. His superb analyses of the posed figure have given us an inheritance of compelling portraits. In a work such as *The Head* of 1938 the lines and planes of the face, framed by the kerchief, present an abstracted examination of the forms as well as a psychological portrait of the sitter.

Holgate contributed to the development of Canadian art on several levels. First, he maintained a lifelong interest in graphics, drawing, and printmaking. This interest in strong line and design is evident not only in his painting but also in his wood engraving, a medium that fascinated him: "Its very directness of statement—its crisp whites and rich blacks—give the woodcut a luminous quality that lends itself to bold design, a dramatic intensity and severity which no other medium possesses, to the same degree."

Secondly, throughout his life Holgate taught and left a positive imprint on many Quebec artists. Finally, Holgate contributed to public art not only with his murals for the Chateau Laurier, for a CNR lounge car, and for the Canadian Pavilion at the New York World's Fair in 1939 but also with his work as an official war artist during World War II.

FISHERMEN'S HOUSES c.1933
Oil on canvas
50.7 × 61.1 cm
Gift of Mr. A.B. Gill in memory of Arthur B. Gill
1977.36

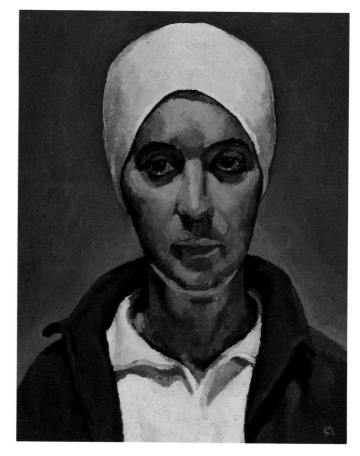

THE HEAD 1938
Oil on panel
46.0 × 36.6 cm
Gift of the Artist
1976.17

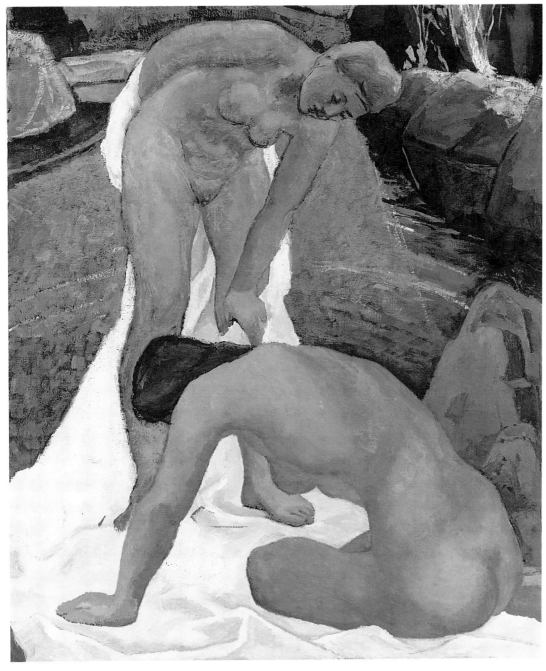

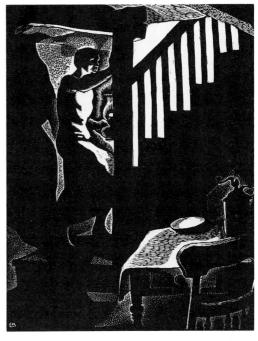

THE STAIRWAY 1930
Woodcut on paper
24.1 × 19.0 cm
Purchase 1986
1986.15

NUDES IN THE LAURENTIANS n.d.
Oil on canvas
56.1 × 66.5 cm
Purchase 1984
1984.31

EDWIN HOLGATE

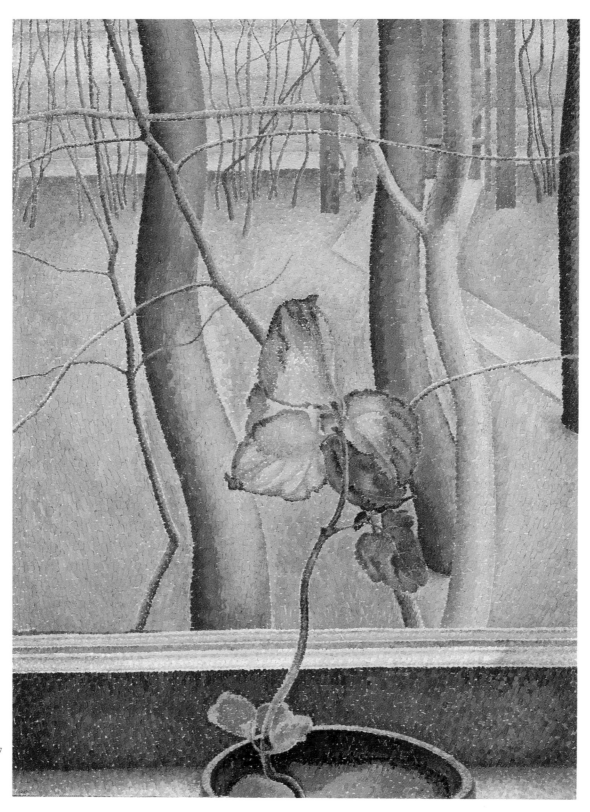

THE LITTLE PLANT 1947
Oil on canvas
60.5 × 45.7 cm
Gift of Mr. R.A. Laidlaw
1969.2.4

LIONEL LeMOINE FITZGERALD
1890–1956

It is necessary to get inside the object and push it out rather than merely building it up from the outer aspect . . . This requires endless search and contemplation; continuous effort and experiment; and appreciation for the endlessness of the living force which seems to pervade and flow through all natural forms, even though these seem on the surface to be so ephemeral.

A latecomer to the Group of Seven, L.L. FitzGerald is distinguished from the other artists by his own distinct style and sensibilities, as well as by the fact that he was removed geographically from their centre of activity. His inclusion in the Group was part of their move to widen their national base. He was asked to join in 1932 after their intention to dissolve had been announced, and FitzGerald never exhibited as an official Group member; indeed, the title was essentially honorary, recognizing his contribution to Canadian art. The artist was, however, a founding member of the Group of Seven's successor, the Canadian Group of Painters.

Although he left school to work at the age of fourteen, FitzGerald's early life was an important formative period. During the day he pursued a variety of jobs; on his own time he read extensively about art, eventually taking night courses with A.S. Keszthelyi, a Hungarian artist who had previously taught at the Carnegie Institute in Pittsburgh. Boyhood summers had been spent on his grandmother's farm at Snowflake, Manitoba, and a deep love of and loyalty to the prairies remained with him all his life. Late in his life he wrote:

Occasionally I get out on the prairie just to wander and look, without making any notes other than mental ones and always come back with an inner warmth from the familiar but always new feeling. Never a highly emotional reaction, just a sort of quiet contentment. And all this finally penetrates the drawings.

FitzGerald's early work, such as *The Harvester*, is related in technique to late nineteenth-century styles in French art. His first one-man show was held at the Winnipeg Art Gallery in 1921, and in

the fall of that year he left to continue his studies in New York at the Art Students' League. Not only did he visit the great public collections of that city but he was also introduced by his teachers to the regionalist and urban realist ideas of the day. Throughout that decade FitzGerald's style and philosophy continued to develop. Contacts in Winnipeg and a trip in 1930 to the institutions of several major American and Canadian cities reaffirmed his interest in a clearly delineated style that explored volume and spatial relationships.

FitzGerald's art is an intellectual and personal experience. Subjects are often simple and homey— a neighbour's backyard or a shelf with a crockery jug. As in *The Little Plant*, his concerns were more intimate, more serene, and more introspective than those of the wilderness-seeking Group of Seven.

FitzGerald's freedom was curtailed by his teaching obligations first as an instructor at the Winnipeg School of Art, then as its principal from 1929 to 1949. Although he had corresponded regularly with members of the Group of Seven since the 1920s and exhibited in their final two shows of 1930 and 1931, his contact with them was limited. However, during a leave of absence from 1947 to 1949 and again after his retirement, he often visited his daughter on the British Columbia coast, and there his friendship with Lawren Harris grew strong. The two must have shared many common thoughts on the inherent spirituality of objects: for Harris, the essential qualities of monumental landscapes; for FitzGerald, the evocative analyses of still life and gentler vistas. In 1928 Harris had written to FitzGerald, "I particularly like the way you extricate a suggestion of celestial structure and spirit from objective nature in your drawings." After 1950, FitzGerald worked on both abstractions and still life.

FitzGerald's art examined different subjects than did that of other members of the Group of Seven. He looked at groupings of objects on a table or in a corner of the room, or out at views seen from an upstairs window or across a rolling landscape under enormous skies. And as Harris noted, his art reveals the essence of his observed world.

TREE TRUNK 1939
Pencil on paper
28.3 × 37.1 cm
Gift from the Douglas M. Duncan Collection
1981.41.5

WILLIAMSON'S HOUSE 1933
Oil on canvas
152.7 × 111.5 cm
Anonymous Donor
1970.14.8

THE HARVESTER c.1921
Oil on canvas
66.8 × 59.5 cm
Gift from the Douglas M. Duncan Collection
1981.41.3

LIONEL LeMOINE FITZGERALD

PART II

BEYOND THE GROUP: PREDECESSORS, CONTEMPORARIES & SUCCESSORS

Davɪd Wɪstow

THE GROUP OF SEVEN HAS LEFT AN INDELIBLE MARK ON the consciousness of Canadians. We can hardly look at a northern lake or a silhouetted pine tree without thinking of the artists' arresting pictures and their underlying struggle—for most it was a lifelong commitment—to comprehend and record the vast spaces and the ruggedness of the land. Yet the myth that their art sprung solely from the soil without foreign influence certainly cannot be supported. Their fascination with light and weather conditions, their belief in the importance of working outdoors, and their reliance on bright colours and expressive brushwork derive primarily from French Impressionism. But Group members didn't have to travel to Paris to become familiar with the style.

A Canadian, Maurice Cullen, was painting scenes of Quebec in just such a manner by the late 1890s. He had in fact already lived and studied in France for several years, and his light-filled snowscapes in particular attracted considerable attention among the younger Canadian artists. A.Y. Jackson visited Cullen in his studio and later wrote: "To us he was a hero. His paintings of Quebec City, from Levis and along the river, are among the most distinguished works produced in Canada."

At the same time a close friend of Cullen's, the Montreal-born James Wilson Morrice, was working in an even more advanced, rigorous style under the influence of such Post-Impressionists as Gauguin, Vuillard, and Bonnard. Although he settled in Paris, Morrice returned regularly at Christmastime to Canada, where he captured the overcast days, the snow-covered streets, and the sleighs. His boldly designed compositions using flattened and simplified forms, as well as his habit of working out of doors in oil on small wooden panels, provided a significant Canadian model for Group of Seven members.

Two Quebec artists, Clarence Gagnon and Albert H. Robinson, painted views of the province in the striking manner of Cullen and Morrice, artists whom they admired deeply. In 1933 Gagnon published his now-famous edition of Louis Hémon's novel *Maria Chapdelaine*, for which he created fifty-four stunning illustrations based on habitant life in Charlevoix County. Robinson too was devoted to expressing his love of rural Quebec. Often in the company of A.Y. Jackson, he painted the quaint towns of the St. Lawrence nestled under a heavy snowfall.

In Toronto, William Beatty—a close associate of future Group of Seven member J.E.H. MacDonald—had returned from study in Europe by 1909 and, under the influence of several local painters, abandoned scenes of Dutch peasant life for distinctly Canadian subjects. In fact, during his first year back he painted in Ontario's north and in 1910 exhibited *The Evening Cloud of the Northland*, a landscape that captured the rawness and majesty of the wilderness. It was certainly one of the first of such images and attracted many admirers, including Tom Thomson.

Two other contemporaries of the Group of Seven have achieved considerably wider acclaim than Beatty. Emily Carr in British Columbia and David Milne, who worked for many years in the United States and then in Ontario, are two of Canada's original talents. Both worked in isolation, both struggled to survive, but both persevered and ultimately found a powerful, unique form of expression. Carr and Milne worked in the shadow of the Group of Seven, along with the many members of the Canadian Group of Painters, an offshoot of the Group formed in 1933 that included twenty-eight founding members from across Canada, including nine women. A few of the younger members were dissatisfied with the Group of Seven's chest-thumping nationalism and dependence on landscape. Many members of the Canadian Group of Painters in Montreal favoured figure and portrait studies, subjects that are increasingly represented on the walls of the McMichael Canadian Art Collection as this portion of the holdings continues to expand.

The most concerted criticism of the Group of Seven came from Montreal figure painter John Lyman. He disagreed with their unquenchable thirst to explore Canada's every corner. "The real adventure," he wrote in 1932, "takes place in the sensibility and imagination of the individual." Lyman had studied art in Paris, and there he met Morrice, who became a close friend. For six months in 1909 he attended a school recently opened by the French master Henri Matisse, an association that was to affect his entire career. Under Matisse's influence Lyman sought to create an art of enriched visual sensation based on pure line and colour and radical simplification. But he found little sympathy with the critics back home when he exhibited in the spring of 1913, and he remained in Europe for the next eighteen years. Back in Montreal in the 1930s he found the reception warmer; Lyman painted with assurance while promoting younger Montreal talent such as Goodridge Roberts. Together with Roberts and several other Montreal-based artists—none of them members of the Canadian Group of Painters—Lyman founded first the Eastern Group and then in 1939 the Contemporary Art Society. This last was to play a crucial role in supporting the most progressive Canadian art well into the 1940s.

Page 119: Emily Carr in her studio with John Vanderpant, c. October 1933.

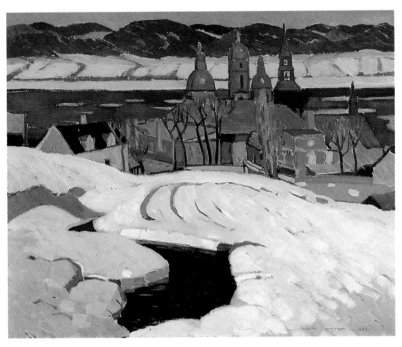

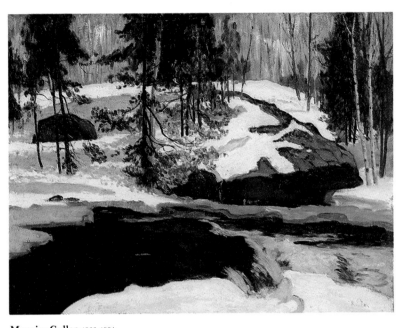

Albert H. Robinson 1881–1956

St. Joseph 1922
Oil on canvas
69.7 × 84.9 cm
Gift of Col. R.S. McLaughlin
1968.7.15

Maurice Cullen 1866–1934

Brook in Winter c.1927
Oil on canvas
61.0 × 81.5 cm
Gift of Col. R.S. McLaughlin
1968.7.16

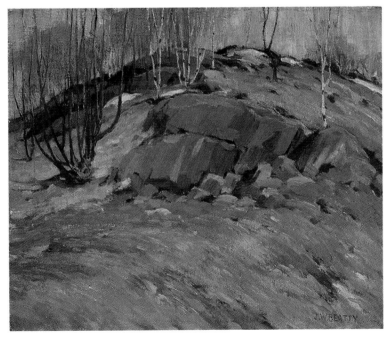

John Lyman 1886–1967

Hauling up the Fishing Boats, Barbados c.1935
Oil on canvas board
16.5 × 35.5 cm
Gift of Harriett Larratt Smith
1983.16

J.W. Beatty 1869–1941

Spring in Northern Ontario n.d.
Oil on canvas
51.2 × 61.7 cm
Gift of Mrs. Geraldine Staples
1981.70

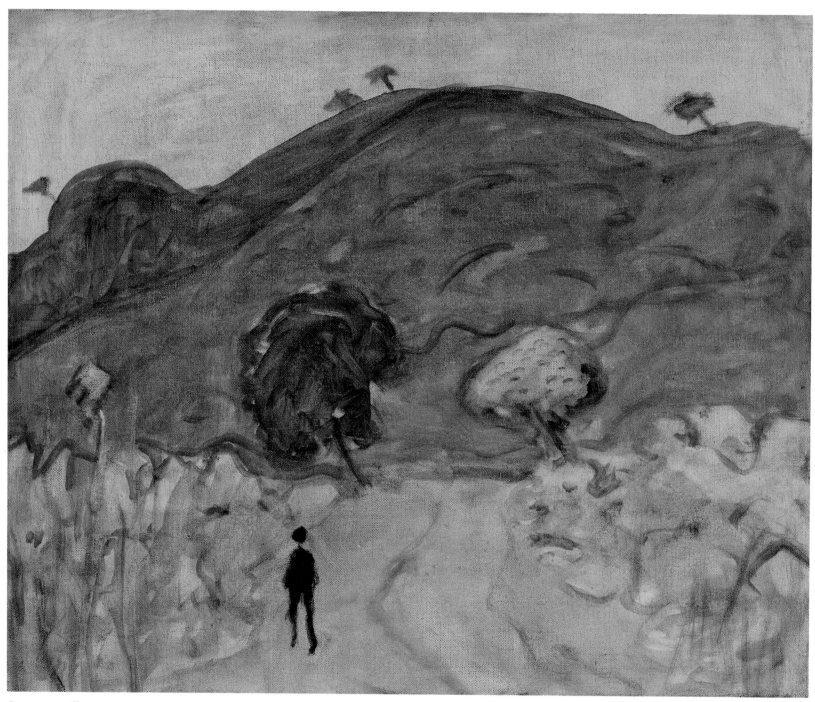

LANDSCAPE IN TRINIDAD c. 1921
Oil on canvas
37.3 × 45.5 cm
Purchase 1975
1975.31

CHAPTER ONE

JAMES WILSON MORRICE
1864–1924

At first glance, Parisians probably saw in the figure of expatriate Canadian James Wilson Morrice simply an Edwardian gentleman, elegantly dressed in a tweed suit, high collar, and cravat, his beard meticulously groomed. No one certainly looked more at home in early twentieth-century Paris than he did. Yet closer inspection undoubtedly provoked some surprise. Inevitably, propped up before him amidst the plates and glasses of his favourite café table was a tiny panel and his equally tiny palette. There he would sit for hours, absorbing the unforgettable ambiance of the French capital and unobtrusively painting it. His sketches, executed in oil on wooden boards small enough to fit into a suit pocket, were everything he himself was—modest, gentle, even touchingly innocent, yet at the same time perceptive and articulate.

Born in Montreal, Morrice never had to work. His father, a rich merchant, supported not only his youthful law studies in Toronto and his early art training in Europe but also his entire career. Yet the artist's rooms were always furnished sparsely, with some books, an old sofa, a wicker chair. He cared little for possessions, spending his money on drink, models, and his mistress. He arrived in Paris in 1892, and the city became his home base—if he could ever be described as having one—until his death. He immediately fitted in. His many new friends, like writers Somerset Maugham and Arnold Bennett, admired his quirky humour, his musical talents, and his unpretentiousness. Above all they spoke of his vision and his rapidly developing skills in watercolour and larger oil paintings on canvas. With several artist friends, Morrice travelled to Italy, Holland, Normandy, and Brittany.

By the turn of the century Morrice's reputation was established. Innumerable exhibitions in Europe, Canada, and the United States brought him sales and much praise, and the French government purchased two works, a mark of special favour. He was to become one of Canada's most acclaimed artists abroad and highly respected at home. His many Canadian friends and admirers included artists Maurice Cullen, William Brymner, Clarence Gagnon, A.Y. Jackson, and Lawren Harris. The Group of Seven's fundamental principle of painting on the spot, and their consistent use of small board

panels, was inspired in part by Morrice's example.

Morrice's early pictures in the muted tones of the American painter James McNeil Whistler gave way around 1900 to vivid, light-filled images influenced by the Impressionists and such artists as Gauguin and Bonnard. His compositions became increasingly looser and more fluid, whether they depicted the Grand Canal of Venice, a street scene in exotic Tangier, fishing boats on the French coast, a portrait, a circus, a restaurant, or a race-track. All his motifs were subjected to a rigorous process of artistic "possession" and re-creation: they were flattened, simplified, and cropped. No painter expressed himself more succinctly with his brush: a single smudge of paint could be made to evoke a figure or a building. Through a highly developed shorthand, Morrice avoided encumbering his pictures with detail, yet they remain eminently readable as images of real places and real people.

Water held a particular fascination for Morrice, whether it was the ocean, a canal, or a river, and it features prominently in his work. That is perhaps one reason why he enjoyed travel so much, making innumerable trips across the Atlantic to Canada and Cuba, then back to France or North Africa. He rarely remained in the same place for more than a few months, though as his health began to deteriorate he visited the warmer climes more and more frequently. The winters of 1911-12 and 1912-13 he spent painting with Henri Matisse in Morocco. Working alongside the French master prompted Morrice to employ an increasingly dazzling palette and to seek even greater luminosity in his landscapes. "The artist with the delicate eye," was how Matisse described him.

Morrice continued his wanderings during the war years and into the early 1920s. Despite a body ravaged by alcohol, he continued to produce paintings that clearly show no signs of decline, such as *Landscape in Trinidad* of 1921. These later pictures possess a new subtlety and expressiveness. Their lush foliage, rolling hillsides, and slumbering villages seem to materialize almost magically through the shimmering light, creating a tranquil, dreamlike atmosphere. Only the occasional presence of a lonely figure on a road disturbs the spell, evoking empathy and a feeling of tenderness.

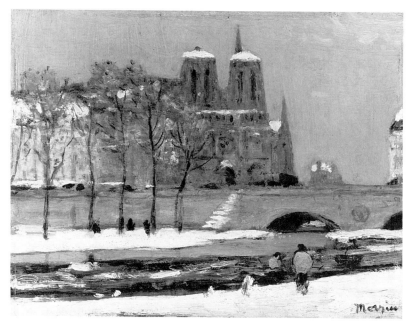

Notre Dame c.1898
Oil on panel
19.0 × 25.4 cm
Gift of Col. R.S. McLaughlin
1968.7.18

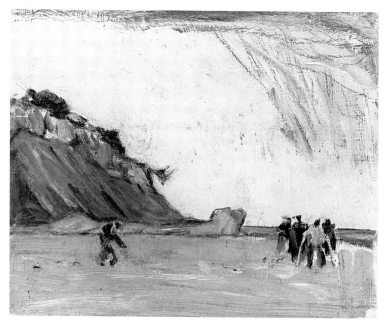

Clam Digging, France c.1914
Oil on panel
12.1 × 15.4 cm
Gift of Col. R.S. McLaughlin
1968.7.29

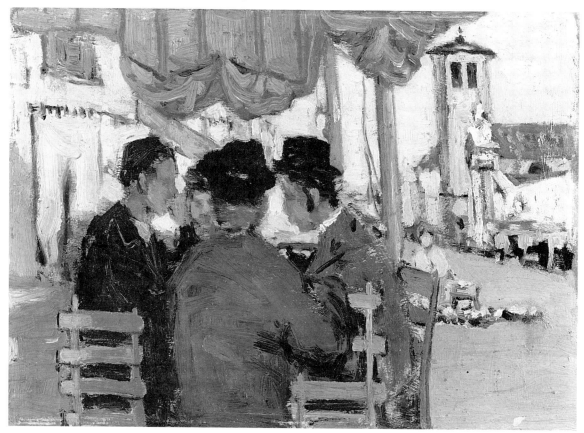

Cardplayers, Spain c.1900–1905
Oil on panel
17.8 × 25.2 cm
Bequest of the D.R. Morrice Estate
1979.3.3

A North African Market Scene c.1912
Oil on panel
12.2 × 15.5 cm
Bequest of the D.R. Morrice Estate
1979.3.1

Along the Bank c.1909
Oil on panel
12.3 × 15.3 cm
Gift of Col. R.S. McLaughlin
1968.7.30

Paris c.1909
Oil on panel
12.3 × 15.3 cm
Gift of Col. R.S. McLaughlin
1968.7.28

JAMES WILSON MORRICE

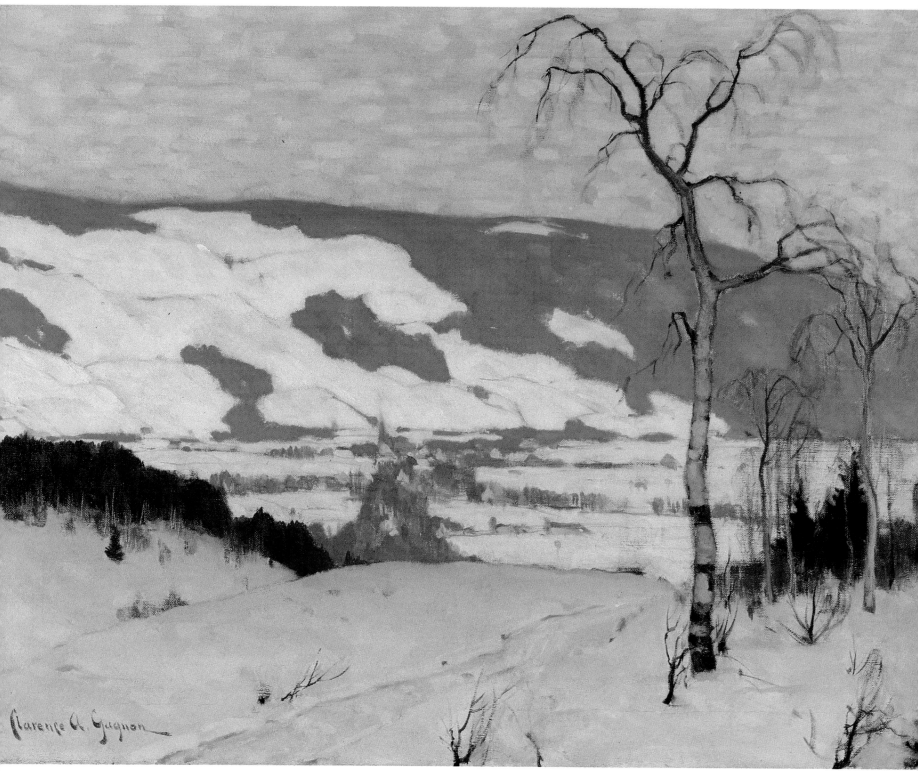

TWILIGHT, BAIE ST. PAUL c.1920
Oil on canvas
49.9 × 65.0 cm
Gift of Mr. Syd Hoare
1975.61

CLARENCE GAGNON
1881–1942

Despite the appeal of Clarence Gagnon's many landscape paintings and his special talents as an engraver, he is best known today for the illustrations he created for *Maria Chapdelaine*. The now-famous novel—written in 1914 by Frenchman Louis Hémon, who had immigrated to Canada—tells the story of a young girl growing up in rural Quebec. Scenes of bread baking, blueberry picking, hay cutting, and maple syrup gathering, played against rolling farmland and dramatic seasonal changes, evoke an age-old way of life untrammelled by the modern world.

Over a dozen artists have been inspired by the romantic account of Maria and her peasant family, but none has achieved the acclaim of Gagnon and his illustrations for a 1933 edition. "My purpose in illustrating *Maria Chapdelaine*," he wrote, "was to catch the spirit of Canada and of the French Canadian life, which the book immortalizes. That book represents the struggle of a brave little minority, and reveals the true pioneering instinct of those early settlers. It is Canadian and yet universal in its picture of a struggle where people are determined to maintain their own religion, language and customs." The original gouache paintings for the fifty-four illustrations constitute one of the most valued treasures of the collection.

These images are so unforgettable because Gagnon clearly holds the habitants in deepest respect; he grew up in late nineteenth-century rural Quebec, north of Montreal, and he knew their way of life intimately. The smells, the sounds, the clothing, the gestures are almost instinctively perceived. And then there's the land—the dark forests, the rail fences, the picturesque wooden houses, and the majestic rivers and valleys. Rarely has an artist fused innate understanding with such acute powers of observation. Light is a prime communicator. Gagnon scrutinizes its every nuance—from brilliant blue shadows on new snow to soft, glimmering sunsets—and bathes his scenes in its poetic eloquence. Despite toil and hardship, his habitants clearly dwell in an atmosphere of harmony with the world around them.

Like many Canadian artists of his time, such as Maurice Cullen and James Wilson Morrice, Gagnon was attracted by Paris and its art schools, and he arrived there in early 1904. In fact, he was to live

in France on and off for most of his life. Rapidly he assimilated the Impressionist style—its loose brushwork, its vivid colours, its reliance on painting outdoors, and especially its preoccupation with light and weather conditions. After sketching trips to Spain and Italy, Gagnon moved into a studio in Montparnasse, where he met such European artists as Chagall, Modigliani, and Brancusi; Morrice also lived there and had already become one of his closest friends. Over the next five years Gagnon explored the French countryside, painting it in the Impressionist mode. At the same time he worked diligently to perfect his considerable gifts as a printmaker. His engravings of rural and town scenes brought him considerable praise and many sales.

In 1909 Gagnon returned to Canada, settling with his new wife in picturesque Charlevoix County on the north shore of the St. Lawrence River, east of Quebec City. It was a place that exerted an irresistible force over him during the next several decades, despite lengthy stays abroad. Gagnon dedicated himself to capturing its special untouched quality, and he particularly loved painting its many remote towns buried under the heavy snows of a Canadian winter. Contemporary photos show the artist on his skis, forever in search of the ideal subject. In many paintings, gaily coloured houses contrast sharply with the dazzling white hillsides behind. In others, such as *Twilight, Baie St. Paul* (c.1920), the distant village has been enveloped in a delicate bluish haze and all is serene and still. Nothing ever disturbs this earthly paradise.

The artist's years in Baie St. Paul from 1919 to 1924 unquestionably represent the high point of his career. His output was prodigious, his touch assured. Never before had the Lower St. Lawrence found such a master of description (although A.Y. Jackson was to arrive on the first of many visits to the region in 1923). During the twenties and thirties Gagnon exhibited extensively, both in Canada and abroad. In 1924 he participated in an important Canadian exhibition in Wembley, England, alongside the Group of Seven, and three years later he personally organized a major display of Canadian art at Paris's prestigious Jeu de Paume. It is, however, the seven hard years he devoted to *Maria Chapdelaine* that have secured Gagnon his place in the annals of Canadian art.

PREPARING THE SOIL 1928–33
Mixed media
20.7 × 20.3 cm
Gift of Col. R.S. McLaughlin
1969.4.42

OCTOBER 1928–33
Mixed media
17.7 × 20.0 cm
Gift of Col. R.S. McLaughlin
1969.4.29

THE BETROTHAL 1928–33 ▶
Mixed media
21.0 × 22.0 cm
Gift of Col. R.S. McLaughlin
1969.4.54

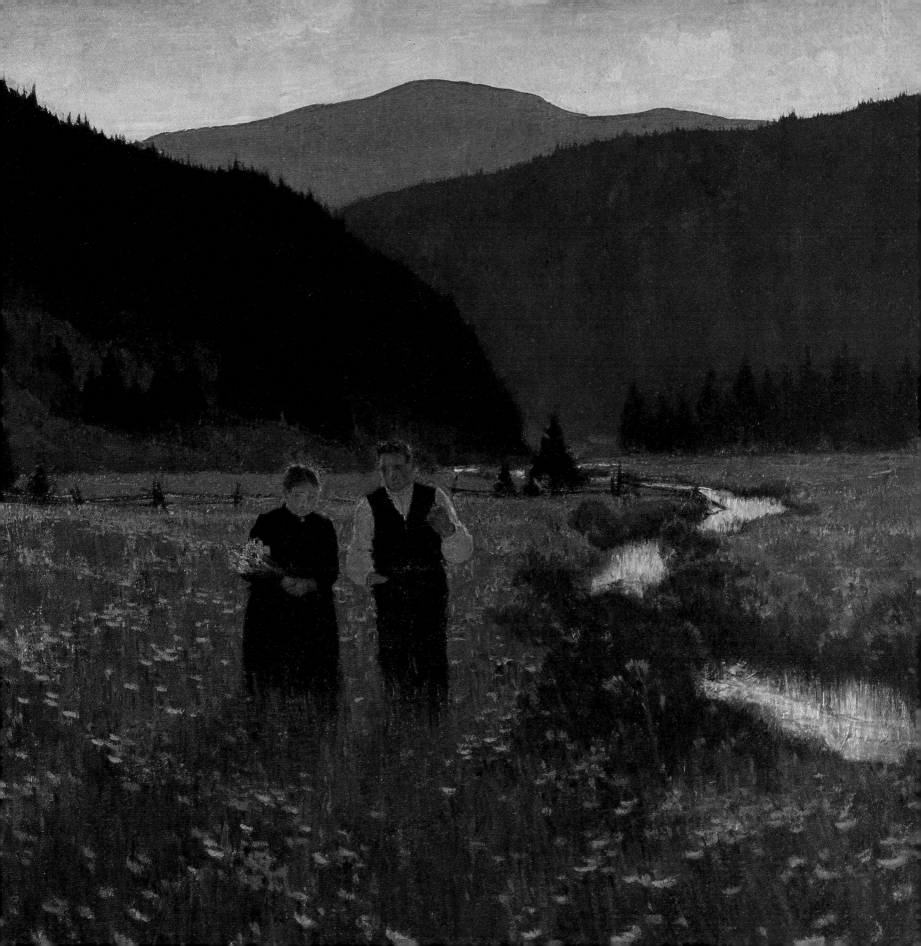

FRANÇOIS PARADIS CAMPING IN THE SNOW 1928–33
Mixed media
17.8 × 21.6 cm
Gift of Col. R.S. McLaughlin
1969.4.12

KILLING THE PIG 1928–33
Mixed media
19.0 × 19.3 cm
Gift of Col. R.S. McLaughlin
1969.4.30

THE GREAT DIVIDE 1928–33
Mixed media
20.5 × 21.0 cm
Gift of Col. R.S. McLaughlin
1969.4.20

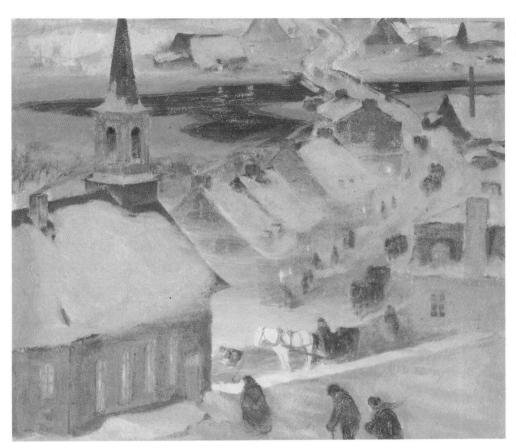

CHRISTMAS MASS 1928–33
Egg tempera on paper
17.9 × 21.5 cm
Gift of Col. R.S. McLaughlin
1969.4.34

LAST RITES 1928–33
Mixed media
19.5 × 20.3 cm
Gift of Col. R.S. McLaughlin
1969.4.49

CLARENCE GAGNON

SHORELINE 1936
Oil on canvas
68.0 × 111.5 cm
Gift of Mrs. H.P. de Pencier
1966.2.1

CHAPTER THREE

EMILY CARR
1871–1945

Ruggedly individualistic, resourceful, adventure-some, indomitable: these character traits convey at least part of the complex personality of Canada's most remarkable West Coast painter, Emily Carr. Despite her genteel upbringing in late nineteenth-century Victoria, British Columbia, Carr was an eccentric. She smoked—a scandalously unladylike thing to do in those days. She owned and single-handedly operated a small rooming house. She tended a menagerie of birds, dogs, and cats, as well as a monkey named Woo and her favourite, the white rat Susie. She suspended chairs from the ceiling of her studio, lowering them by ropes only if a visitor's presence made them necessary, and in town she used a baby carriage to haul everything from firewood to groceries. She stayed alone for months in the forest, living in a tiny trailer heated by a woodstove she concocted out of automobile scraps and bits of tin and wire. She didn't care the slightest about grooming or fine clothes or her ever-increasing girth, but she did feel uneasy in public and could be cantankerous. She travelled to remote regions of British Columbia, contending with rough seas and interminable rains in her search for the rich culture of the Northwest Coast Indians. And she sought tirelessly to establish her right to be an artist—especially a female artist—in the isolated and conservative world of Victoria. Nothing could weaken her resolve to comprehend fully the powers of the natural world and her God and to find expression for them in paint.

Shoreline (1936) epitomizes Carr's triumph over both personal and artistic obstacles—a triumph achieved especially late in life, during the late 1920s and 1930s. As in many works from her mature period, she has positioned herself alone on a narrow beach. Water, air, and land sweep around her in broad rhythms while an unearthly light pulsates overhead. The artist's presence is felt intensely throughout, yet her energy appears indistinguishable from the energy of nature itself. Every brush stroke expresses a joy in the harmony of all living things.

After the death of both parents when she was a teenager, Carr left Victoria in 1890 for art studies in San Francisco, returning after three years to teach art to children in a barn on the family prop-erty. Before further studies in London, England, she made the first of several trips into the British Columbia wilderness—to Ucluelet in 1898—driven by a curiosity about Northwest Coast Indians and their many villages, with their carved and painted houses and totem poles. Initially Carr concentrated on figure and portrait studies, but eventually she turned her attention almost exclusively to the mon-umental native carvings. Often, as in *Totem Pole* (1912), the paintings are brilliantly coloured and brushed—evidence of her stay in France in 1910 and her adoption of up-to-date European artistic modes. In 1913 she organized an exhibition in Vancouver of almost two hundred of her works devoted to Indian subjects. "I glory," she stated, "in our wonderful west and I hope to leave behind some of the relics of its first primitive greatness . . . Only a few more years and they will be gone forever into silent nothingness."

Despite some favourable response, the exhibition did little to satisfy either Carr's search for recogni-tion or her financial needs. The family home in Victoria had been sold, and with her share of the proceeds she had built a small rooming house. It drained her energies, and the next fifteen years proved unfruitful. She painted little and struggled just to survive. But in 1927 an event dramatically altered her life. Carr was invited to participate in an exhibition of Northwest Coast Indian art at the National Gallery in Ottawa, and she received a free pass to make the train trip east. Her meeting in Toronto with members of the Group of Seven, particularly Lawren Harris, rekindled her urge to paint. She was thrilled by their support and encour-agement (Harris had said, "You are one of us") and by their similar struggles to comprehend the immense forces of nature and the spiritual world. She returned to Victoria invigorated.

Carr painted and wrote passionately over the next decade and a half until her death. Her images of the dense, moody rain forests of the West Coast, like *Edge of the Forest* (c.1935), quiver with an unher-alded expressive force, sometimes menacing, sometimes exhilarating. She had at last discovered her true creative self when she was nearly sixty.

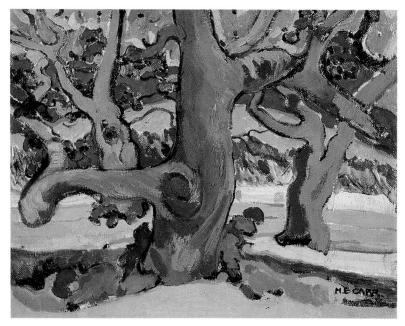

KEW GARDENS c.1911
Oil on canvas
35.3 × 45.5 cm
Gift of Dr. Max Stern
1980.18.6

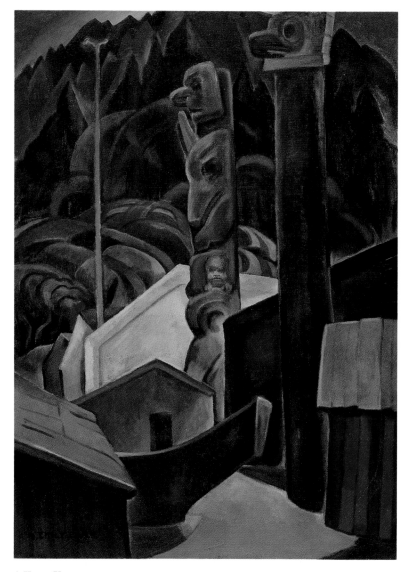

A HAIDA VILLAGE c.1929
Oil on canvas
82.7 × 60.7 cm
Gift of Dr. and Mrs. Max Stern,
 Dominion Gallery, Montreal
1974.18.1

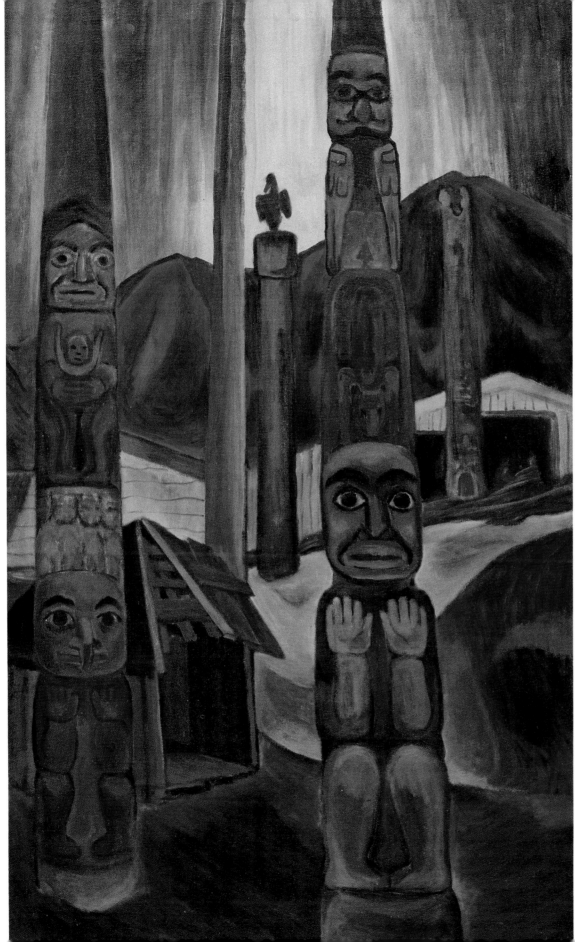

CORNER OF KITWANCOOL VILLAGE c.1930
Oil on canvas
111.5 × 68.0 cm
Gift of Dr. and Mrs. Max Stern,
 Dominion Gallery, Montreal
1977.42

EMILY CARR

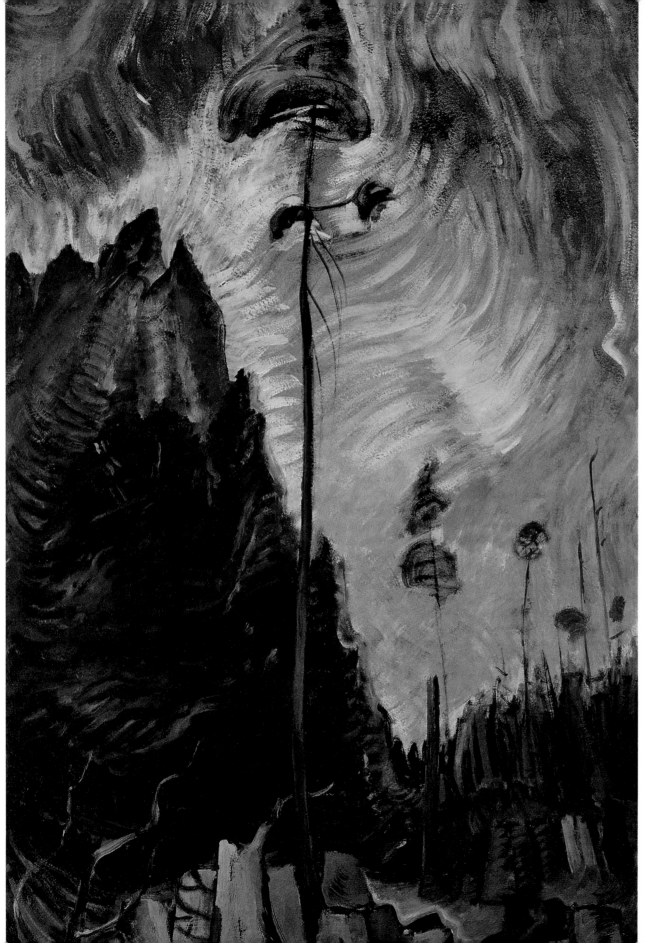

EDGE OF THE FOREST c.1935
Oil on paper
86.7 × 58.4 cm
Gift of Dr. and Mrs. J. Murray Speirs
1969.20

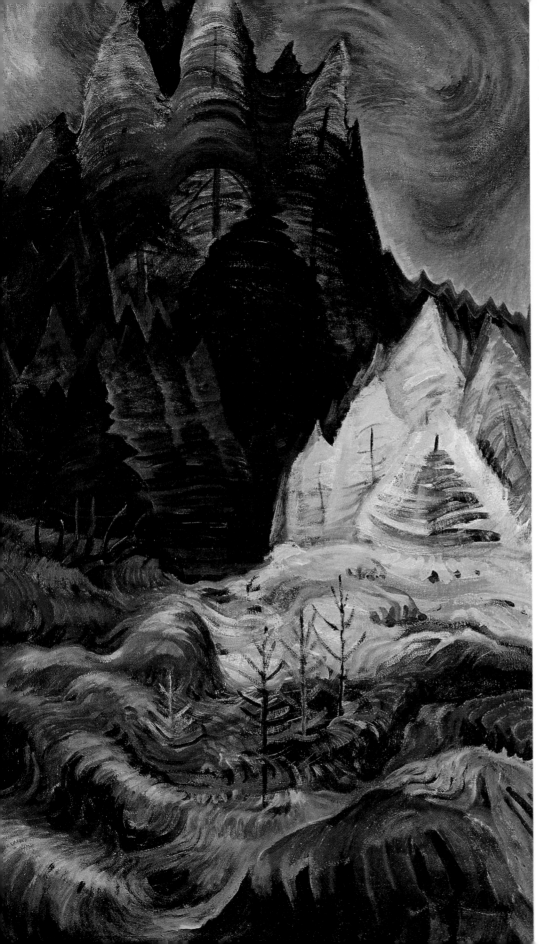

REFORESTATION 1936
Oil on canvas
110.0 × 67.2 cm
Anonymous Donor
1966.16.17

EMILY CARR

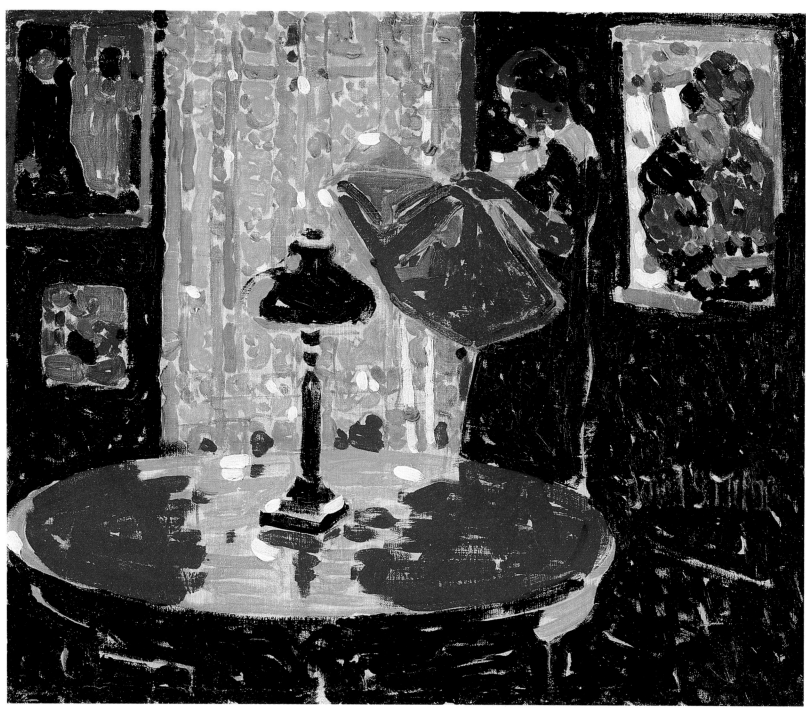

BLACK 1914
Oil on canvas
51.9 × 62.1 cm
Anonymous Donor
1966.16.23

DAVID MILNE
1882–1953

David Milne is a Canadian artist whose reputation is still in the making, and unjustly so. Despite absorption of avant-garde tendencies in New York, despite his inclusion in one of this century's most famous experimental exhibitions, and despite a prolific output in a wide variety of media—not to mention the sheer beauty and originality of his images—Milne remains a less than fully appreciated figure in Canadian art.

Milne was an exact contemporary of the Group of Seven. While they were at home in Canada painting their wilderness images, Milne was living and working in the United States for twenty-four years. While he had only one voice they had seven, which effectively drowned out opposition and did much to promote their nationalist landscape movement, despite other equally valid currents in Canadian art. Even their paintings—big, strongly coloured, full of monumental motifs—spoke louder than Milne's more modestly proportioned and less aggressive imagery. Yet, like Group members, he immersed himself in nature, for many years (unlike them) actually living in Ontario's wilderness. Milne didn't advertise himself as a rugged outdoorsman: he just quietly painted some of the most poetic images of our northland ever.

In 1904 Milne moved to New York City. It was a bold step for a young country teacher from the small town of Paisley, Ontario. For several years he studied art part-time, supporting himself with commercial jobs on the side. He began to exhibit his watercolours and in 1913 was invited to contribute works to a now-famous avant-garde exhibition known as the Armory Show. He was working then in the forceful flat patterns of the Post-Impressionists. His oil painting *Black* (1914), an interior with a woman reading by a table, indicates an assurance typical of works from these years. Yet he had little real success in New York and by 1915 had moved to the town of Boston Corners in rural New York State. After an interlude in Europe as an official war artist documenting the Canadian effort in World War I, he returned to Boston Corners, settling there until he moved back to Canada in 1928.

Milne's many works from the New York State years reveal his mature style. *The Gully* (1920) demonstrates his unusual, unique combination of almost contradictory stylistic approaches. A powerful compositional design using bold tree patterns injects a special dynamic strength into the painting; it is intentionally offset, however, by the almost transparent brush strokes, the preponderance of white, and the unobtrusive colours. The resulting image is refined, almost Oriental, in its delicacy and elegance. Forms that are massive and three-dimensional in the real world are rendered paper-thin and weightless by Milne's brush. Even when the motifs are substantially heavier, such as in *Painting Place: Brown and Black* (c.1926), a whitish tone peeking through from the back lends the landscape an unreal quality. Clearly his pictures, despite their recognizable motifs, depict an imaginary realm of the mind.

Back in Canada, Milne headed first to Ottawa and then in the spring of 1929 to the Temagami wilderness region. In early 1930 he moved to Palgrave, a short distance from Toronto, where he lived for three years. At the urging of the National Gallery he entered into an agreement whereby large numbers of his paintings were purchased by the wealthy Vincent Massey, a diplomat and heir of the famous Massey-Harris Company, and his wife, who then placed them on consignment in a Toronto commercial gallery. For five years the arrangement gave Milne some financial security in a career dogged by poverty. In the spring of 1933 he moved to Six Mile Lake, north of Orillia, where he built himself a small cabin. Over the next seven years, living alone in the bush, he created some of his finest works, not just of the forests and lakes around him—most memorably under deep snow—but of intimate still lifes like *The Waterlily* (1935).

In 1940 Milne settled in the village of Uxbridge, closer to Toronto, although he continued to paint in the north until his death. Little changed; he received limited critical attention and simply carried on painting. But an indestructible will lay beneath his mild exterior—nothing could stand in the way of his quest to perfect his mode of expression. His commitment is slowly gaining for David Milne the place that rightfully belongs to him among the true masters of Canadian art.

LILIES c.1914
Oil on canvas
51.0 × 51.0 cm
Anonymous Donor
1966.16.18

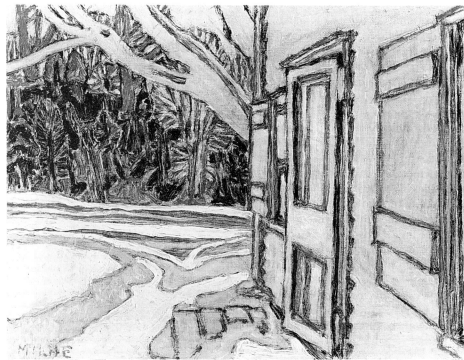

SIDE DOOR, CLARKE'S HOUSE c.1923
Oil on canvas
30.5 × 40.7 cm
Anonymous Donor
1976.25.2

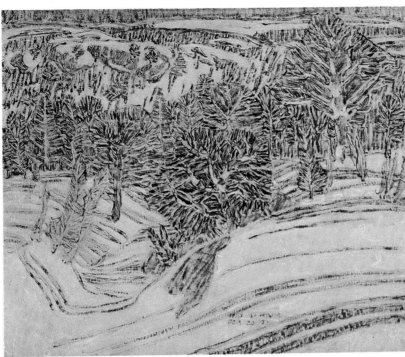

THE GULLY 1920
Oil on canvas
50.7 × 61.0 cm
Anonymous Donor
1966.16.21

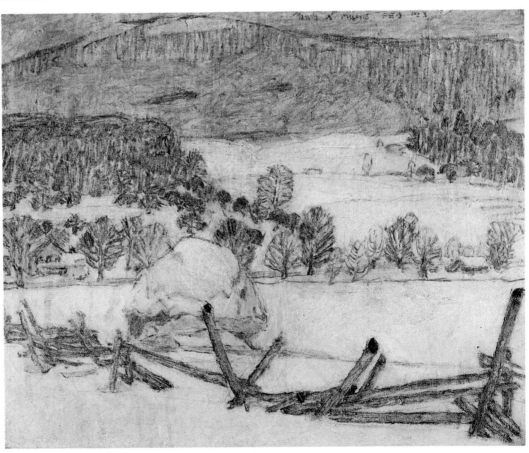

HAYSTACK 1923
Oil on canvas
30.5 × 40.7 cm
Anonymous Donor
1966.16.26

DAVID MILNE

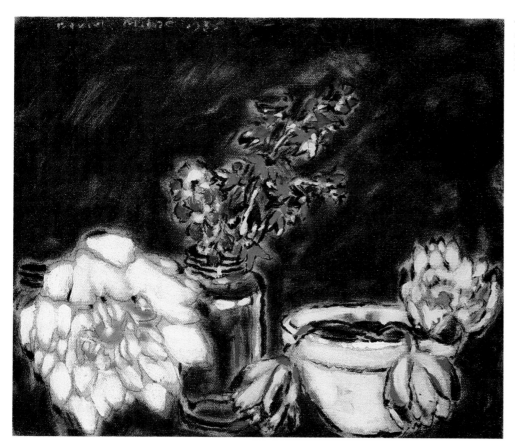

THE WATERLILY 1935
Oil on canvas
45.0 × 55.0 cm
Purchase 1983
1983.7

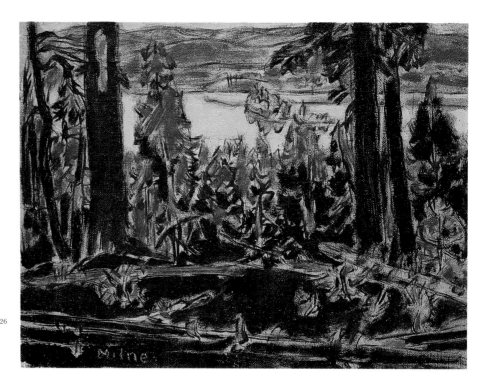

PAINTING PLACE: BROWN AND BLACK c.1926
Oil on canvas
30.7 × 41.0 cm
Gift from the Douglas M. Duncan Collection
1981.41.1

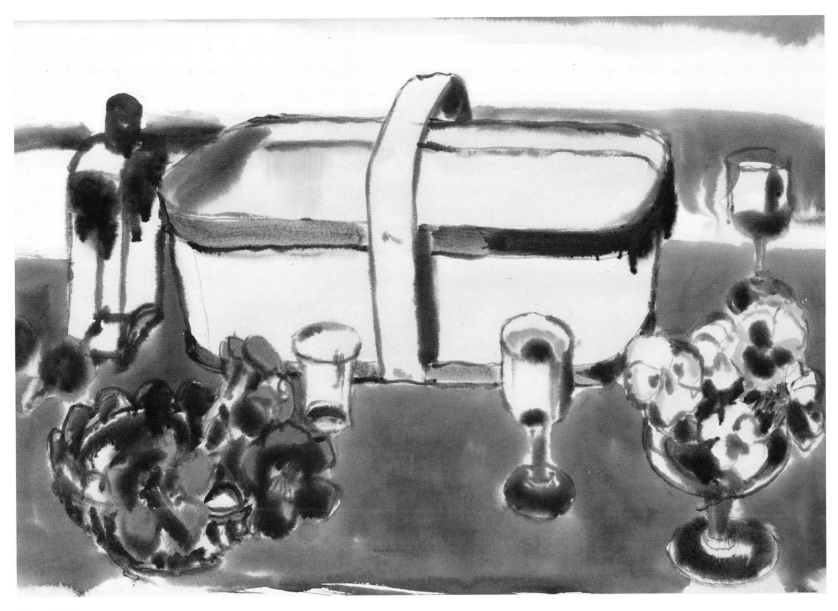

PANSIES NO. 1 1941
Watercolour on paper
38.1 × 55.3 cm
Gift of Mr. R.A. Laidlaw
1969.2.1

DAVID MILNE

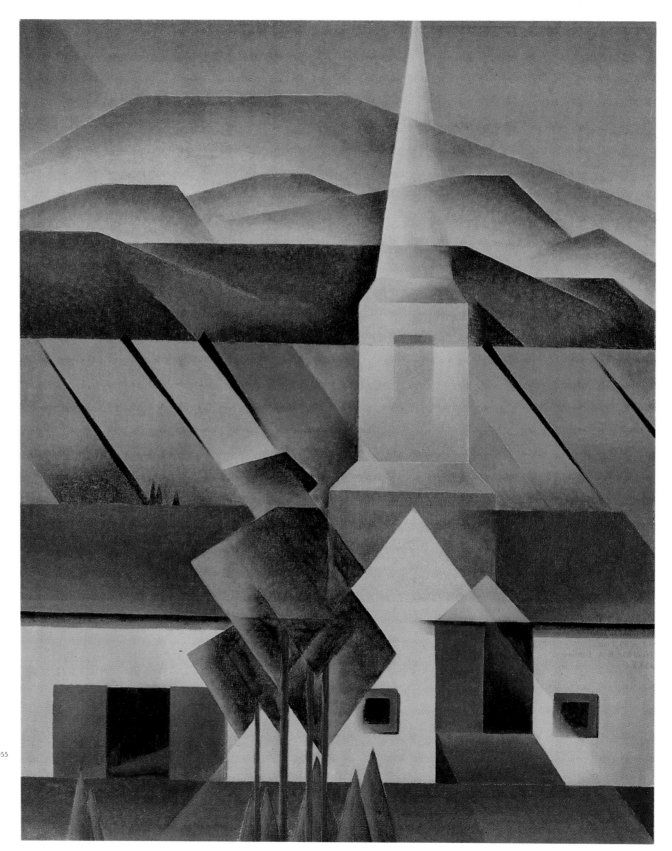

Bertram Brooker 1888–1955

QUEBEC IMPRESSION c.1942
Oil on canvas
96.5 × 76.2 cm
Purchase 1985
1985.55

CHAPTER FIVE

THE CANADIAN GROUP OF PAINTERS

"The experimentation is over." So wrote a young artist reviewing the 1930 exhibition of the Group of Seven. The statement was not completely correct, nor was it totally unfounded. For almost twenty years the Group had produced dramatic interpretations of the Canadian wilderness, landscapes of a sort never before seen in this country. Their images of rock and water and pine were raw and forceful—to many even startling. Experimental they certainly were. By 1930, however, there was little doubt that a formula had been established and an unofficial landscape style entrenched. What in 1914 had been a bold new direction was by then a stranglehold on development. Surely there was more to art in this country than the Canadian Shield!

The urge to broaden the mandate of the Group came, perhaps surprisingly, from within. A.Y. Jackson and Lawren Harris were committed to the concept of an expanded membership. "We feel," Harris wrote, "it is essential to form a society of the so-called modern painters in the country, secure a charter and make ourselves felt as a country-wide influence in terms of the creative spirit. We propose to call the society 'The Canadian Group of Painters'." By early 1933 the group had been formed and so-named, with twenty-eight founding members and many nonmember contributors. Although the bulk of members were from Vancouver, Toronto, and Montreal, the CGP was unquestionably national in scope, and in its first exhibitions it was clear that the hegemony of landscape was at an end. As one critic wrote, "Not only are we moving toward human life, away from landscape . . . but in growing up we are beginning to show the effects of the profound disturbances in human affairs which have shaken the world."

Many of the younger generation of painters looked to the Group of Seven for inspiration and guidance. Toronto-born Yvonne McKague Housser, for example, one of several women in the CGP, felt a special affinity for the work of Harris, clearly evident in the sharp contours and fully modelled forms of her work; yet her images, whether portraits or scenes of lonely mining towns in northern Ontario, clearly indicate an original talent. Carl Schaefer, despite working in a decidedly Group of Seven manner into the late 1920s, found his own unique voice when, because of the Depression, he was forced to abandon Toronto in the thirties during summer and winter holidays for his home town of Hanover in rural Ontario. In sympathy with the times, his farm scenes are dark and gloomy—fences are broken, trees often leafless—and drenched in a mood of impending disaster. No more eloquent testimony to the economic and social hardships of the times was produced in Canada.

In Montreal the impact of the Group of Seven was also felt during this period. Edwin Holgate had become a later member of the Group, joining in 1930. But the overwhelming predilection of the Montreal artists, including Holgate, was for portraiture and the figure. Randolph Hewton painted landscapes in the fluid manner of the Group, yet developed a reputation as a gifted portraitist. Similarly, Prudence Heward and several other Montreal women, including Lilias Torrance Newton, developed bold portrait styles.

In Winnipeg, Lionel LeMoine FitzGerald continued to express his fascination with fully modelled, painstakingly realized still lifes and nudes, while farther west J.W.G. (Jock) Macdonald embarked on a series of colour-filled experimental abstract pictures. As was the case with so many of his contemporaries, however, Macdonald was often forced to sacrifice his painting to the necessity of making a living and raising a family. The troubled thirties were clearly no time to be an artist: few paintings sold. In such a social climate, the CGP was all the more significant. Whether artists were painting still lifes or nudes or images of social unrest, or even landscapes in a traditional mode, until it disbanded in 1969 the Canadian Group of Painters provided invaluable opportunities to exhibit and to participate in a renewal of the visual arts.

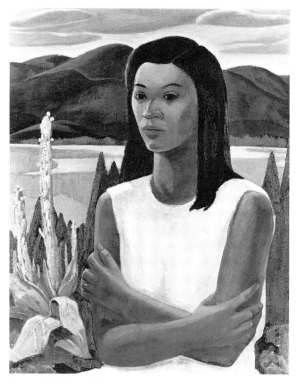

Yvonne McKague Housser 1898–

**MARGUERITE PILOT OF DEEP RIVER
(GIRL WITH MULLEINS)** C.1932
Oil on canvas
76.2 × 61.0 cm
Gift of the Artist
1966.16.13

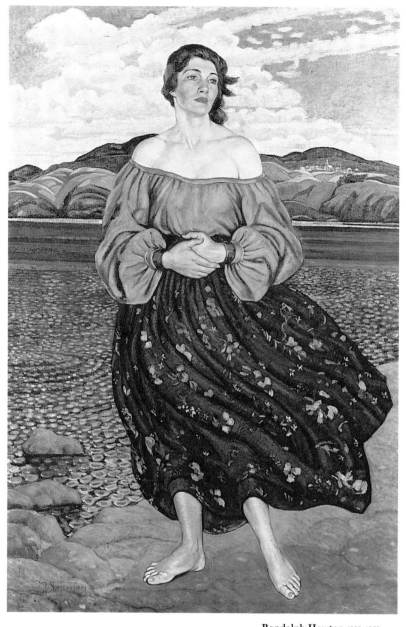

Randolph Hewton 1888–1960

BENEDICTA C.1935
Oil on canvas
183.0 × 121.0 cm
Gift of Mr. and Mrs. H.J. Campbell
1969.25.6

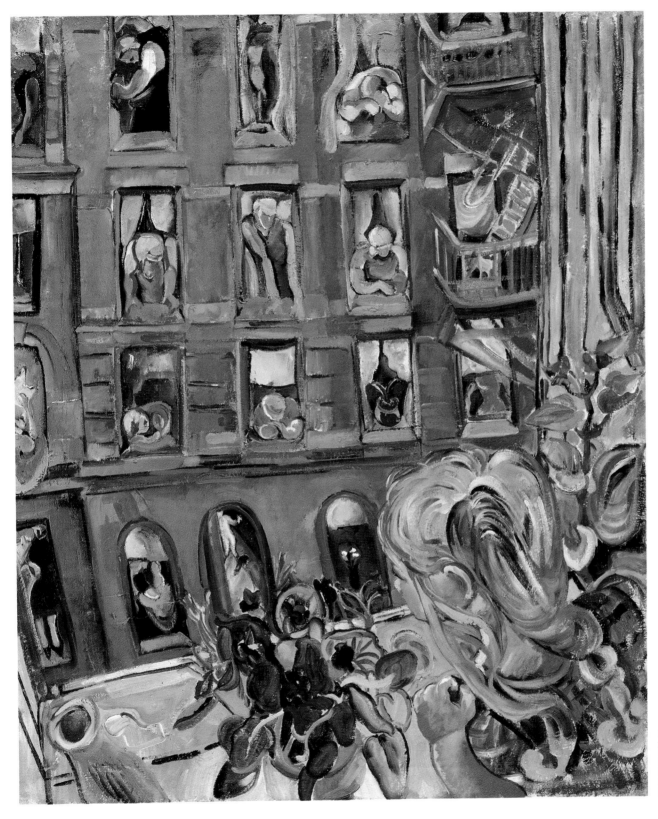

Pegi Nicol MacLeod 1904–49

Young Girl at the Window n.d.
Oil on canvas
80.7 × 68.5 cm
Purchase 1985
1985.40

THE CANADIAN GROUP OF PAINTERS

J.W.G. (Jock) Macdonald 1897–1960

BRILLIANT SKY 1937
Oil on board
30.3 × 37.8 cm
Purchase 1985
1985.28

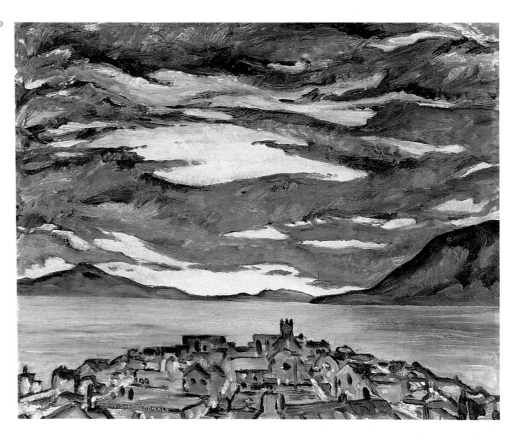

Anne Savage 1896–1971

WILD APPLES, LAURENTIANS, P.Q. n.d.
Oil on plywood
50.8 × 61.0 cm
Gift of the Artist
1981.71

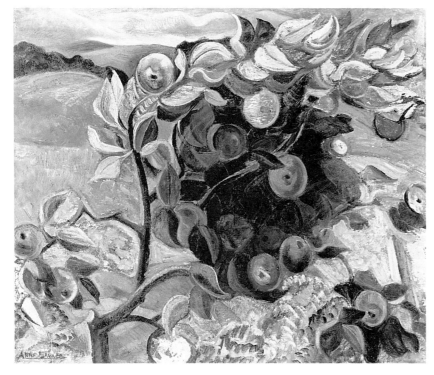

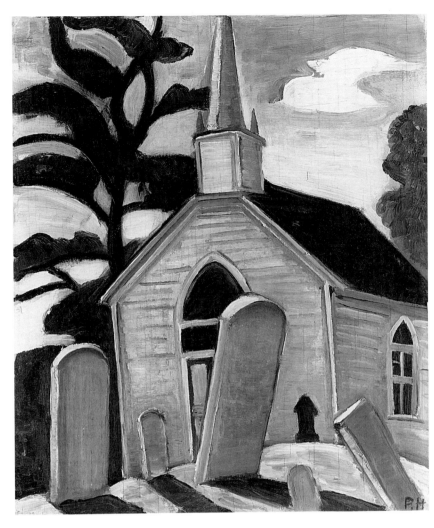

Prudence Heward 1896–1947

THE BLUE CHURCH 1933
Oil on panel
35.2 × 30.4 cm
Gift of Dr. Naomi Jackson Groves
1984.18.3

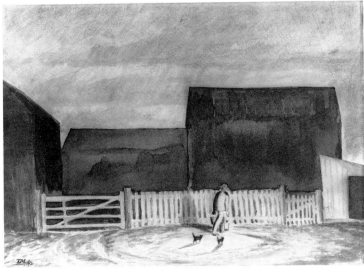

Thoreau MacDonald 1901–1989

WINTER MORNING'S CHORES c.1942
Watercolour, ink, graphite, coloured pencil on paper
24.6 × 35.0 cm
Gift of Mr. Jeremy Pierpoint in memory of Sidney Pierpoint
1987.32.12

PART III
THE ART OF
THE INUIT

JEAN BLODGETT

ROBERT AND SIGNE MCMICHAEL ACQUIRED THEIR FIRST piece of Inuit sculpture in 1956, and the collection has grown since then to include approximately a thousand works. The majority of the collection is contemporary, drawn from a period in Inuit art history that began in the late 1940s.

The Contemporary period of Inuit art is a recent manifestation of a tradition that dates back some three thousand years and encompasses several Arctic cultures. Artifacts from the earliest Paleoeskimo culture, the Pre-Dorset (2000–500 BC), demonstrate a sensitivity to visual form that reached its peak in the succeeding Dorset culture (500 BC–AD 1000). In addition to decorated utilitarian objects, the Dorset culture produced exquisite carvings of animal and human subjects, carvings particularly notable for their realistic detailing on a miniature scale.

The Thule culture (AD 1000–1600), which moved into Canada from Alaska and displaced the resident Dorset culture, had a distinctive art form of its own. In contrast to the Dorset emphasis on naturalistic three-dimensional form, the Thule Inuit tended to focus more attention on linear surface decoration. After 1600, changing climatic conditions adversely affected the whale populations that the Thule Inuit depended on for their livelihood, and the culture underwent considerable adaptation. These changes and the arrival of non-Inuit in the Arctic at about the same time heralded the transition into the Historic period (1600–1948).

During the Historic period the focus of artistic activity for the Inuit shifted from products for themselves to those for their visitors. Certainly they continued to make objects for their own use, but the growing number of outsiders coming to the Arctic created an increasing market for trade and gift items. The visitors had desirable objects such as guns, while the Inuit had or could make souvenirs that were equally desirable to the visitors. In making these objects, the Inuit adapted their traditional skills to a new purpose, producing work that expanded their range of style, quality, subject matter, format, and materials. For example, the earliest extant drawings by Inuit date to the middle of the nineteenth century, when visiting explorers provided paper and pencil. Yet for all this change, the objects the Inuit made remained firmly rooted in their own tradition and personal experience—a testament to their enduring heritage and adaptability.

Until 1948 the artistic endeavours of the Inuit received little attention and were virtually unobtainable outside the Arctic. But a trip to Arctic Quebec in the late 1940s by artist and writer James Houston changed all that. Houston was impressed with the carvings he saw, and he worked hard to win public recognition for Inuit art—recognition that came quickly and soon expanded far beyond Canada. As a result the Contemporary period is dated from his first trip north in 1948.

The Contemporary period has been an era of widespread popularity, increasing demand, and extensive development and experimentation for Inuit art. As in the Historic period, the Inuit have responded with their traditional ingenuity. They continue to make such things as sculpture, but they have also adapted and expanded their skills to work in larger sizes and in a wider range of formats, techniques, and media.

The McMichael Canadian Art Collection includes examples of contemporary Inuit sculpture, printmaking, drawing, collage, tapestry weaving, and wall-hanging sewing. Though a number of these works were purchased, much of the collection has been donated; as a result, it reflects the particular interests or strengths of the individual collectors. Noteworthy areas of strength within the McMichael Inuit collection are Baker Lake drawings, early Cape Dorset drawings, and late sculptures by the Cape Dorset artist Sheokjuk Oqutaq.

Contemporary Inuit sculptures in the collection range in date from about 1950 to the late 1980s. The 1950 sculpture *Mother and Child* by an unknown artist is typical of some of the best of classic 1950s Inukjuak (Port Harrison) carving. Made of local deep green translucent stone, the mother and her perky little child are embellished with incised markings and inset ivory detailing. David Ruben Piqtoukun, a younger and much later artist, uses auxiliary materials to complement his striking sculpture, *Shaman Transformation*. The variety of materials, the large size, and the two-sided format all help to convey the spiritual significance of the subject in this powerful sculpture.

Other noteworthy sculptures in the collection include the *Bust of a Woman* by John Tiktak of Rankin Inlet, a work unusually large and representational for this artist. The two sculptures by Joe Talirunili, *Artist as a Young Man* and *Artist as an Old Man*, are typically animated personal expressions by this Povungnituk artist. From the same community is the sculpture *Mother Nursing Child* by Peter Ussuqi Anauta, in which the artist's depiction of an everyday subject is conveyed in elegant forms.

Cape Dorset sculpture in the McMichael collection is represented by some particularly fine and remarkable works. Visitors to the gallery are greeted by the large stone *Bear* near the front entrance. Made by Pauta when he came to Toronto to participate in a sculpture festival during Canada's Centennial in 1967, this massive carving was subsequently moved to the McMichael from its downtown location.

The popular sculpture *Smiling Family*, made of local bright green stone by Kiawak Ashoona of Cape Dorset, was recently joined by another more unusual carving by this artist—the masklike *Child's Face* carved of whalebone — reminiscent of Inuit doll heads and Dorset culture maskettes.

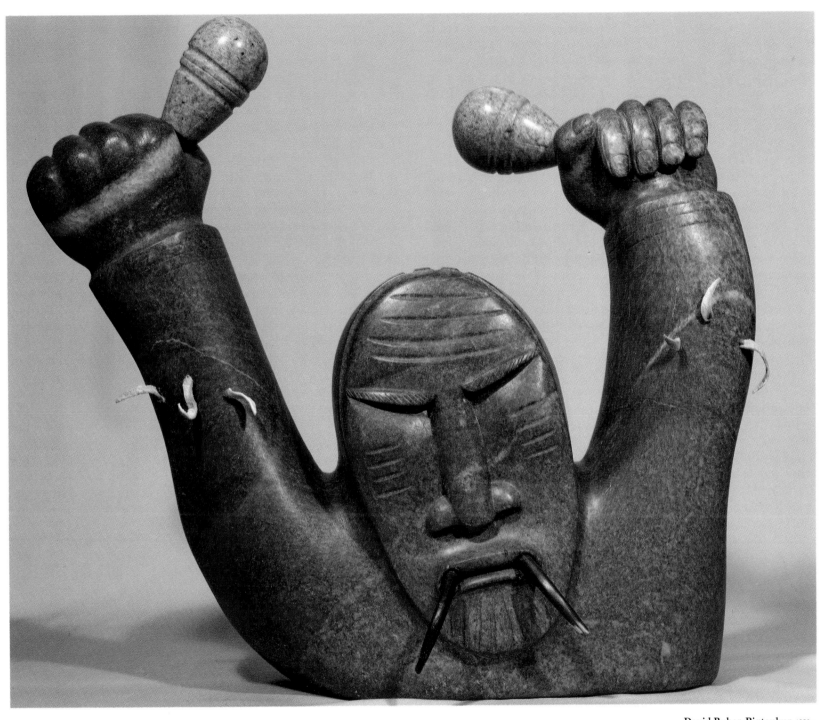

David Ruben Piqtoukun 1950-

SHAMAN TRANSFORMATION 1984
Brazilian soapstone, bear claws, and hide
50.5 × 56.0 × 23.0 cm
Purchase 1984
1984.34

Page 151: Inuit bone carver,
Repulse Bay, N.W.T., 1968.

THE ART OF THE INUIT

Whalebone, because of its large size and textural qualities, is a popular medium for some artists. It is not commonly carved by Cape Dorset sculptors, but Lukta Qiatsuk, better known for his printmaking, has used it to make the striking portrayal of a bird spirit (*Owl Spirit*). This sculpture was part of a donation generously made to the McMichael in 1988 by the West Baffin Eskimo Co-operative of Cape Dorset; the rest of the gift included thirty-seven sculptures by the late artist Sheokjuk Oqutaq. Sheokjuk's work, especially his distinctive loons, became very popular during the latter part of his career, and the McMichael is extremely fortunate to have this large collection of his later work. The sculptures, primarily of animals, well illustrate Sheokjuk's artistic talents. Although his work is limited to a small number of subjects, his treatment is varied and inventive, as if he were spurred on to try different approaches and new configurations for old subjects. And his treatment of the stone medium is impressive even for Cape Dorset, a community of consummate carvers. Sheokjuk shaped his original stone material to an unusually thin, even brittle, exaggerated dimension, then gave it a high polish, and finished it with incised realistic details.

In Cape Dorset in the 1950s, discussion of the printmaking process and experimentation with this technique, which was new to the Inuit, led to the establishment of the first printshop in the Canadian Arctic. In making their stonecut and stencil prints, the printmakers created a demand for original images that was met increasingly by Cape Dorset people, who began making drawings with the paper and pencil only recently provided to them. Graphics soon became another major art form in this community already well known for its sculpture. The McMichael collection of material from Cape Dorset includes prints dating from 1958 to 1988; a rare proof print of the famous *Large Bear* by Lucy; several experimental sealskin stencils; and a number of early drawings by such artists as Kenojuak, Pitaloosie, Eleeshushe, Kingmeata, and Parr, who is represented by some forty works done in 1961.

Other Inuit communities—such as Povungnituk, Holman, Baker Lake, and Pangnirtung—that have established printshops over the years are also represented in the McMichael collection. Of special interest are two charming drawings by Josie Papialuk of Povungnituk and a group of more than four hundred drawings from the mid-1970s from Baker Lake. Most of the drawings were done by four major artists—Harold Qarliksaq, Luke Anguhadluq, Simon Tookoome, and Victoria Mamnguqsualuk—but there are also works by other important Baker Lake artists, such as Jessie Oonark.

Oonark is represented in the McMichael by a number of prints, a wall hanging from the early 1970s, and several rare and unusual works. One is an untitled collage from the mid-1960s, when Oonark experimented with cutting up coloured paper and mounting it on backing paper with rubber cement, then adding graphic details with black ink. Oonark apparently found the technique too restrictive, and very few of these collages were made. Also in the McMichael collection is the only extant set of components for an Oonark print: the original drawing made by Oonark, the actual stonecut used in the printmaking process, and the final print, *Day Spirit*.

In the late 1940s Inuit art was little known outside the Canadian Arctic. Since then it has played an increasingly significant role in this country's culture and gained world-wide recognition. The contribution of Inuit—and Indian—artists to Canadian art history is recognized and demonstrated by ongoing collecting and display of these two art forms at the McMichael Canadian Art Collection.

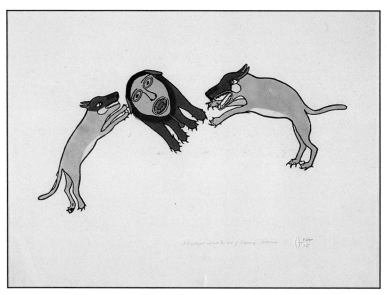

Janet Kigusiuq 1926–
Printed by Simon Tookoome 1934–
A Frightened Spirit 1973
Stonecut and stencil
52.5 × 68.0 cm
Gift of Judge and Mrs. Darrell Draper
1989.11.23

Artist Unknown

MOTHER AND CHILD C. 1950
Dark green stone, ivory, blacking and whitening
28.7 × 16.9 × 10.5 cm
Purchase 1983
1983.14.4

Peter Ussuqi Anauta 1934–

MOTHER NURSING CHILD C. 1968
Grey stone
56.5 × 45.0 × 42.7 cm
Purchase 1968
1981.98.4

Kiawak Ashoona 1933–

SMILING FAMILY 1966
Green stone
32.5 × 48.5 × 17.5 cm
Anonymous Donor
1975.69.2

THE ART OF THE INUIT

Kakulu Sagiatuk 1940–

SPIRIT late 1960s
Felt-tip pen
50.5 × 66.2 cm
Gift of Norman E. Hallendy
1989.7.27

Josie Papialuk 1918–

BIRDS GOING SOUTH c.1983
Felt-tip pen
48.7 × 64.0 cm
Gift of Judith Morrow James
1989.6.3
The syllabic text on this drawing reads:
> *These birds are going south.*
> *They are running away from the cold.*
> *The birds are ducks.*

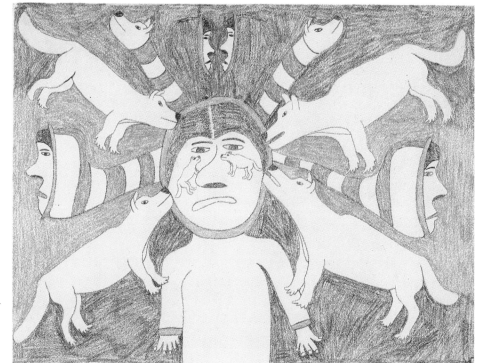

Simon Tookoome 1934–

SHAMAN n.d.
Coloured pencil
57.6 × 77.0 cm
Gift of Mr. Sam Sarick
1978.25.328

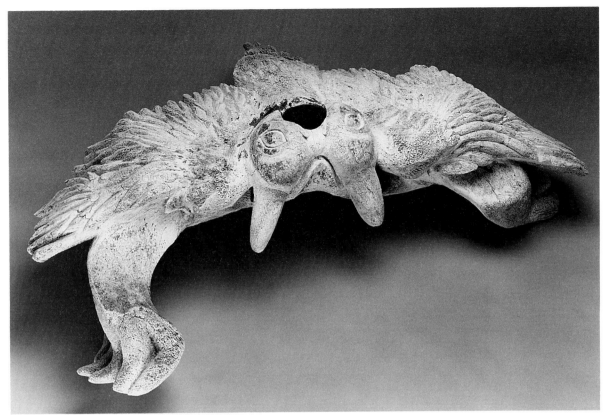

Lukta Qiatsuk 1928–

OWL SPIRIT 1987
Whalebone
46.0 × 156.8 × 103.5 cm
Donated by the West Baffin
Eskimo Co-operative Limited, Cape Dorset
1989.8

John Tiktak 1916–81

BUST OF A WOMAN 1966–67
Grey stone
54.0 × 20.0 × 20.0 cm
Gift of Norman E. Hallendy
1980.11

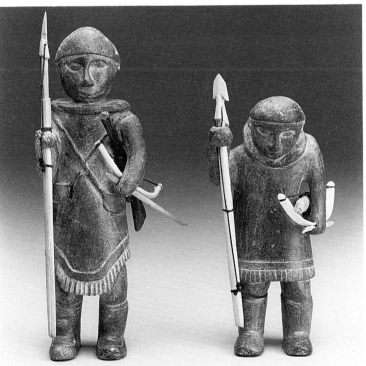

Joe Talirunili 1906–76

ARTIST AS A YOUNG MAN
Grey stone, wood, paper, and thread
23.9 × 5.6 × 4.5 cm
Purchase 1983
1983.14.1

Joe Talirunili 1906–76

ARTIST AS AN OLD MAN
Grey stone, wood, plastic, and thread
18.8 × 5.6 × 3.5 cm
Purchase 1983
1983.14.2

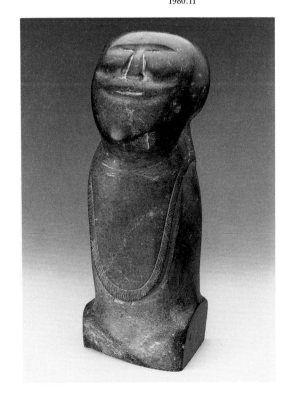

THE ART OF THE INUIT

Pitaloosie Saila 1942–

SEDNA SUCKLING early 1970s
Felt-tip pen
50.7 × 66.1 cm
Gift of Norman E. Hallendy
1989.7.35

Kingmeata Etidlooie 1915–

PRINTED BY PITSEOLAK NIVIAQSI 1947–
ONE KIND OF FISH 1988
Lithograph
58.2 × 82.5 cm
Purchased with funds donated by
 Ben Robinson in the name of Mia McDonald
1989.5.2

Jessie Oonark 1906–85 ▶

UNTITLED early 1970s
Wool, felt, embroidery floss, and thread
120.2 × 130.3 cm
Gift of Sam and Esther Sarick
1977.43

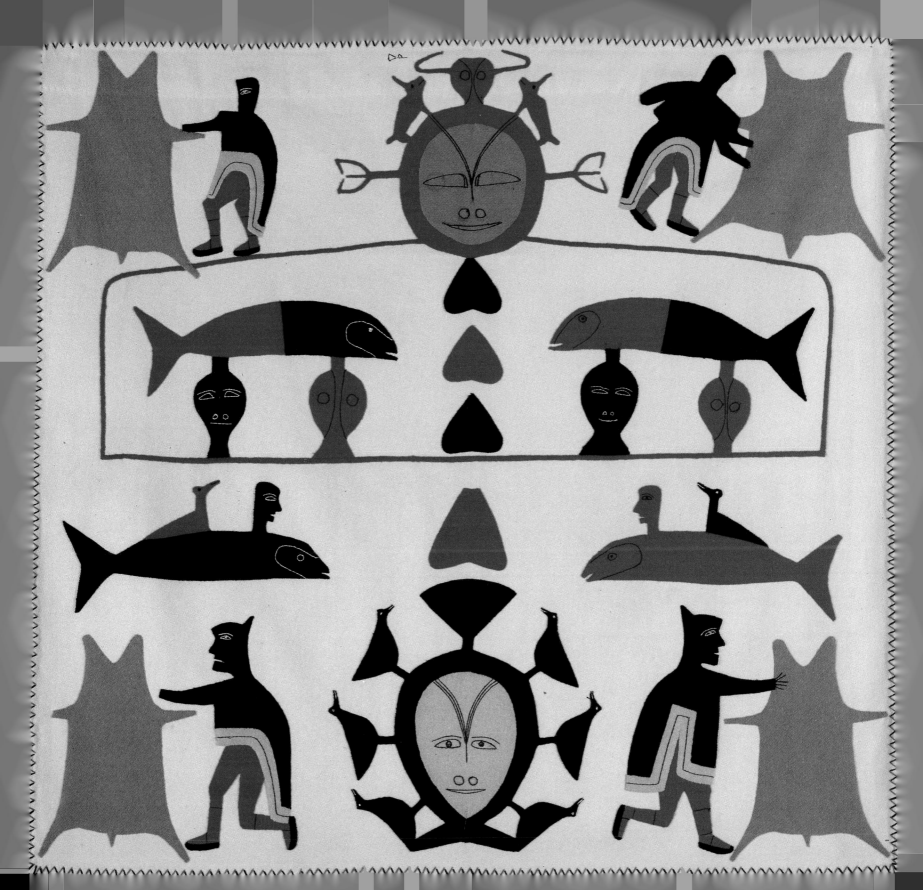

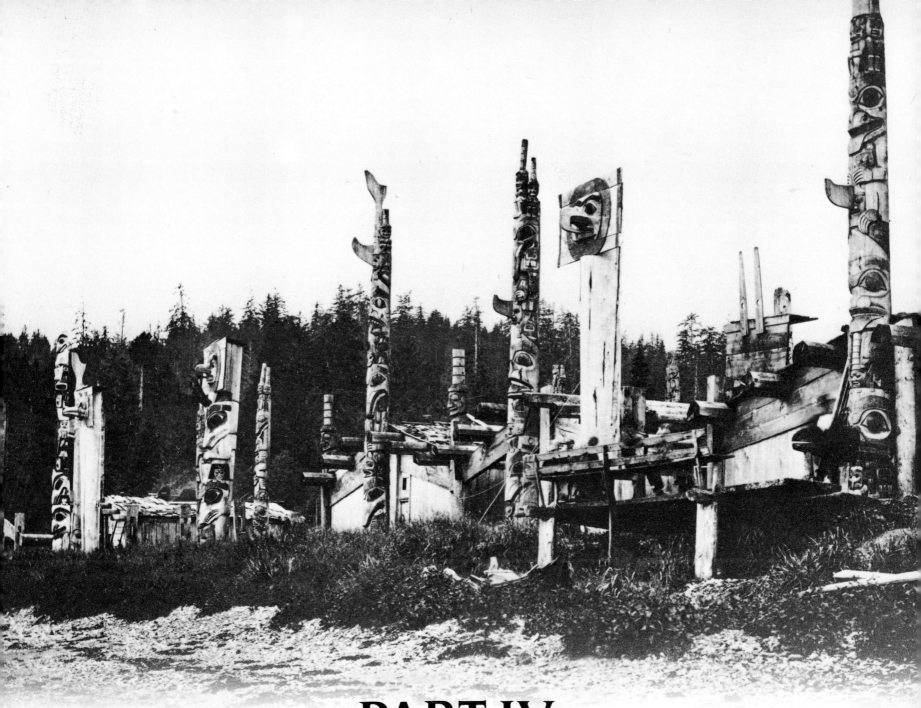

PART IV

CANADIAN
INDIAN ART

Lee-Ann Martin

Since the arrival of the first European peoples in this country, the arts of the Native peoples have been admired and collected. To the earliest collectors these objects were exotic curiosities, trade goods, and, later, tools with which to study the indigenous cultures. In the twentieth century, recognition of the artistic merits of these objects has heightened an interest in the Native arts and, more recently, in artists of Native ancestry. Early in its development the McMichael Canadian Art Collection recognized the esthetic expressions of the Native peoples of Canada, and their work today comprises one of the three major components of the collection.

Wooden masks and many other carved objects from nineteenth-century Northwest Coast Native cultures formed the beginning of the Indian art collection. Through a program of purchases and gifts, 115 objects from the Northwest Coast were collected by 1985. The Raven's Work Gallery, opened in 1986 and designed to resemble a coastal longhouse, contains a sampling of this collection. Skilled carvers from many different Native cultures created these objects during the nineteenth century primarily for use in social and religious ceremonies. The highest esthetic standards guided them, and religion and history provided the subject matter. Each artist worked within a tradition of long-established rules for composition and design. While certain formal and symbolic similarities exist throughout the region, individual and cultural styles abound.

Masked ceremonies and dances were an integral part of all Northwest Coast cultures. Masks, which vary in physical form, complexity, and artistic style from one area of the coast to another, are usually the means by which the supernatural world is made visible. In the south, the Kwakiutl perpetuated a complex system of secret societies, which were dramatized during the winter months. The c.1900 *Kwakiutl Mask* known as Crooked Beak of Heaven mask was used during the ceremonies of the Hamatsa or cannibal society, which was one of the most prestigious of the Kwakiutl secret societies. This large mask has a movable mouth to further dramatize the dancer's movements. The *Northern Wakashan Mask* known as Wildman mask is one of the finest grotesque humanoid forms in any Canadian collection. It is particularly notable for its dramatic refinements and its fine state of preservation, including much of the original paint.

The northern groups such as the Haida, Tsimshian, and Tlingit used masks most often at feast dances to portray animal, human, and spiritual beings, and an outstanding portrait-masking tradition developed there. The *Haida Portrait Mask* represents an outstanding achievement within this tradition. The *Tsimshian Mask* known as Niska Face mask exemplifies the superbly carved objects from the northern groups. The *Haida Raven Rattle* is typical of those used extensively by coastal peoples

to accompany dancing and singing. This one is exceptional for its artistic rendering and its high-quality Native-made paint. The ultimate expression of the wood-carver's art is found in the abundance of ceremonial objects, but utilitarian objects were also decorated. The *Haida Fish Killing Club* depicts a sea lion.

Since the early nineteenth century Haida carvers have produced miniature totem poles, figures, plates, and pipes from a lustrous black slate called argillite. Twenty-one argillite pieces are included in the McMichael Canadian Art Collection. Today, carvers and printmakers continue to explore the strong artistic traditions of the Northwest Coast. The collection also includes silver jewellery and prints that represent the evolution of this tradition.

The collection includes more than 250 paintings, prints, and sculptures by artists of Native ancestry. During the 1970s collecting activities focussed upon the paintings and prints made by artists working within the Woodland Indian Art style introduced by Norval Morrisseau. These Woodland paintings comprise 75 per cent of the contemporary Native collection, acquired both through purchase and gifts. In the early 1960s Norval Morrisseau, an Ojibway artist from northwestern Ontario, began to paint the legends of his culture. Inspired by the teachings of religious leaders and the imagery of ancient birchbark scrolls and rock paintings, Morrisseau created an iconography and form of his own. His works had wide appeal to the Canadian public and to a new generation of Indian artists. Daphne Odjig, an Odawa artist from Manitoulin Island, and Carl Ray, a Cree artist from Sandy Lake, Ontario, were contemporaries of Morrisseau's who adapted and personalized his pictographic style of painting. Odjig brought to the style a fluid line and rich texture. Ray adapted the style to an illustrative mode, depicting legends and events that represented the dichotomies of the Indian and non-Indian worldviews. The art and teachings of both Morrisseau and Ray strongly influenced a second generation of Woodland artists in northwestern Ontario and Manitoulin Island. The personal imagery and symbolism of both Blake Debassige's and Saul Williams's paintings often comment upon non-Indian values and society.

Iroquois sculptures of steatite were also collected by the McMichael during the 1970s. This brown stone provided a new medium for the artistic interpretation of the history and religion of the Iroquois people. The works of Joseph Jacobs and Duffy Wilson represent some of the finest achievements within this evolving tradition.

Since the mid-1970s the McMichael Canadian Art Collection has acquired contemporary works by artists of Native ancestry who do not necessarily draw upon traditional imagery or fall within recognizable artistic schools. Their art cannot be under-

Blake Debassige 1956–

THE ENLIGHTENMENT 1983
Acrylic on canvas
76.3 × 61.0 cm
Purchase 1984
1984.3

Page 161:
Skidegate Village, Queen
Charlotte Islands, 1881.

CANADIAN INDIAN ART

stood strictly by reference to traditional cultural esthetics. Most choose to transcend traditions to create personal interpretations of contemporary realities, providing rich and varied approaches to their art. Alex Janvier combines Plains imagery and symbolism with a sophisticated sense of design and a personal interpretation; working at the same time as Morrisseau during the 1960s, Janvier rejected the stereotyped images and forms of the day to become Canada's first Indian modernist artist. Carl Beam and Jane Ash Poitras often use a collage technique to juxtapose provocative images and words for their social and political commentary; their works place issues of Native cultural survival within a global technological context. Clifford Maracle's colourful paintings provide another approach to Native peoples' contemporary realities. Both European and North American artistic traditions equally inform the paintings of Robert Houle. Houle sometimes discreetly adds sweetgrass and porcupine quills to create textural effect and to make a statement about his cultural heritage.

Gerald McMaster and Arthur Shilling produce portraits that are very different in nature. McMaster's graphite renderings of historical figures make a political statement about the treatment of Métis people on the Plains during the last century. Shilling's portraits were produced lovingly to capture the essence of special people in his life.

Diversity in media, style, and attitude defines contemporary Indian art today. The McMichael Canadian Art Collection displays many of the major developments in Canadian Indian art history over the last century. Not only are the works significant artistic productions but they also give expression to a strong cultural identity among Native peoples today.

HAIDA FISH KILLING CLUB 19th century
Wood
5.6 × 58.7 × 4.5 cm
Purchase 1972
1972.8

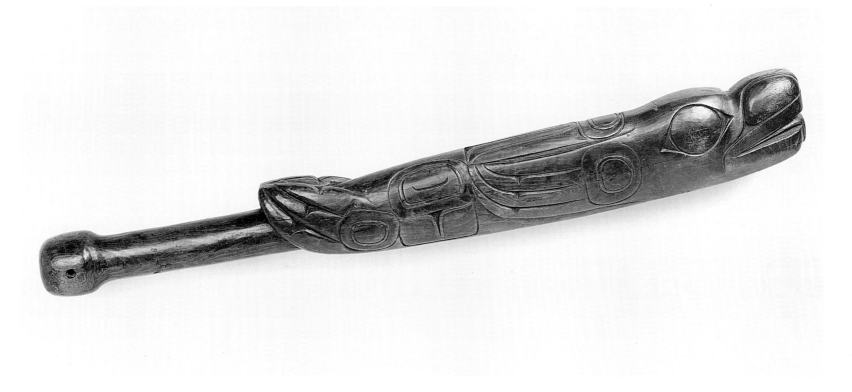

KWAKIUTL MASK c. 1900
Wood, cedar bark, and paint
29.0 × 20.3 × 86.0 cm.
Purchase 1977
1977.2.3

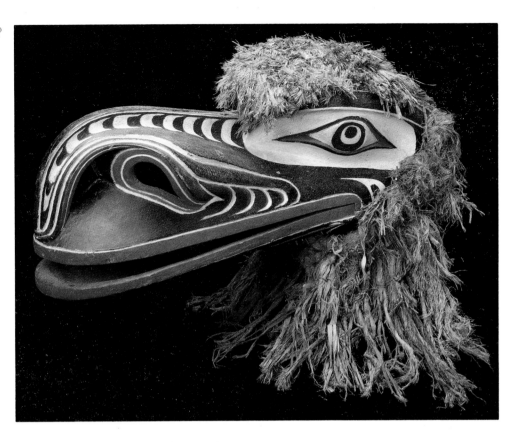

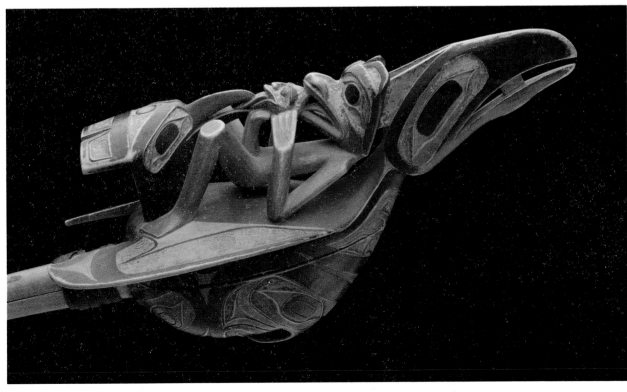

HAIDA RAVEN RATTLE 19th century
Wood and paint
11.0 × 31.7 × 10.3 cm
Purchase 1974
1974.6

CANADIAN INDIAN ART

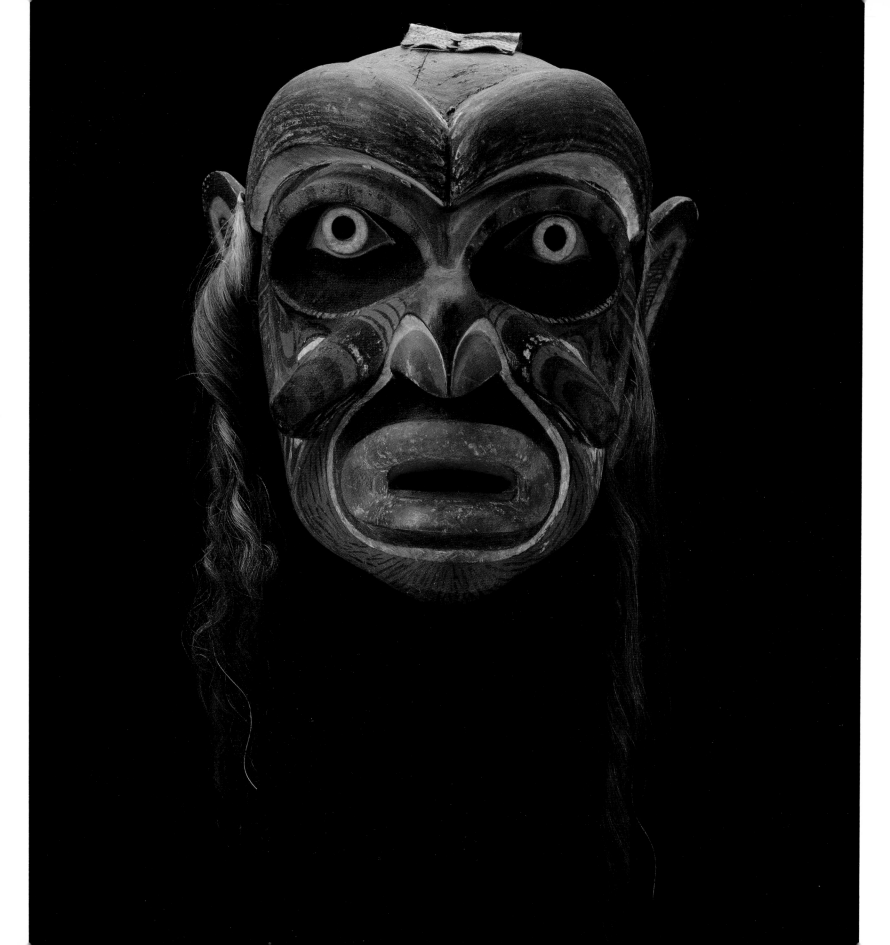

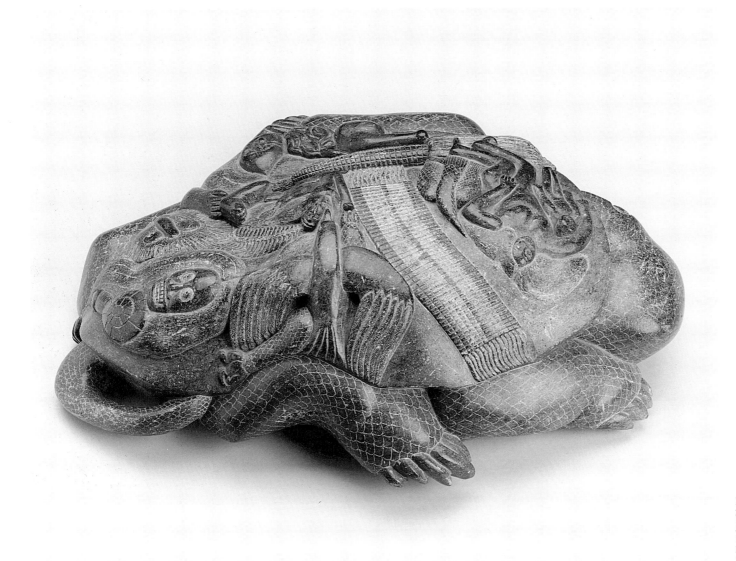

Duffy Wilson 1925–

The Creation Legend 1975
Brown stone
13.0 × 40.2 cm
Purchase 1975
1975.52

◀**Northern Wakashan Mask** 19th century
Wood, paint, and hair
50.1 × 32.0 × 20.7 cm
Purchased with the assistance of a grant through the
 Cultural Property Export and Import Act
 1984.5

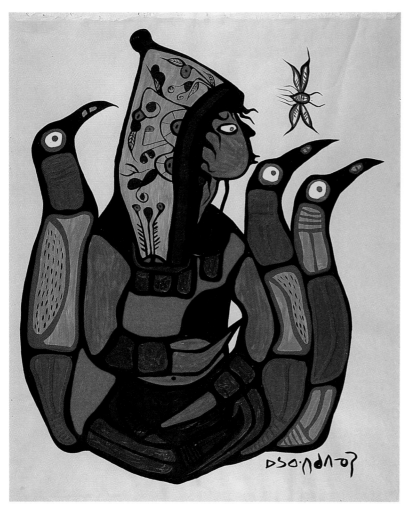

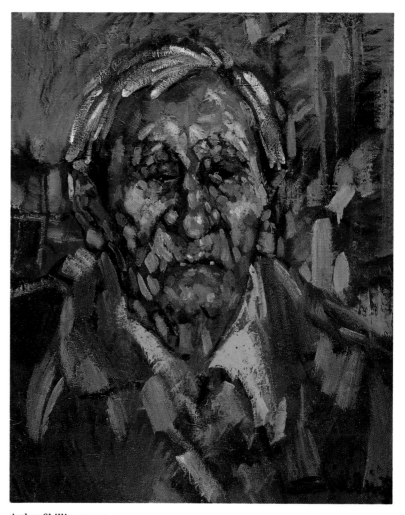

Norval Morrisseau 1931–

INDIAN CHILD WITH LOONS 1969
Acrylic and tempera on paper
123.0 × 101.8 cm
Gift of Mr. and Mrs. James J. Casey
1989.1.14

Arthur Shilling 1941–86

OLD MIKE c. 1974
Acrylic on Academy board
75.8 × 60.5 cm
Purchase 1975
1975.33.2

Daphne Odjig 1925–
TRIBUTE TO THE GREAT CHIEFS OF THE PAST 1975
Acrylic on canvas
101.8 × 81.0 cm
Purchase 1975
1975.11.1

Alex Janvier 1935–

THE DOGGONE WEAKBACKS 1975
Acrylic on canvas
56.0 × 71.3 cm
Purchase 1975
1975.26.3

Norval Morrisseau 1931–

SHAMAN AND DISCIPLES 1979
Acrylic on canvas
180.5 × 211.5 cm
Purchase 1979
1979.34.7

CANADIAN INDIAN ART

Gerald McMaster 1953-

RIEL 1985
Graphite on paper
97.0 × 127.0 cm
Purchase 1986
1986.5.2

Carl Ray 1943–78

UNTITLED 1975
Acrylic on paper
76.0 × 56.0 cm
Purchase 1975
1975.49.3

CANADIAN INDIAN ART

Clifford Maracle 1944–

Blue Indian Thinking 1975
Acrylic on canvas
122.1 × 122.1 cm
Purchase 1975
1975.42

Robert Houle 1947-

UNTITLED 1987
Oil on canvas
135.8 × 151.2 cm
Purchase 1987
1987.25

CANADIAN INDIAN ART

INDEX

This index includes the names of all Canadian artists mentioned in the text. *Italic* numerals indicate illustrations.